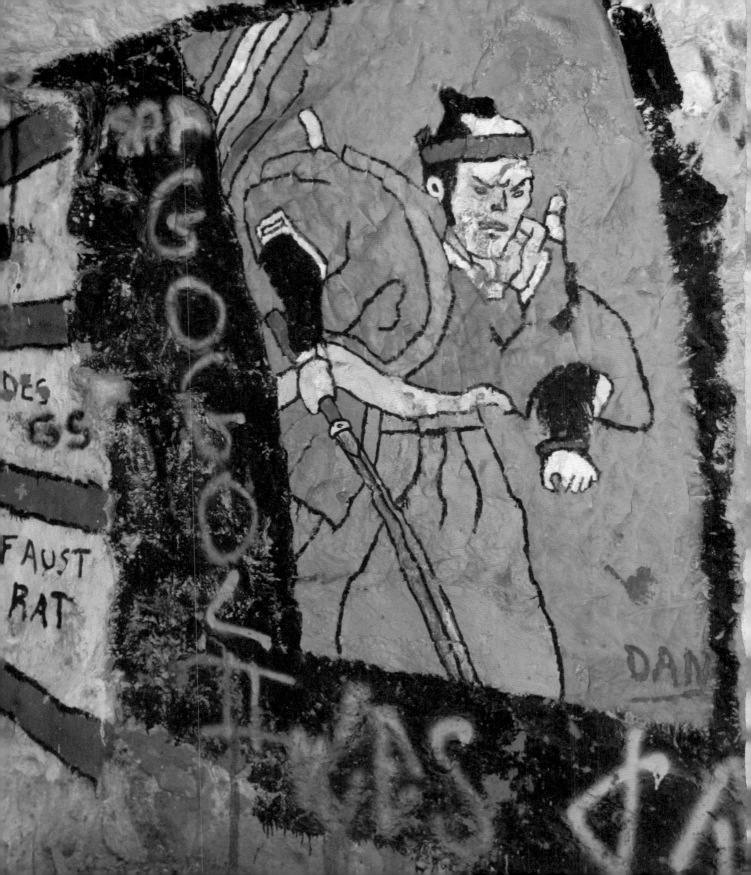

PARIS

UNDERGROUND

PARIS UNDERGROUND

CAROLINE ARCHER

WITH ALEXANDRE PARRÉ

MARK BATTY PUBLISHER 2005

PARIS UNDERGROUND

This book is typeset in Linotype Didot
Design: Lauren Prigozen
Production: Nicole Recchia

First Edition
10 9 8 7 6 5 4 3 2 1

This edition © 2005 Mark Batty Publisher, LLC
6050 Boulevard East, Suite 2H
West New York, New Jersey 07093
www.markbattypublisher.com

Library of Congress Control Number:
2005924481

Printed and bound at the National Press
The Hashemite Kingdom of Jordan

ISBN 0-9724240-7-5

CONTENTS

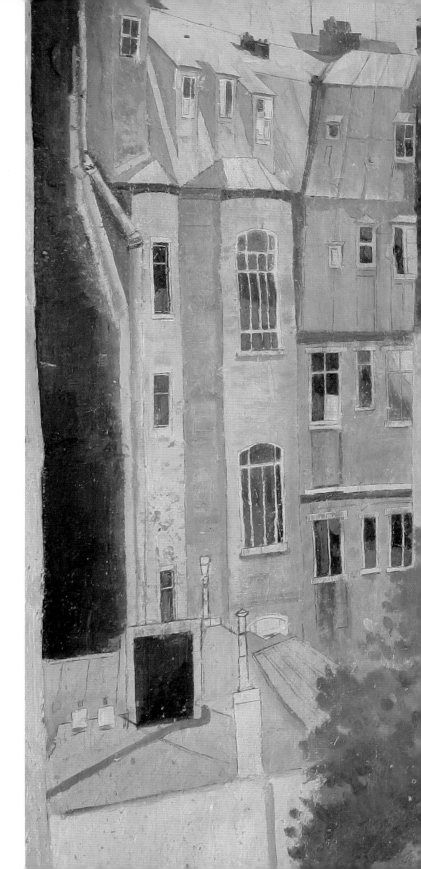

ACKNOWLEDGEMENTS

Inspection Générale des Carrières, Paris
Observatoire de Paris

With special thanks to
Gilles Thomas

And the following individuals:
Caton
Cavage
Claustrophile
Paella Chimicos
Gilles Cyprès
Gandalf
Gargouille
Michel KTU
Jérôme Mesnager
Misticatafille
Julian Pepinster
Nigel Roche
Titan

PROMO
95
VI CATAS
Guillaume NEVEUX
MARRAINE

Gilles CYPRÈS
Jules Guy

270

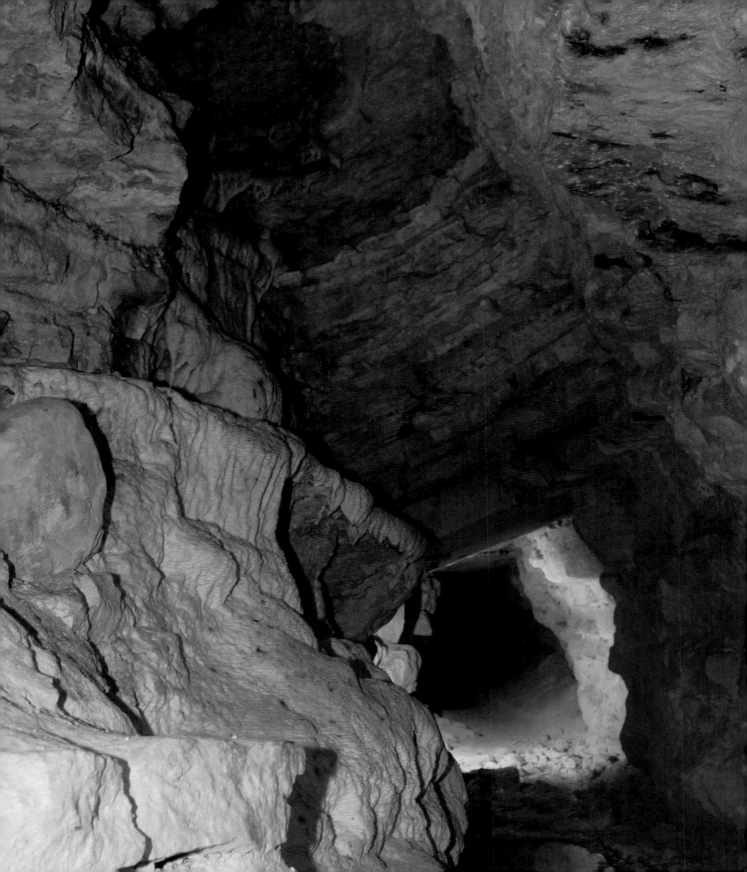

PARIS

UNDERGROUND

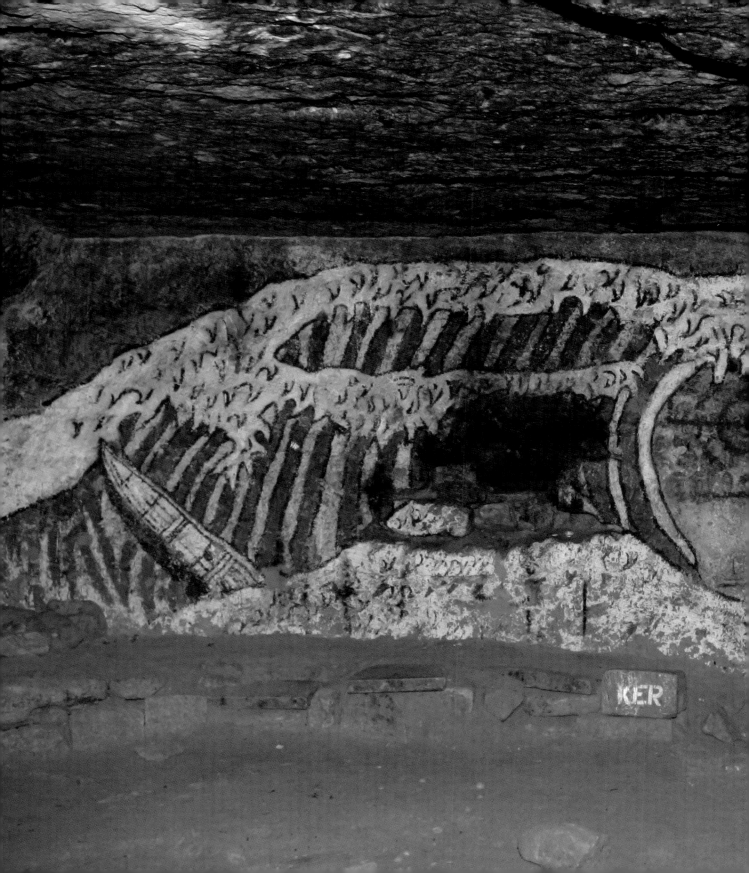

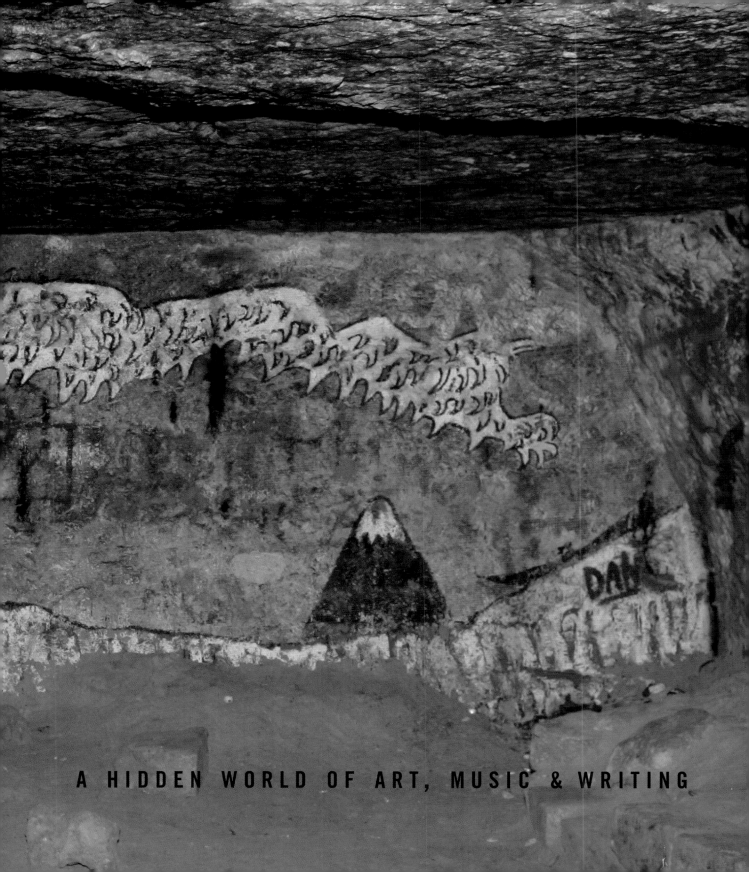

A HIDDEN WORLD OF ART, MUSIC & WRITING

anus would feel at home in Paris. The two-headed Roman god of doorways, passages and bridges would surely delight in the city with its thirty-seven river crossings and extensive labyrinth of little-known entrances and tunnels that are buried below the boulevards and which give a fascinating and unique expression to the capital.

At street level Paris is particularly multifaceted. It is one of the worlds most diverse cities, a public and private metropolis that is made up of reality and illusion, fact and mythology expressed through politics, art and architecture. It is a city of passion, of bloody histories and turbulent regimes that have produced a lifetime of stormings, terrors, revolutions, sieges, communes, occupations and liberations that have shaped it both physically and spiritually. The allure of Paris is so great that more than one powerful man has been moved to great declarations: to secure the French throne Henri IV changed his religion for her, Napoléon Bonaparte proclaimed her 'the most beautiful city in the world', and Hitler would have had her burn rather than outshine Berlin.

But it is not just emperors, kings and dictators that have influenced the face of Paris. Artists including Monet, Degas and Toulouse Lautrec have contributed to the Parisian illusion with work that is familiar the world over; and writers from de Beauvoir and Collette, to Hemingway and Orwell all add a layer to the myth. Music successfully perpetuates the fable: the tremulous voice of Piaf adds fragility to the Parisian face, the Folies-Bergère gives expression to uncontrollable exuberance, while the Moulin Rouge more than hints at the simmering sexuality of the French capital. Above all, Paris has a romantic aspect and has hosted great love affairs from Héloïse and Abelard to Napoléon and Josephine.

The physical face of Paris is provided by the grandiose architecture of the great city planners from Phillipe Auguste, Louis XIV and Haussmann to Mitterand's *Grands Projects*. There is a homogeneity to the city's buildings many of which have been constructed from locally excavated limestone, but despite architectural harmonization there is also diversity: the great Gothic structure of Notre-Dame, the red brick and stone of the sixteenth-century place des Vosges, the sumptuously Baroque seventeenth-century Eglise de Val-de-Grâce, the grandly neo-classical Place de la Concorde, and the emphatic Eiffel Tower. The twentieth century has also added its touch to the city with Nouvel's Institute du Monde Arabe and Perrault's Bibliothèque Nationale.

THE HIDDEN ART GALLERY OF PARIS

These are the showy, flamboyant and very public faces of Paris. There is, however, a quiet, intimate and undisclosed face of the French capital that is integral both to its physical structure as well as its spiritual being. It is Janus in an introspective mood.

Below the graceful boulevards lie miles of dank, subterranean galleries; they are a result of city planning every bit as impressive as that above the surface. The underground galleries make their way through limestone and gypsum quarries found under the capital. The excavation of these quarries began in about the twelfth century when they provided the raw material needed to build the city, including Notre Dame. Extractions were made indiscriminately: when a quarry had been stripped of its contents it was abandoned and vacuums developed below the city that caused potential danger to the people and buildings on the surface.

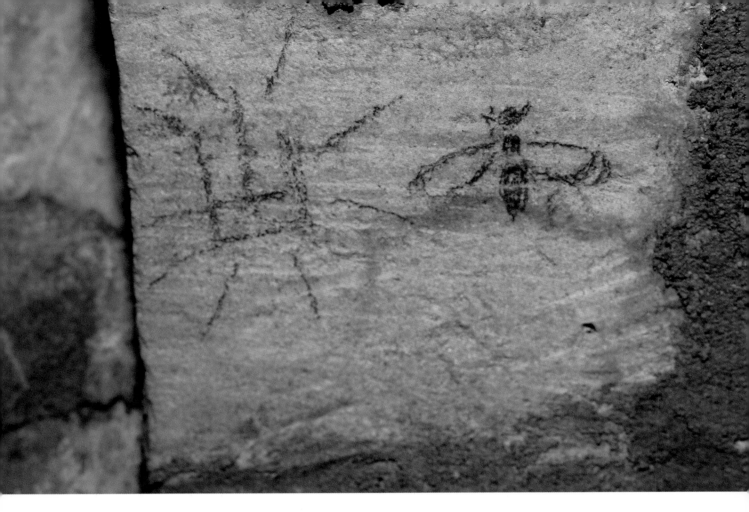

In 1774 the inevitable happened: one of the city streets collapsed. The empty quarries threatened the stability of Paris and the Inspection des Carrières was established to explore, map and make safe those that were in bad condition. It was a colossal job. To do the work inspection galleries had to be constructed that would allow the quarrymen to explore the basement and so a complex network of passages was built that extended approximately 177 miles across the city. Today the inspection galleries and abandoned quarries contain an extraordinary, incalculable and ever-growing collection of visual material that has been amassing on the walls for over three centuries. And just as the romance of street level Paris has been the inspiration behind a wealth of art, literature and music, so the quarries have provided the muse for many artists, writers

and musicians, and the ambience for more than just a little *amour*.

Some of the artwork is official, others illicit. It is the creation of a wide range of individuals: engineers, quarrymen, Prussian and German soldiers, Resistance workers, civilians, secret societies, Cataphiles, students, tourists and mushroom growers. It embraces art forms of various types: incised inscriptions, handwriting, graffiti, painting, sculpture, mosaics, cartoons, sketches, directional signage, art installations, ephemeral paper tracts and music. The artworks were made over a period that takes in such momentous events as the storming of the Bastille, 1789; the Grand Terreur, 1794; the declaration of the Republic, 1792; the Prussian siege, 1870; the Commune, 1871; the German occupation, 1940; the liberation of 1944; and the student riots

and workers' strikes, 1968. Amidst political turmoil, art flourished in Paris's basement and important moments have been recorded and preserved in the underground. These sometimes functional, frequently personal, often fantastic, and always unique artworks are the creation of Everyman. They reflect and record the individual's role in the evolution of a metropolis and a nation. Collectively the works form a visual memory and memorial of the city: it is the hidden art gallery of Paris.

THE QUARRIES IN HISTORY

The quarries gave life to Paris: they provided the material from which the city was built. For three hundred years they have also been the invisible physical support of the city, the reinforcements that have propped up the surface. While Paris above ground was in political upheaval, its underground foundations were stable and provided a refuge from war, death and destruction. The quarries have supported and nurtured successive generations, and provided work for many. Much of the artwork reflects this positive force. On the other hand, the underground has also become synonymous with death: over six million Parisians found their final resting place in the quarries when in the 1780s the contents of the overcrowded city cemeteries were transferred to specially created catacombs within the quarries, which later included victims of the Grand Terreur. This association with death has engendered artwork of a more macabre nature.

The underground inspection galleries are covered in official letterforms of every conceivable style made in every imaginable medium: they are a reminder that the quarries were once a thriving work environment. Quarry employees made most of the inscriptions in the eighteenth and nineteenth centuries; they are technical engineering marks that tell the history of the quarrymen's progress. The letterforms were made by laborers and are often crudely executed and inexpertly constructed but their naïveté engenders charm and their abundance arrests the eye. In addition to the

engineering marks, road signs appear in profusion and can be found in every gallery. The road names usually, but not always, correspond to those on the surface and their creation has been left to the quarrymen who incised the stone in situ with varying degrees of competence. Their works provide interesting commentary on vernacular interpretations of letterforms and the historical topography of Paris.

But amid the official inscriptions there is also a multitude of illicitly produced graffiti and roughly made sketches. The graffiti ranges from discrete pencil marks to the extravagant aerosol tags of contemporary graffiti writers. Of the sketches, some are boldly made with black smoke; others are delicately rendered in pencil and are scarcely visible. Their

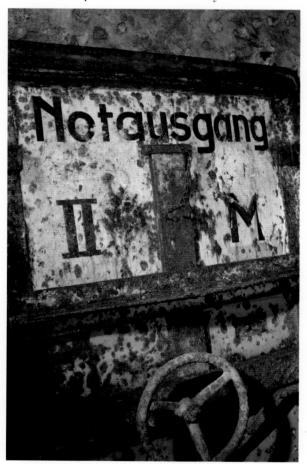

A well executed, sans serif sign produced by German soldiers during the 1940-44 occupation of Paris. The sign states "no exit" (notausgang).

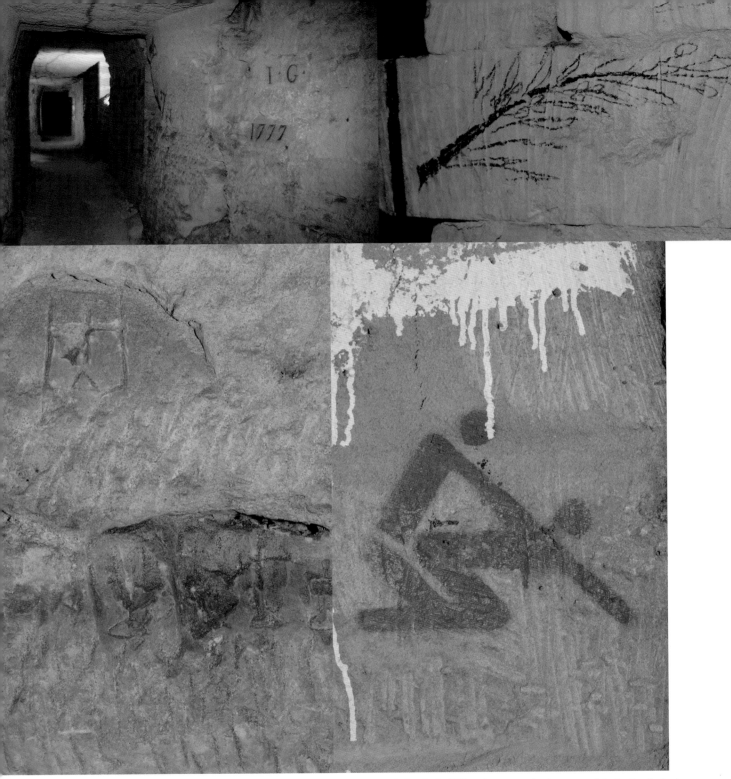

For nearly 300 years there have been visitors, legal and illegal, to the quarries below Paris. All have been moved to leave a mark indicating their passage through the quarries. Some of the images are pornographic others are political. They are all highly personal, and a cultural history is projected in layers as an ever-developing artwork.

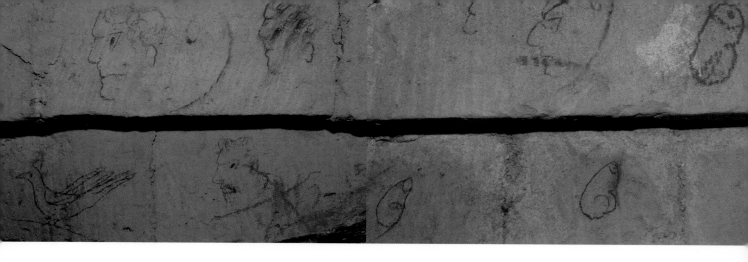

subject matters include prosaic representations of quarrymen and more esoteric images whose meaning has faded with the passage of time.

The quarries are closely associated with war, revolution and siege, and evidence of the turbulence raging above ground can be found in the underground, from the Prussian soldier who marked the walls with his name and home town: 'E. Bochon, Potsdam, 18.11.70'; to the Parisian civilian sheltering from Allied bombing: 'En souvenir d'une charmante alerte qui a eu l'audace de me faire rater mon train' [in memory of a charming alert that had the audacity to make me miss my train]. During the occupation of 1940-44, the Germans availed themselves of the quarries to escape from allied bombing and adapted the underground to form shelters. At the same time, the Free French of the Interior (FFI) used them as a headquarters. Both parties have painted the walls with characteristic inscriptions and directional signs.

DRAWN TO MAKE SIGNS & IMAGES

Every visitor to the quarries seems to need to leave their sign, or to draw images: 'liberty birds', houses, flowers and religious or esoteric symbolism. Some of the images are pornographic; others are the political scrawlings of post-war Parisian youths.

They are highly personal and intimate sketches whose reason for being can only be surmised.

Since the 1980s, more blatant and sophisticated paintings have appeared as students from various colleges have invaded the quarries and painted giant frescos some as large as twenty meters wide. Other paintings have been left by individuals and are of a remarkable technical quality and often located in particularly remote parts of the quarries. Their subject matter is various but they are frequently harsh and thought-provoking visual essays on death, politics and power, colorfully rendered on the dark and expansive canvas provided by the quarry walls.

Marking and writing, on walls even in the quarries, is ephemeral, so why have so many individuals left their marks, simple or complex, particularly as few will see the images and almost none will understand? Human vanity urges individuals to indelibly record their existence, to document for posterity their presence at great events. There is also the spirit of confrontation: the quarries are difficult to access, problematic to negotiate and a test of endurance; marking their walls is proof of having braved the environment. Whatever the reason for their presence, the paintings and inscriptions in the quarries bring a human and domestic quality to an

19

SHEEK/DONKISHOT/LES TROLLS/GORKI PLUBAKTER/JOSEF/JAMES DELLECK/
RAPACES/NERF/STRYTCH9 & MASTA ROTH/KESSKIYALA KREW/ANN'SO/
SAI SAI/SYNDI-K-XION/LES PETITS CLONES MAJOR-LIKE/PSYCKOZE ...

CD 17 TITRES INEDITS CONTRE LA FRENCH MAJOR-MIMETIC TOUCH ET LA CENSURE SECURITAIRE !

A ECOUTER
TRÈS FORT,
LA NUIT,
TOUT EN GARDANT
UNE OREILLE
BIEN
TENDRE
AU CAS OU
LE MONDE
S'ECROULERAIT

VOIX SOUTERRAINES-ONZIEME CAVE

dans les bacs indés en Avril 2003 enregistrements du
HIPHOPTERBREAKFLOPCOREFUNKFREESTYLE HTTP://CAVAGE.C8.COM CAVAGE 11

inhospitable world and record the role of the individual in the history of Paris.

PERFORMANCE & MUSIC

Although the Parisian quarries have encouraged many people to produce a wealth of visual material, they have also been the inspiration behind many literary and musical creations some of which have been performed in the underground while others have also been made available to the world on the surface.

Music has played a large part in the life of the underground during the late twentieth century. Concerts and festivals have been held in the quarries that have given exposure to a wide range of musical genres and which have been attended by large numbers of cataphiles. They have also been the inspiration behind more than one contemporary musical composition. But quarry music is not just a modern phenomenon. In 1873 the artist and architect Victor Hart-mann died. Although he was a gifted artist who painted with vigor and flair, his name would not be so familiar if it were not for the inspiration his friendship gave to that extraordinary but morose genius of Russian music, Modest Mussorgsky. Hart-mann spent three years in France where he made a series of drawings and paintings that included one of the catacombs beneath the streets of Paris. *The Catacombs* is a self-portrait of Hartmann and includes the architect Kenel and a guide holding a lamp in the underground. As a memorial to his friend, Mussorgsky com-posed *Pictures at an Exhibition*, a series of ten musical sketches for the piano inspired by ten of Hartmann's paintings. One of the musical sketches is called *The Catacombs*; it is a slow succession of deep, mournful chords that describe the path taken by Hartmann and his two companions through the underground. Mussorgsky inscribed the original manuscript with the words *Con mortuis in lingua mortua* (with the

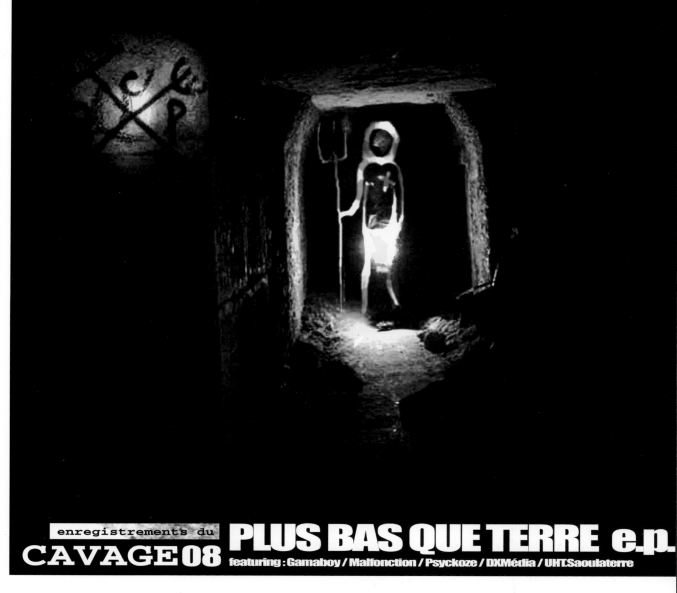

enregistrements du
CAVAGE 08 PLUS BAS QUE TERRE e.p.
featuring : Gamaboy / Malfonction / Psyckoze / DXMédia / UHT.Saoulaterre

dead in a dead language), followed in Russian by: 'Hartmann's creative spirit leads me to the place of skulls, and calls to them – the skulls begin to glow faintly from within.' They are appropriately melancholic lines of death, which are characteristic of most music from the underground.

The quarries and catacombs have not only been a source of inspiration for composers they have also been used as unusual, if illicit, music venues. As early as April 2, 1897, a clandestine concert took place between midnight and two in the morning in the catacombs below Place Denfert-Rochereau. The event was attended by about 100 people and was made possible by the co-operation and kindness of two workmen of the Inspection des Carrières. Unfortunately the two men were dismissed for their actions but were reinstated a short time later. The chosen music was undoubtedly apposite for the setting and the program included: *Funeral March*, Chopin; *Danse Macabre*, Saint-

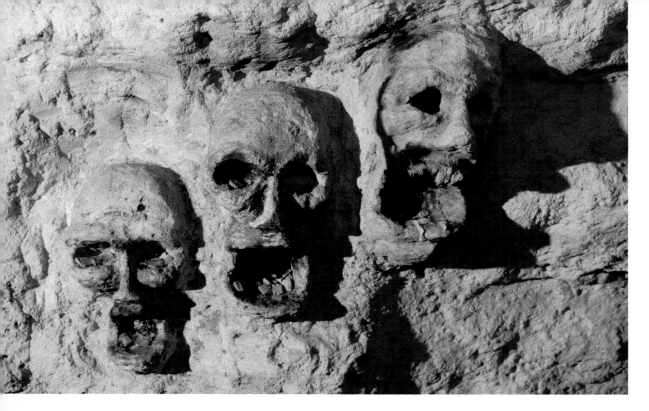

Saëns; *Ave Maria*, a poem written and recited by M. Alla; Choir and *Funeral March* from the *'Perses'*, Xavier Leroux; Aux Catacombs, a poem written and recited by M. Marlit; *Funeral March* from *'Heroic Symphony'*, Ludwig Van Beethoven; and the evening was concluded with verse by Henri Cazalis for which Saint-Saëns composed the *Danse Macabre*:

Zig et zig et zig, la Mort en cadence,
Frappant une tombe avec son talon,
La Mort à minuit joue un air de danse,
Zig et zig et zig, sur son violon.

Le vent d'hiver souffle et la nuit est sombre;
Des gémissements sortent des tilleuls;
Les squelettes blancs vont à travers l'ombre,
Courant et sautant sur leur grands linceuls.

Zig et zig et zig, chacun se trémousse,
On entend claquer les os des danseurs.
Mais psit! tout à coup on quitte la ronde,
On se presse, on fuit, le coq a chanté...

TRANSLATION

Tum, tum, tum, the measured
 rhythm of Death,
Drumming on a tomb with his claw,
Death at midnight playing a wisp
 of a dance,
Tum, tum, tum, on his violin.

The winter wind blows and the night is dark,
A shiver in the lime blossom,
The white skeletons passing
 across the shadows,
Running and jumping on their shrouds.

Tum, tum, tum, each flutters,
To the sound of the dancer's bones.

But suddenly the dance halts,
Hurry, escape, the rooster has crowed...

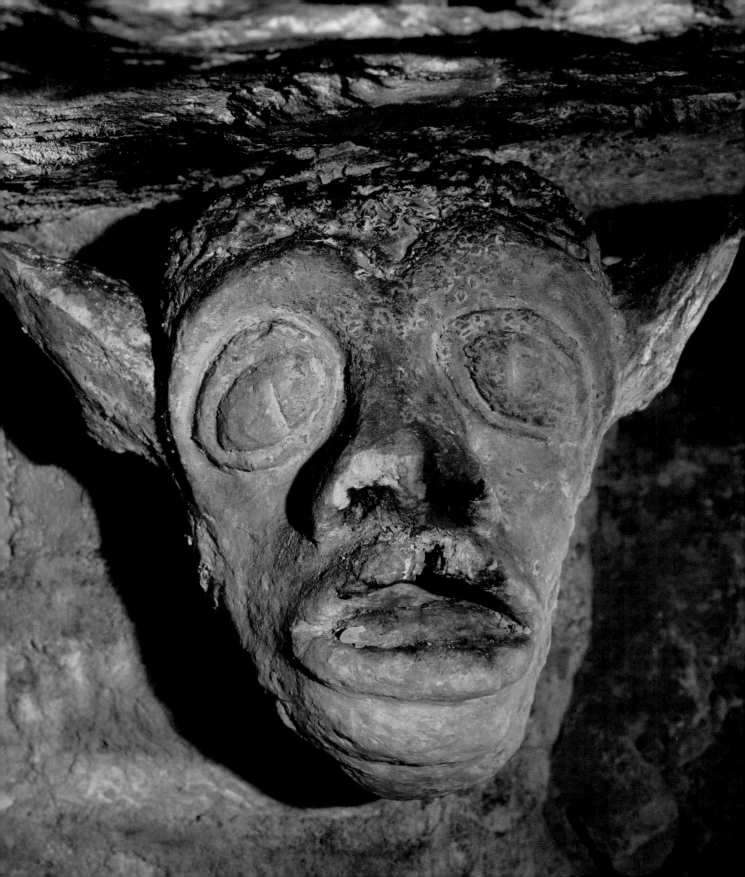

The influence of the quarries on the arts has continued through the decades and a number of contemporary musicians have taken the underground as their muse. In 1998, Jean-Michel Jarre wrote a score entitled *Paris Underground*, which was played on July 14 at a concert held in the shadow of the Eiffel Tower. The event was a visual spectacle and the music was complemented by light shows and projected images from the Parisian quarries. A video of the event was also produced which included photographs taken in the underground.

The quarries have also had their influence on

more unconventional artists. Cavage is a Paris-based record label and many of its artists are active visitors to the underground who have chosen the quarries as an inspiration for writing their music, as a metaphor for their political beliefs, a fascinating subject for their CD covers, and as a primal no-man's-land that provides a wonderful venue for the playing of music. The concept behind the Cavage label is about producing '. . . freestyle music, sounds, emotions and subversion via frequencies and sub-senses. It is about metaphoric disassociation. The motivations for track selection are influenced by those feelings. It is also a witness label of the catacomb/underground tunnels of Paris, it is an aesthetic and political mimetic for the way of living in that no-man's-land. Cavage provides a pure, intimate and cooperative platform for its artists who can express their beliefs and political ideas of independence and auto-production, through the medium of sound. The "concept" of the label is not about stability at all; it is a real time thing and is constantly mutating'. For Cavage and its artists the quarries are a wonderful source of inspiration for their music, publications and paintings. However, they perceive a new threat to this unique and valued environment in the shape of television program makers who 'assault the catacombs almost every summer, because it seems they are always needing "secret Paris" programs on TV. The camera hunt is on; long-live the underground of Paris!'

As well as television, the Paris quarries have had roles in both stage and screen productions. Andrew Lloyd Webber's stage musical, 'Phantom of the Opera' (based on the infamous thriller of the same name by Gaston Leroux) has played to over 58 million people in 109 cities in twenty countries around the world. The main character is Erik, a

scarred fiend who lurks in the vacuums beneath the Paris Opera House and who serves as unseen mentor to the singer Christine. On the big screen, the quarries provided the backdrop for *Les Gaspards* (The Holes), a 1973 film directed by Pierre Tchernia and staring Gérard Depardieu. It is an irresistible funny story of a group of people living under Paris who kidnap a busload of tourists, most of the police force, and some of the choicest beauties in the city in order to convince the administration to stop the works that were destroying Paris.

In 2004, a clandestine group of 'urban explorers' known as La Mexicaine de Perforation, built a cinema with restaurant and bar in 4500 square feet of the quarries below the Palais de Chaillot. The cinema was open for a seven-week summer season showing a subversive programme of work, including Dark City (Alex Poryas), Rumble Fish (Coppola), Eraserhead (David Lynch) and Brazil (Terry Gilliam). Planning and building the fully functioning subterranean cinema took eighteen months. Piping electricity and phone lines caused the group few problems, but importing tables, chairs, bar, projector and screen through a eleven-by-sixteen-inch hole on the surface was a test of ingenuity. The group have great respect for the underground environment, and went to great pains to ensure their presence was not to the detriment of the quarries' heritage. Parisian police could charge them with nothing other than 'theft of electricity'!

WRITING

Above all, the quarries and catacombs of Paris have inspired words: poetry, prose, short stories and musings from the lofty pen of the classical writers to the humble scribbling of contemporary Cataphiles. The literary output shares common themes with its visual counterparts: death, life everlasting, and the fragility of man. Most of the texts are darkly contemplative and introspective but there is also the occasional glimmer of humor.

Victor-Marie Hugo (1802-85) was a poet and novelist and the leader of the French Romantic

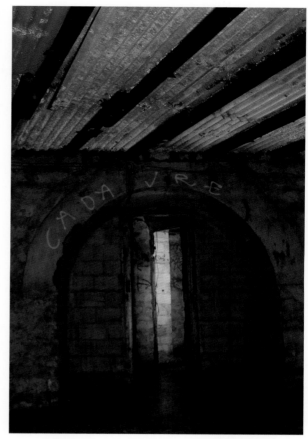

movement. He entered politics after the Revolution of 1848 and became an eloquent defender of liberty. In 1853 he wrote *Les châtiments* (The punishments), a violent satire against Louis Napoléon in which he uses the catacombs as a political symbol:

La terre est sous vos pieds comme
votre royaume;
Vous êtes le colosse et nous sommes l'atome;
Eh bien! guerre! et luttons, c'est notre volonté.
Vous, pour l'oppression, nous, pour la liberté!
Montrer les noirs pontons, montrer
les catacombes.
Et s'écrier, debout sur la pierre des tombes:
Français! craignez d'avoir un jour pour
repentirs
Les pleurs des innocents et les os des martyrs!
11 - Le parti du crime

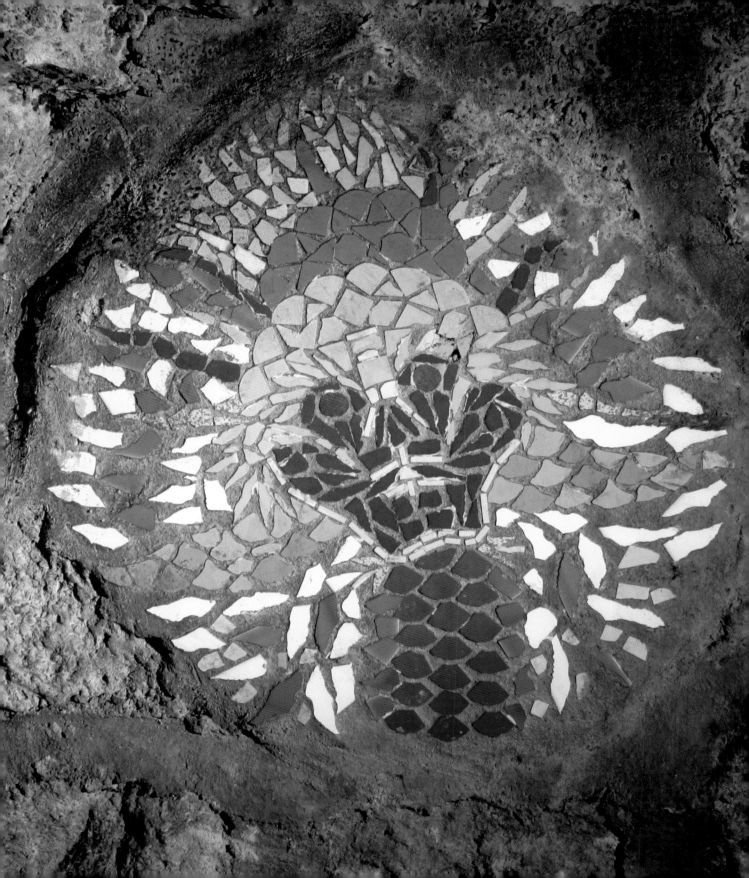

TRANSLATION

The earth is under your feet like your kingdom;
You are the colossus and we are the atom;
Well! war! let's fight, it's our wish.
You, for oppression, we for liberty!
And cry out, standing on the tomb stones:
'Frenchmen! Hope to have a day to repent
The tears of the innocents and the bones
of the martyrs!'

In *Les contemplations* (The meditations),
written a few years later in 1856, Hugo writes
of the catacombs in more reflective and
romantic tones:

Paix à l'Ombre! Dormez! dormez!
dormez! dormez!
Etres, groupes confus lentement transformés!
Dormez, les champs! dormez, les fleurs!
dormez, les tombes!
Toits, murs, seuils des maisons, pierres des
catacombes,
Feuilles au fond des bois, plumes au fond
des nids,
Dormez! dormez, brins d'herbe, et
dormez, infinis!
Calmez-vous, forêts, chêne, érable, frêne, yeuse!
Silence sur la grande horreur religieuse,
Sur l'Océan qui lutte et qui ronge son mors,
Et sur l'apaisement insondable des morts!
Paix à l'obscurité muette et redoutée!
Paix au doute effrayant, à l'immense
ombre athée.

TRANSLATION

Peace in the shadows! Sleep! sleep!
sleep! sleep!
Beings, confused and slowly
transforming groups!
Sleep, the fields! Sleep, the flowers!
Sleep the tombs!
Roofs, walls, thresholds of houses,
stones of catacombs,

Leaves of the forest, feathers of the nest,
Sleep! Sleep, blades of grass, and sleep, eternal!
Be calm, forests, oak, maple, ash, ilex!
Silence on the great religious horror,
On the Ocean which fights and gnaws
at it's bit,
And on the bottomless quieting of the dead!
Dread dumb obscure peace!
Frightful doubting peace, with a huge
atheist shadow.

It is not just poets of the past who have been
inspired by the catacombs and quarries; their
unique muse has also struck writers of the
present. Franck Lozac'h, an advocate of the
French sonnet and admirer of Ronsard,
Baudelaire and Mallarmé wrote his own *Le
Livre des Sonnets* in 1996 in which he includes
a verse entitled *Les catacombs*:

Dans les catacombs
Froides et grinceuses
Où des femmes affreuses
Emergent de chaque tombe,
Des lueurs blanchâtres
Faiblement éclairent
Les murs d'albâtre:
Un spectre mortuaire
Décambule et vacille
En ce lugubre monde
Alors mes pas fébriles
Devant ces torches fugaces
Voient l'empreinte profonde
De mémorables traces!...

TRANSLATION

In the catacombs
Cold and gritty
Where frightful women
Come out of each tomb,
Whitish gleam
Lighting slightly
The walls of alabaster:
A mortuary ghost

The earth is under your feet like your kingdom;
You are the colossus and we are the atom;
Well! war! let's fight, it's our wish.
You, for oppression, we for liberty!
And cry out, standing on the tomb stones:
'Frenchmen! Hope to have a day to repent
The tears of the innocents and the bones
of the martyrs!'

In *Les contemplations* (The meditations),
written a few years later in 1856, Hugo writes
of the catacombs in more reflective and
romantic tones:

Paix à l'Ombre! Dormez! dormez!
dormez! dormez!
Etres, groupes confus lentement transformés!
Dormez, les champs! dormez, les fleurs!
dormez, les tombes!
Toits, murs, seuils des maisons, pierres des
catacombes,
Feuilles au fond des bois, plumes au fond
des nids,
Dormez! dormez, brins d'herbe, et
dormez, infinis!
Calmez-vous, forêts, chêne, érable frêne, yeuse!
Silence sur la grande horreur religieuse,

Sur l'Océan qui lutte et qui ronge son mors,
Et sur l'apaisement insondable des morts!
Paix à l'obscurité muette et redoutée!
Paix au doute effrayant, à l'immense
ombre athée.

Peace in the shadows! Sleep! sleep!
sleep! sleep!
Beings, confused and slowly
transforming groups!
Sleep, the fields! Sleep, the flowers!
Sleep the tombs!
Roofs, walls, thresholds of houses,
stones of catacombs,
Leaves of the forest, feathers of the nest,
Sleep! Sleep, blades of grass, and sleep, eternal!
Be calm, forests, oak, maple, ash, ilex!
Silence on the great religious horror,
On the Ocean which fights and gnaws
at it's bit,
And on the bottomless quieting of the dead!
Dread dumb obscure peace!
Frightful doubting peace, with a huge
atheist shadow.

It is not just poets of the past who have been
inspired by the catacombs and quarries; their

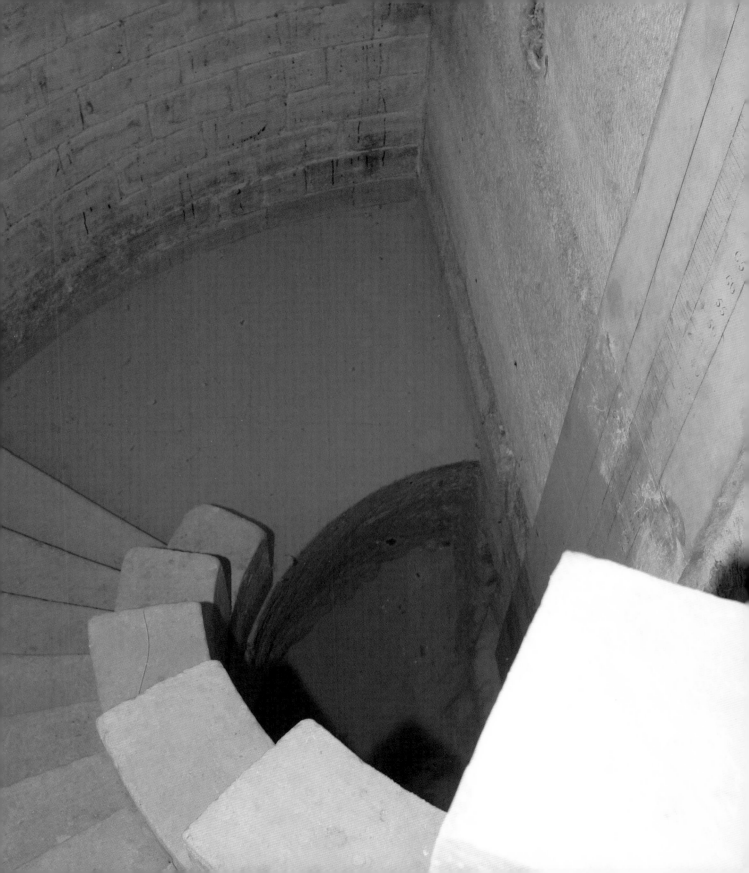

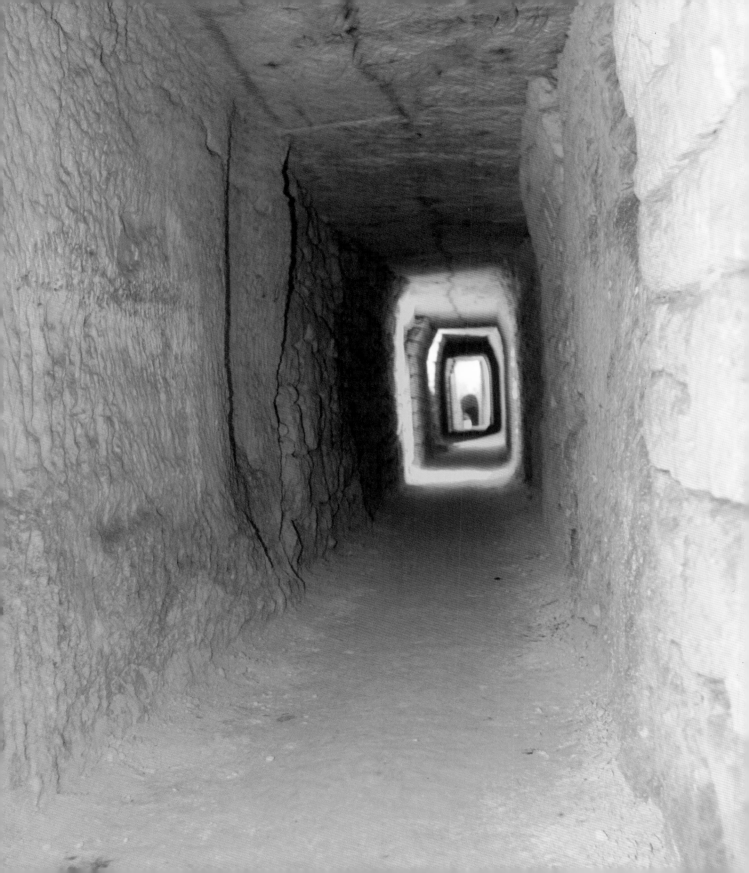

THE
QUARRIES
AND
TUNNELS

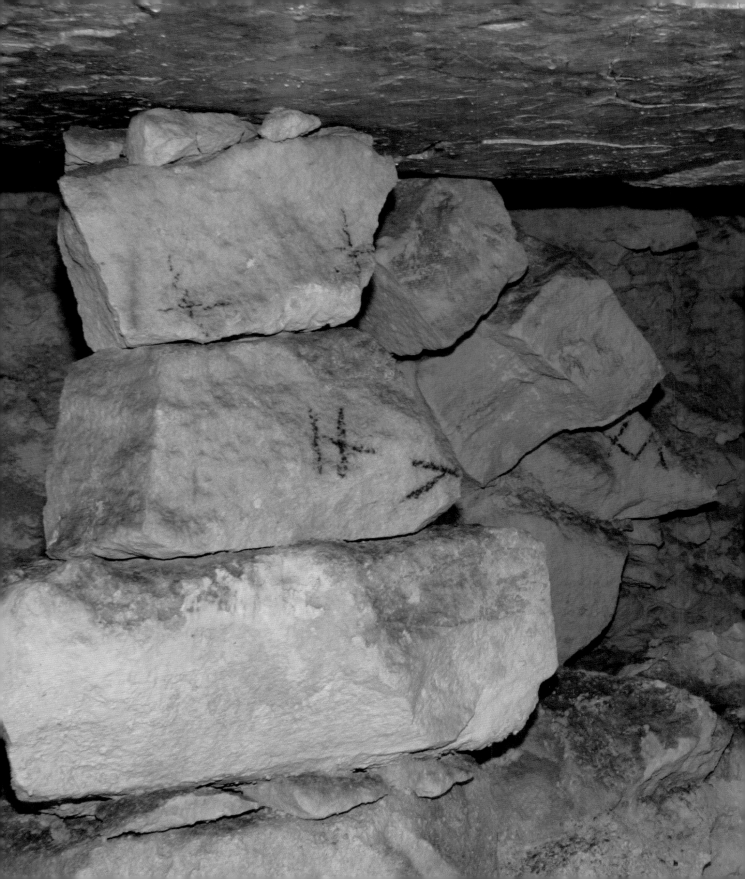

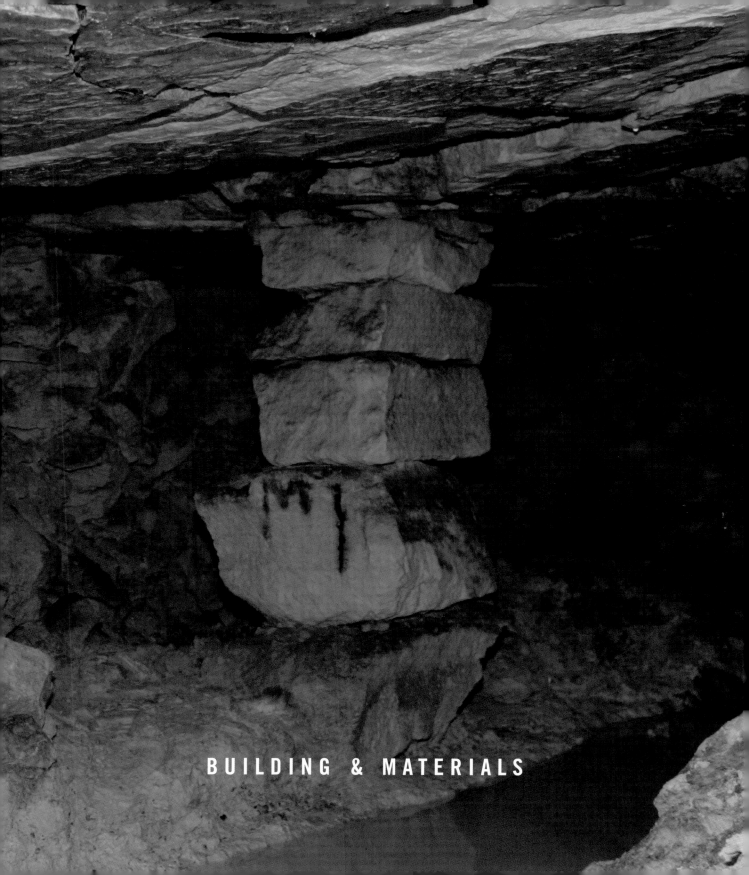

BUILDING & MATERIALS

Paris is built on a very large sponge: it is a multi-cellular underground environment with a complex system of damp passages supported by a chalky framework that was precipitated there from the sea fifty-five million years ago. For five centuries this calcareous rock provided the necessary material for building the city and after extensive and indiscriminate quarrying the stone was abandoned, full of vacuums.

There is a rich geology below the city that comprises white chalk topped with clay, fresh water limestone, gypsum, marl, and sandstone beds made of marine shells. Limestone and gypsum was of most use to the city builders but they also used the clay. The limestone was needed to erect stone buildings, gypsum to make plaster, and clay to make bricks and roof tiles. The limestone is mainly located in the south of the city in the v, vi, xii, xiii, xiv, xv, and xvi arrondissements; and outside the péripherique to the south as far as Vitry-sur-Seine, to the southeast out to Champigny-Marne and the northwest as far as Nanterre. Gypsum can be found to the north and northeast of the city in the x, xviii, xix and xx arrondissements; and beyond the

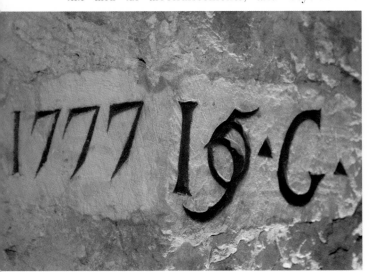

Incised lettering indicating a consolidation made in 1777 by Charles-Axel Guillaumot, first controller and general inspector of quarries. The lettering displays the characteristically sharp, pointed letters associated with the work of Guillaumot, and a cheerfully unconcerned and clumsy attempt at correcting mistakes.

péripherique mainly to the north of the Seine.

A GREAT CITY IS BUILT

Initially, ground level stone was excavated to build the city. When the surface material was exhausted or the stone had become too difficult or too expensive to remove, underground quarries were made to access the rich subterranean supply of limestone and gypsum. At first quarrying took place beyond the city boundaries, but as Paris expanded and more material was need for construction, the quarries progressed towards the center. From around the time of King Louis VI (1108-37) to that of Louis XVI (1774-91), monarchs, monks, statesmen, city-planners, architects, and private individuals have all exploited the Parisian quarries either for the aggrandisement of the city or for personal gain. It was Henri I's consort who complained that in Paris 'the houses were gloomy, the churches ugly and customs revolting'. Thirty years later all that changed when Louis VI, assisted by his minister Abbé Suger, built the soaring spires of the Basilique Saint-Denis, which represented a turning point in the architectural, artistic and intellectual development of Paris. Many other great edifices followed: work on Notre Dame started in 1163, and with the accession of Phillipe Auguste (1165-1223), construction began on the Louvre. Paris started to develop rapidly and the quarries were raided to satisfy ambitious building programs. Charles V (1364-80) expanded the city when he built the Bastille, and François I (1515-47) left his mark when he updated the Louvre and built his renaissance palace at Fontainebleau. Grand building projects continued aplenty under Henri IV (1589-1610) when new quarries had to be opened to construct the Place Dauphine and the Place des Vosges. The expansion persisted when Louis XIII (1610-43) built the Palais-Royal and remodelled the Sorbonne. The quarries were further called upon when Louis XIV (1643-1715) attempted to make Paris into the greatest city in Europe with grand views, illustrious buildings, sweeping boulevards and tri-

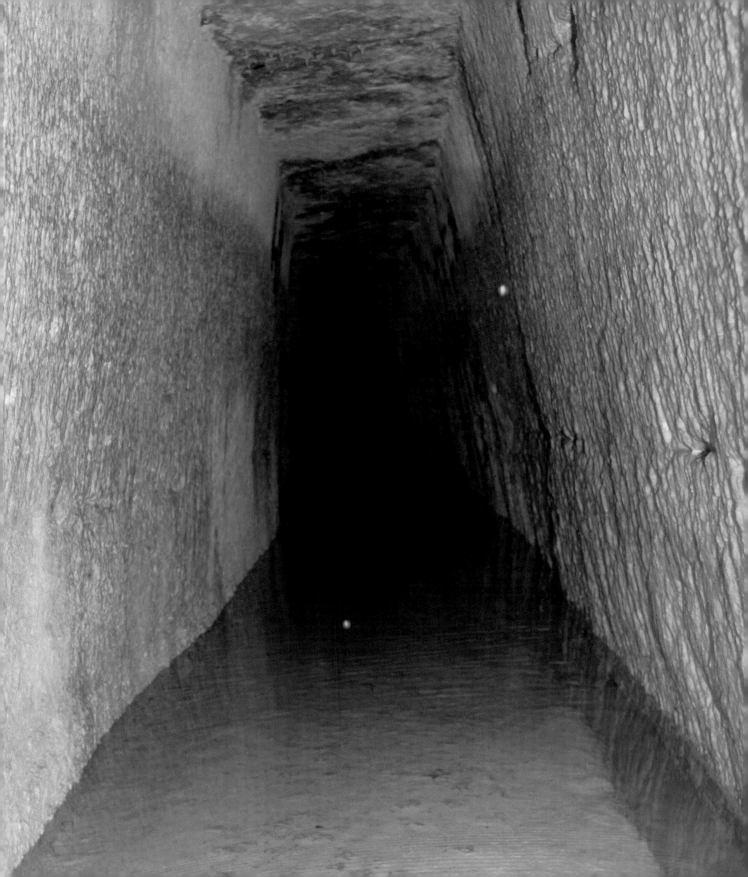

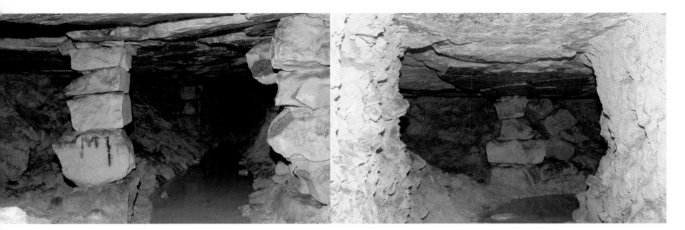

umphal arches; in this he succeeded with the Place Vendôme and Porte Saint-Denis. The capital was decorated still further when Louis XV (1715-74) built the Place de la Concorde. The architecture of Paris undoubtedly owes a great debt to its underground quarries.

But the development of Paris was not just about impressive monuments and broad boulevards. The city's monasteries were also built with stone torn from the underground, and when construction was completed the monks made the quarries safe and re-ascribed their use to brewing beer and maturing alcohol. As the city expanded its growing population also had to be housed: the nouveaux-riches favored limestone-constructed houses in the Marais, Ile-Saint-Louis and Saint-Germain, while the working classes built cheap gypsum housing in the northeast. Trade was facilitated with the construction of new roads, bridges and markets.

In order to satisfy the considerable demands of the city, construction projects it became necessary to excavate further into the underground stone masses. Long parallel passages ten to twelve feet broad were dug into the quarries and the extracted material was carried vertically and quickly to ground level via wells sunk into the stone. Transverse passages crossed the parallel ones to form a chessboard pattern. Sometimes two levels of passages were built one under the other. Between the intersections of the passages natural stone pillars remained that served to support the quarry ceiling. Once a quarry had been stripped of its contents it was abandoned and the workmen left behind unsteady vacuums that relied on the stone pillars for stability. Unfortunately, the quarry ceilings often degraded and the pillars developed fissures and were prone to collapse.

MENDING THE QUARRIES

By the time Louis XVI came to the throne the quarries had been exploited for nearly 500 years and had been exhumed to such an extent that the French capital found itself sitting on a labyrinth of vacant passages that had become increasingly unstable. By contemporary standards Paris had developed into a sizeable city, the largest in Europe; however, her splendor was threatened by a basement that was struggling to support the city above and depressions started to appear in the surface.

On December 17, 1774, the accident that was

waiting to happen finally occurred: an excavation of a quarry below the northern part of the present-day Avenue du Général Leclerc, near the Place Denfert-Rochereau, caused the street to collapse. Three hundred meters of road disappeared and the attics of houses suddenly found themselves in their basements. The Conseil du Roi intervened, threatened the owners of the quarries, and ordered them to make them safe. But Paris, and all her residents, was stunned by the discovery of the subterranean terror as a contemporary writer remarked: 'when one reflects on what carries the ground of this superb city, a secret quiver seizes you.'

Following the alarm and disapprobation of the population, the Conseil du Roi commissioned a study into the condition of the quarries that threatened the stability of the roads and buildings and which put the residents of Paris in peril. The findings were so alarming that on April 4, 1777, the Counseil du Roi created the Inspection des Carrières to explore, map and make safe the quarries under Paris. On April 27, 1777, the King's architect, Charles-Axel Guillaumot, was named Controller and General Inspector of Quarries.

Guillaumot's appointment came not a moment too soon. On his first day at work a house collapsed, falling one hundred feet into the quarries below. A month later a subsidence in a café in Vaugirard alerted people to further dangers. Seven people were killed in July in another subsidence; the first victim was found after six days buried fifty-six feet deep, the last was found after twenty-five days incarcerated at a depth of eighty-nine feet. Eventually, Louis XVI prohibited anyone from opening new quarries or exploiting old ones within one mile of Parisian suburbs without permission.

The task of the newly formed Inspection des Carrières was to map and make safe the quarries under Paris. To expedite the work, two teams were created: the first team built research and inspection galleries that allowed ease of movement in the underground and facilitated the search for abandoned, empty and hazardous quarries; and the sec-

ond team made safe and mapped those vacuums that were in bad condition. Every quarry that was discovered was consolidated and charted and the individual plans were gradually amalgamated so that a complete map of the underground network was formed. Slowly a comprehensive and accurate picture of the Paris underground took shape. Initially the Inspection des Carrières confined itself to the important work of making safe the quarries under public roads. Research and inspection galleries were built throughout the old quarries corresponding to the roads at street level. On each side of these galleries, the dangerous quarries were embanked with waste left over from the exploitation or with imported material. Spiral staircases and wells were built that ensured access for the workers and materials. Only the quarries that were stable or which could be easily reused were left as they were found. Throughout the nineteenth and first third of the twentieth century, the Inspection

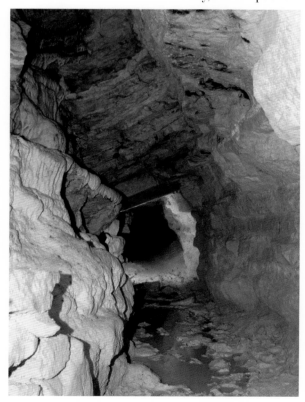

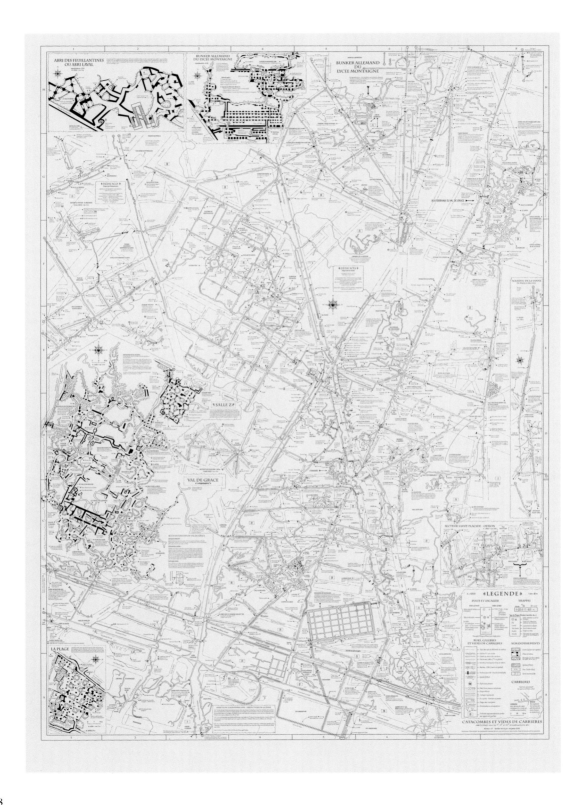

des Carrières continued consolidating underground Paris, and once the public roads had been made secure, the monuments and the public buildings, reservoirs, public gardens, stations, hospitals and colleges were protected.

Today, there are a total of 177 miles of underground inspection galleries: approximately eighty miles below the highways and public buildings of Paris and an estimated ninety-five miles of galleries under private properties. The most extensive systems are in the xiii and xvi arrondissements, which have a combined network of sixty miles of galleries. To reach the galleries, the Inspection des Carrières made 276 entry points through wells and staircases, only a few of which are preserved today for the city services.

In 1977 the Inspection des Carrières' teams left after 200 years of making the Parisian underground safe. In the same year the Inspection Générale des Carrières (IGC) was formed. It has many roles including the monitoring of both exhausted and active quarries, and maintaining and updating the underground maps, assessing building applications, monitoring the catacombs and preserving what are the most architecturally significant underground stone quarries in France. For some people, it is this architecture that is the most important piece of Parisian art underground.

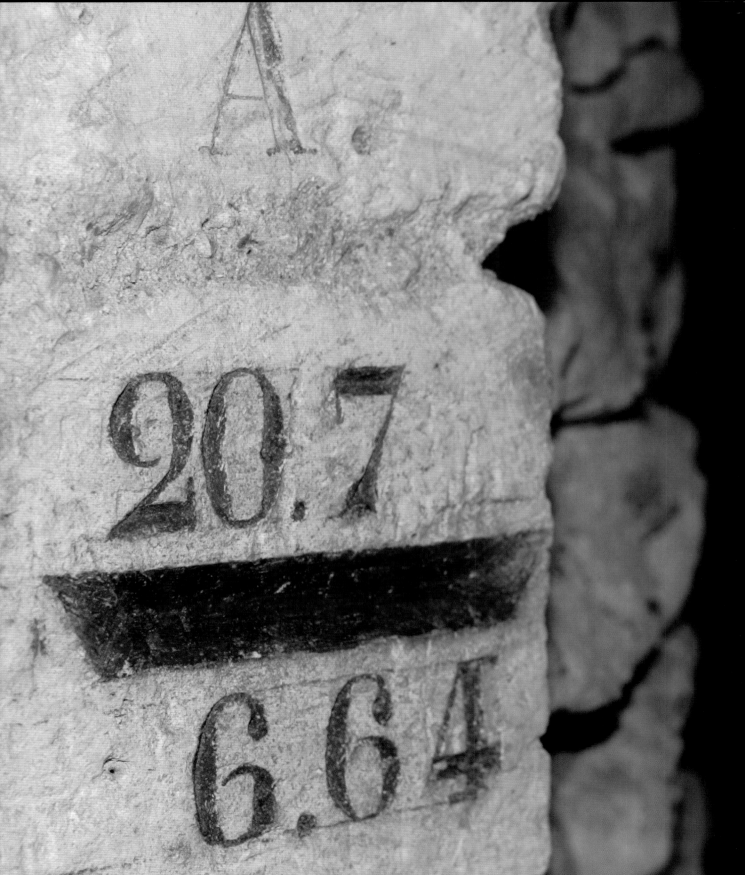

OFFICIAL INSCRIPTIONS

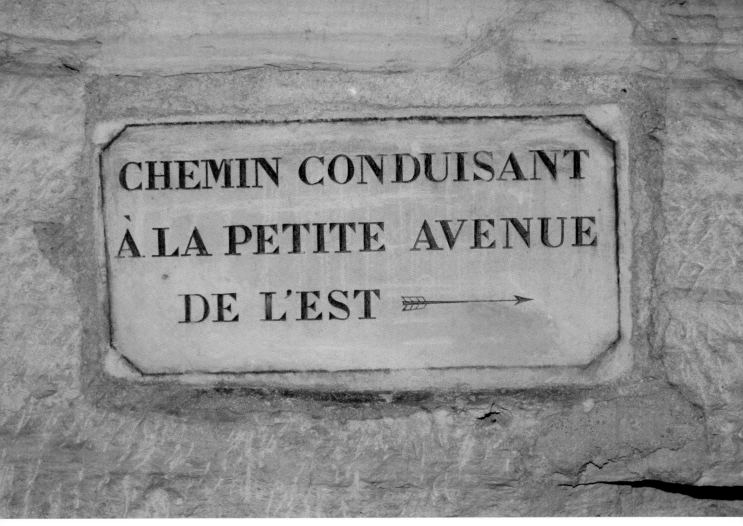

The quarries under Paris are full of characters: capitals and lowercase with or without serifs; roman letters and cursives, some made with a chisel others using a stencil; large and small characters produced with smoke, paint, pencil or incised letters that have been blackened or left with the natural stone still visible. Visitors to the underground cannot fail to be impressed by the volume, variety and ranging competence of the letterforms that have been left on the walls. Many of the inscriptions are official engineering marks that were incised by men employed by the Inspection des Carrières during the course of their work: topographic signs and consolidation marks created with the aim of dating, referencing, directing, orientating and locating the work of the reinforcements. In addition there is an abundance of street nameplates and commemorative plaques.

The engineering inscriptions were made as marks of instruction that assisted communication between teams of quarrymen, or supervisors and workers. The street signs were made to indicate the location and orientation of the inspection galleries, while the plaques commemorated significant moments in the development of the underground. For those concerned with the history of the quarries, these official marks tell the story of the underground and the topographical development of the surface; some also bear witness to times of conflict; the inscriptions are an integral part of the quarry's heritage. To those interested in letterforms the underground has given rise to a curious gallery of

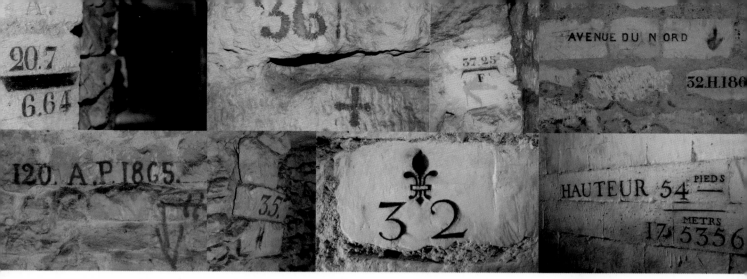

(Center, second down) This inscription shows the Royal symbol, the fleur-de-lys. The figure "270" indicates the number of the property above the consolidation at ground level. Between 1779 and 1791 the quarry workers used the Royal system of consecutively numbering property to locate the underground in relation to street level. In 1791 this was abolished in favor of a district numbering system, but this was difficult to understand and in 1805 it was abandoned in favor of an alternating street numbering system. (Below) This inscription indicates the level of the work compared to the level of low water in the Seine taken at the Pont de la Tournelle in 1719. The level was marked in both feet and meters.

vernacular interpretations on the art of inscription. All the official letters and symbols in the quarries were made with a specific purpose and each has its own meaning and function.

TOPOGRAPHICAL MARKINGS

Before a quarry could be consolidated, a topographical description had to be made. During this process graphic symbols were left on the walls and ceilings that indicated where the reinforcements were to be built. Many of these symbols were made with red paint or black smoke. They generally comprise a dot or circle with a hole for a nail (from which a plumb-line could be dropped), which is surrounded by four perpendicular bars forming a cross. Next to the dot is a figure that indicates the chronological order of the description. The sizes of the symbols vary enormously and the main axis could be as small as six inches or as large as ten feet. In 1871 the Hotel de Ville de Paris, home to the topographical archives, was attacked and burnt during the Commune fighting, the archives were destroyed

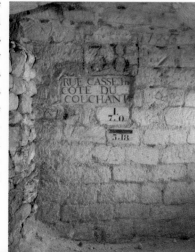

and the description of underground Paris had to be re-made. Topographers began re-mapping and re-measuring the quarries and they marked each point of reference with a small cross, an arrow, and a letter that indicated the initials of the person in charge of the survey. The marks were made with soft lead pencils and appear at each change of direction and angle of the gallery. They are the basis of the current map of the Paris quarries. Topographers of the twenty-first century continue to take measurements and more than 250 years of hastily drawn topographical symbols now collide and merge together to produce a cornucopia of graphic art in the quarries.

In the middle of the eighteenth century inscriptions were made that indicated the depth of the quarry compared to the surface. This was done using both imperial and metric systems of measurement that were marked on plates close to access staircases. From the middle of the nineteenth century these inscriptions became more detailed: a letter represented the chronological order of the description (starting

43

with a capital letter "A", then moving to lowercase once the alphabet was exhausted) and figures indicated the elevation of the consolidation and its height compared to the level of low water in the Seine. The presence of these inscriptions add yet another layer to the graphic and typographic life of the underground.

ENGINEERING NOTATIONS

The quarries were often strengthened using stone blocks hewn from the underground. Stonemasons had to cut the blocks to dimensions specified by the engineers and on the quarry walls there remain working pencil drawings from which the masons took their measurements. Most of the men were paid piecework, and scattered arbitrarily around the quarries are marks indicating the work done by each mason; marks from which their wages were calculated and which add a particularly domestic and human aspect amid all the technical inscriptions in this subterranean world.

Once a quarry was consolidated, a record was made on its walls: a figure indicates the chronological order of the reinforcements; an initial specifies the engineer in command of the work; and a date records when the job was completed (this practice remained until the beginning of the twentieth century). From 1777, Charles-Axel Guillaumot was Inspector of Quarries with responsibility for making the underground safe. Thus a mark that reads: "I.G-1777" indicates that it was the first consolidation made by Guillaumot in 1777; while "15.HT-1811" indicates it was the fifteenth consolidation made by Héricart de Thury in 1811. During the Revolution, the principle of numbering and initialling continued, however, the Gregorian calendar was substituted with that of the Republic (see following spread) and thus 1794 becomes R2 (II) and 1805 is written R13 (XIII).

The research and inspection galleries that were built throughout the quarries correspond to the roads at street level. The galleries represent an immense network and without signs and directions it was easy to get lost. One of the first tasks of the Inspection des Carrières was to locate the position of the underground galleries in relation to the surface. As the underground was the reflection of the street level each gallery was given a road name corresponding with that above: the oldest inscriptions are from the eighteenth and nineteenth century and are engraved into the limestone quarry walls; thereafter they appear on plaques secured to the wall. It was also necessary for the orientation of each gallery to be established, and directions were indicated by denominations of time: "setting" for

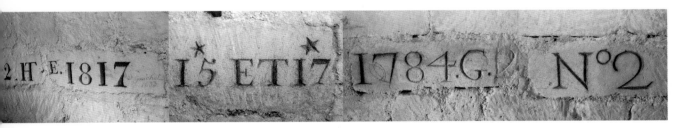

When a quarry was consolidated a record of the work was carved on its walls. A figure indicated the chronological order of the reinforcements, and letters specified the engineer responsible for the work, and the date showed when the work was concluded.

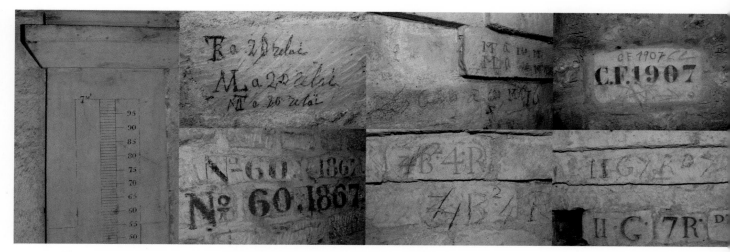

These marks were made for the records of the chief engineer by one of the leaders of his team. The top center two images show indications of the quantites of stone (ML), mortar (MT) and the ground for filling (TR) and the left hand image is a water height gauge. The other marks shown are consolidation marks made by engineers.

west; "rising" for east; "midday" for south; while "north" remained unchanged. Many of the road names also carry fine arrows that further assist with the orientation.

Most of the official underground inscriptions were incised by quarry laborers who were generally uneducated men with limited degrees of literacy and for whom the letters and signs had little meaning beyond their specific purpose in the quarries: they were simply letters as symbols. Many of the inscriptions are crudely rendered and naïvely produced by hands that had little understanding of the forms they were creating, but the inscriptions are not without charm and their sheer volume cannot fail to impress.

The inscriptions were entirely the creation of the individual laborers who cut without prescription from architects, calligraphers, designers or printers. They were simply following their own

habits, instincts, preferences and the discipline of their craft. Most of the cutters rendered traditional and conservative letterforms; they carved sturdy "masculine" roman characters that have an affinity with the strength and directness of the quarrymen who cut them. Others were more adventurous and love of their task, enthusiasm for letterforms or perhaps sheer high spirits encouraged some cutters to show off and express their pleasure and pride in their work.

It was the engineer or supervisor in charge of the consolidation work who wrote in pencil on the quarry wall the information he wished to have incised and the position it was to take on the stone. It was left to the individual quarrymen to interpret and render this information to the best of their ability and therefore the style, quality and competence of the letterforms changes according to who made them and when and where they were incised.

THE ENGINEERS

DATES	NAMES	INITIALS
1777 – 1791	Guillaumot, Charles-Axel	G
1791 – R II	Duchemin, Noël Laurent	D
R II	Duchemin, Noël Laurent; Demoustiers, Pierre Antoine	D and D2
R III – R IV	Bralle, François Jean; Demoustiers, Pierre Antoine	B and B2
R III – 1807	Guillaumot, Charles-Axel	G
1807 – 1809	Commission administrative, Le Bossu, Caly, Husset	CMON
1809 – 1831	Héricart Ferrand de Thury, Louis Etienne François	HT
1813 – 14 /1818/1820	Héricart Ferrand de Thury, Louis Etienne François	EHT
1831 – 1842	Trémery, Jean Louis	T
1842 – 1851	Juncker, Chrétien Auguste	J
1851 – 1856	Lorieux, Théodore	L
1856 – 1858	Blavier, Edouard	B
1858 – 1865	de Hennezel, Charles Louis	H (et un N)
1865	unknown	AP
1865 – 1866	du Souich, Charles Aimable Alban	S
1866 – 1870	Lefébure de Fourcy, Michel Eugène	F
1870 – 1871	Jacquot, André Eugène	EJ
1871	Lantillon	unknown
1871 – 1872	Jacquot, André Eugène	EJ
1872 – 1875	Descottes, Edouard Victor	D
1875 – 1878	Tournaire, Louis Marcellin	T
1878 – 1879	Gentil, Ernest	G
1879 – 1885	Roger, Emile Louis	R
1885 – 1896	Keller, Octave	K
1896 – 1907	Wickersheimer, Charles Emile	W
1907 – 1911	Weiss, Paul	W

THE REPUBLICAN CALENDAR

1793	1794	1795	1796	1797	1798	1799	1800	1801	1802	1803	1804	1805
R1	R2	R3	R4	R5	R6	R7	R8	R9	R10	R11	R12	R13

(Top, left) G is the initial of Charles-Axel Guillaumot, the first of the quarry consolidation engineers, carved in 1777. (Top, right) D and D2 are the initials of Noël Laurent Duchemin and/or Pierre Antoine Demoustiers, and were carved in 1794.

(Second down, left) B and B2 are the initials of François Jean Bralle and/or Pierre Antoine Demoustiers carved between 1795 or 1796. (Second down, right) The trade mark ligature HT represents Louis Etienne François Héricart Ferrand de Thury, carved in 1811.

(Third down, left) J is the initial of Chrétien Auguste Juncker, carved in 1843. (Third down, right) L is the initial of Théodore Lorieux, carved in 1855.

(Fourth down, left) B is the initial of Edouard Blavier, carved in 1856. (Fourth down, right) H is the initial of Charles Louis de Hennezel, carved in 1864.

(Bottom, left) F is the initial of Michael Eugène Lefébure de Fourcy, carved in 1867. (Bottom, right) T is the initial of Louis Marcellin Tournaire, carved in 1876.

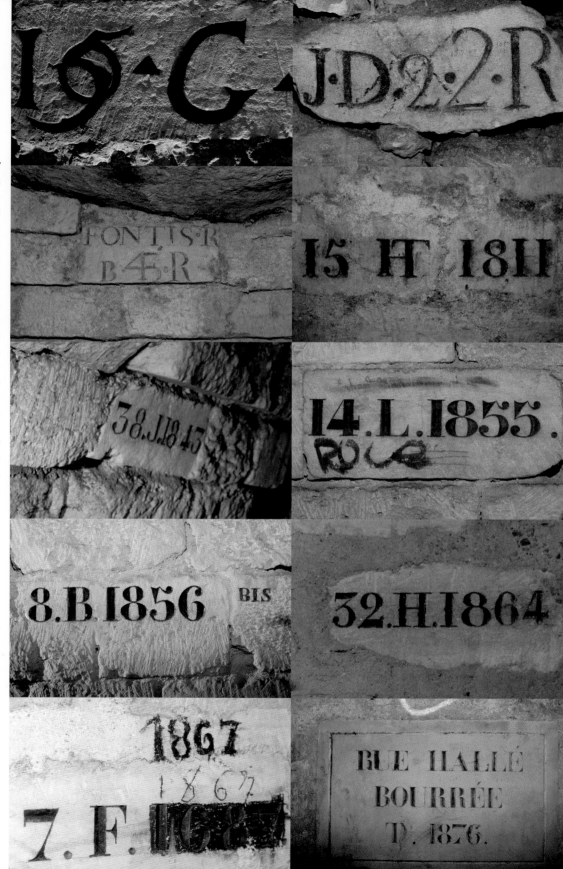

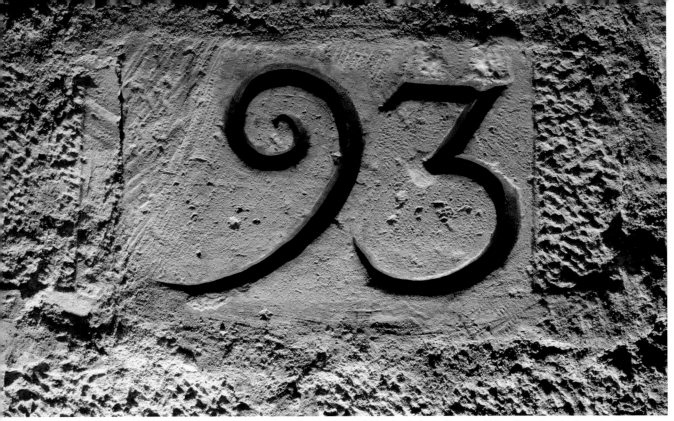

This extravagantly rendered "93" indicates the 93rd consolidation made by the engineer Dupont. Although no date is given, the figures were carved before April 4, 1777.

LETTERS AS SYMBOLS

The earliest known incised inscription is simply a date: 1609. It is competently executed using non-lining figures with contrasting weights of strokes and in a style much like a printed Old Face. But the majority of the inscriptions date from 1777 onwards. The engineers' marks range in size from one and a quarter inches to six inches high and the road names are between one and a quarter and two and three-quarters inches. Generally the older letters are the largest and nearly all have been blackened using a material or substance that contemporary scientists have been unable to successfully replicate. The early lettering is irregular; the characters frequently fail to conform to a common baseline, are uneven in height, variable in weight and inconsistent in word and letter spacing. Little attempt has been made at uniformity of letter style either between one inscription and another or even within a single piece. There are marked variations

in letter design and it appears not all the words in an inscription were produced at the same time or even by the same hand. But most of the letter cutters have made some attempt at manufacturing characters with contrasting thick and thin strokes and at producing bracketed serifs which join the main stem of the character with varying degrees of subtlety ranging from the relatively accomplished to the downright ham-fisted. Spacing caused the amateur letter carver no end of problems: line lengths were frequently misjudged and when the carver ran out of space he was forced to render the excess characters in smaller sizes and place them wherever space allowed. It is with the earliest inscriptions that perhaps the most lively and inimitable letterforms can be found: a figure nine with a spiral bowl, a capital letter Q with a backwards tail and the widespread persistence in dotting the capital letter I. Some of the more curious interpretations of the roman alphabet appear to be the results of the carvers trying to emulate the cursive forms

they are copying, while others are the products of men unfettered by preconceived notions of what a letter should look like, and more than one laborer showed some sense of adventure and exuberance in his carving and developed trademark characters that appear all over the quarries.

LETTERS & STYLE

Over time the inscriptions became smaller and increasingly consistent in style and execution. By the early decades of the nineteenth century the letters are noticeably more orderly and care has been taken by the cutters to produce their letters to a common baseline and ascending line; but there is always the exception! By the 1830s the stonecutters were carving letters that owed their appearance less to Old Face letters and more to printed Modern Faces with flat unbracketed serifs, vertical stress

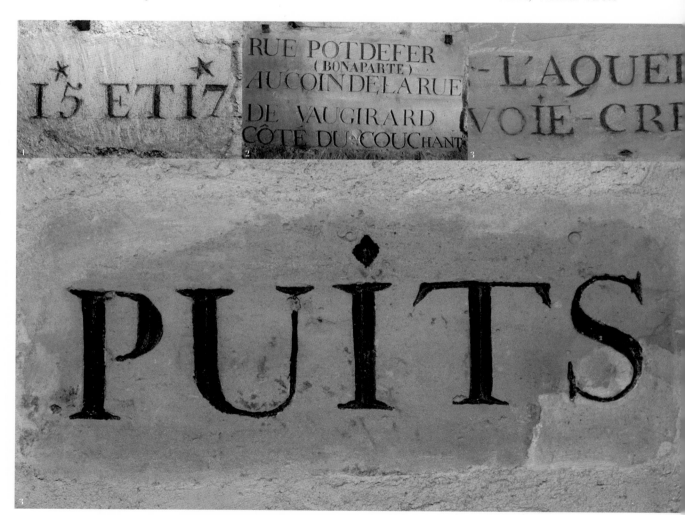

1. The quarry workers responsible for producing much of the official lettering in the underground were unfettered by preconceived notations of what a letter should look like; they were free to produce creative interpretations of letters and figures – such as this figure "5" – and these frequently became "trade mark" characters of the individual carvers. 2. Word and letter spacing frequently caused the amateur letter-carvers in the quarries problems. Line lengths were often misjudged forcing the letter-carver to render the excess characters in a smaller size, or place them indiscriminately on the stone. 3. Men who were unfamiliar with the customary shapes of letters were responsible for making the official letterforms in the quarries. This resulted in some curious and spirited interpretations of the Roman alphabet, such as this capital "Q" which is carved with the tail in reverse. 4. Many of the letters cut by the amateur stone cavers show a persistence in dotting the capital "I".

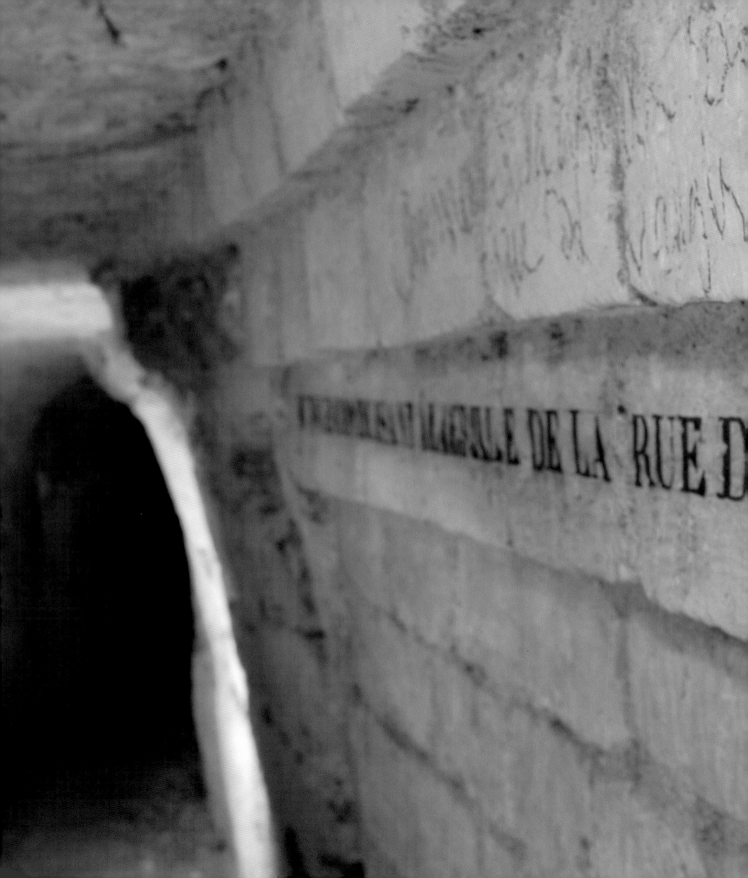

VAUGIRARD

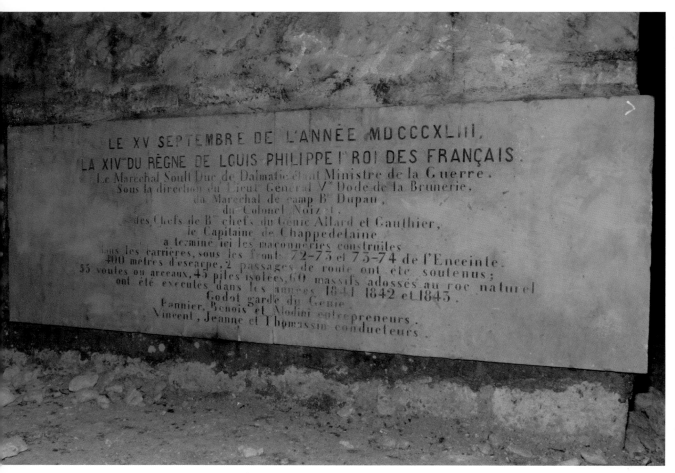

LE XV SEPTEMBRE DE L'ANNÉE MDCCCXLIII,
LA XIV DU RÈGNE DE LOUIS PHILIPPE I ROI DES FRANÇAIS.
Le Maréchal Soult Duc de Dalmatie étant Ministre de la Guerre.
Sous la direction du Lieut Général V Dode de la Brunerie,
du Maréchal de camp B Dupau,
du Colonel Noizet,
des Chefs de B chefs du Génie Allard et Gauthier,
le Capitaine de Chappedelaine
a terminé ici les maçonneries construites
dans les carrières, sous les fronts 72-73 et 73-74 de l'Enceinte.
400 mètres d'escarpe, 2 passages de route ont été soutenus;
55 voûtes ou arceaux, 45 piles isolées, 60 massifs adossés au roc naturel
ont été exécutés dans les années 1841 1842 et 1843.
Godot garde du Génie
Pannier, Benois et Modini entrepreneurs.
Vincent, Jeanne et Thomassin conducteurs.

(Above) Official plaques, commemorating events or people, appear across the quarries, produced by professional, offsite carvers. (Below) Much of the quarry lettering is produced in haste and without thought to presentation. However, some signs in the underground show that a workman took pleasure and pride in his work and made an attempt at a distinctive style, such as this imaginative use of a framing a street sign.

and abrupt variations in color. By the 1840s these characteristics had been pushed to their limits and letters akin to Fat Faces appeared with extreme contrasts between the thick and thin strokes and extravagantly blobbed finials.

One reason for the increased uniformity is that from the mid-nineteenth century the stonecutters began to use stencils in the quarries. By this time, stencil letters were regularly used by painters, artists and engineers: they were easily bought, relatively cheap, employed on a variety of commercial jobs and more prevalent in France than most other countries. Why the quarry workers started using stencils at this time is hard to judge; it may simply

be when it was realized that stencils were useful: they allowed inexpert carvers to quickly produce reasonable quality letters with uniformity of height and regularity of weight. However, for a stencil to be used effectively the rock face had to have a reasonably flat surface to allow the stencil plate to be pressed flat against the wall, and so the carver had

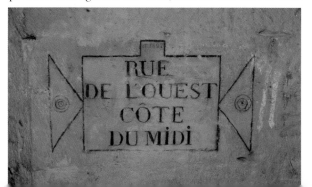

RUE
DE L'OUEST
CÔTE
DU MIDI

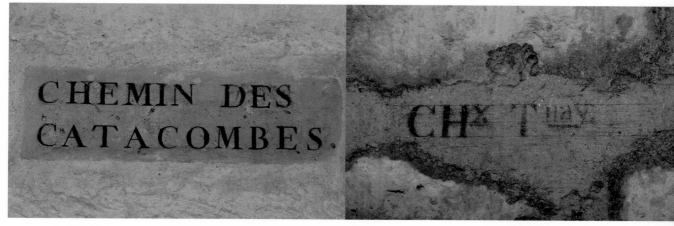

A plaque inscribed circa 1850. The abbreviations indicate that the mortar was made with some chaux (CHx) from Tournay (Tnay), Belgium.

to ensure the stone was properly levelled. He would then trace the outline of the character in pencil, remove the stencil and then carve his letter. Not all the mid-nineteenth century letterforms have been made using a template, and not all the characters within an individual inscription have been stencilled. Frequently just the figures were stencilled and the letters were carved in a style similar to those of the numerals. From about 1885, black painted letters made with stencils can also be seen alongside the inscribed letters and from around 1896 the letters are painted in red.

DELETING SYMBOLS, ADDING NAMEPLATES

The Revolution left its impression on the quarry inscriptions with its anti-royalist and anti-Christian attitudes. The fleur-de-lys, the emblem of royalty, appeared on road nameplates below religious buildings. They were particularly found in the Rue Saint-Jacques where there were many religious establishments. These engravings were made between 1777 and 1782 under the authority of Guillaumot, the first Inspector of Quarries. On July 4, 1793, the Revolutionary Convention ordered the elimination of all traces of royalty on public monuments. All the fleur-de-lys that had been carved on the quarry street signs were obliterated, broken or hammered by the workmen of the Inspection des Carrières, often by the same men that had engraved them in the first instance. Of the 200 originals only a few survived, saved because they had been hidden under the clay or because the gallery in which they

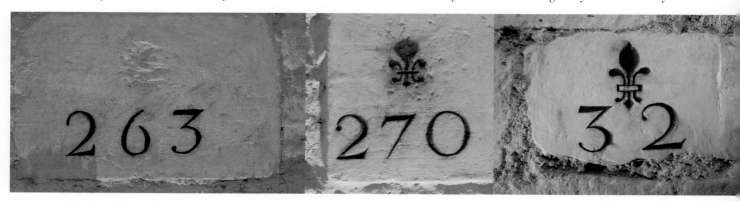

The fleur-de-lys, emblem of royalty, appeared on quarry street nameplates made between 1777 and 1782. In 1793 the Revolutionary Convention ordered the elimination of symbols of royalty and all the fleur-de-lys found in the quarries were obliterated by the quarry workmen.

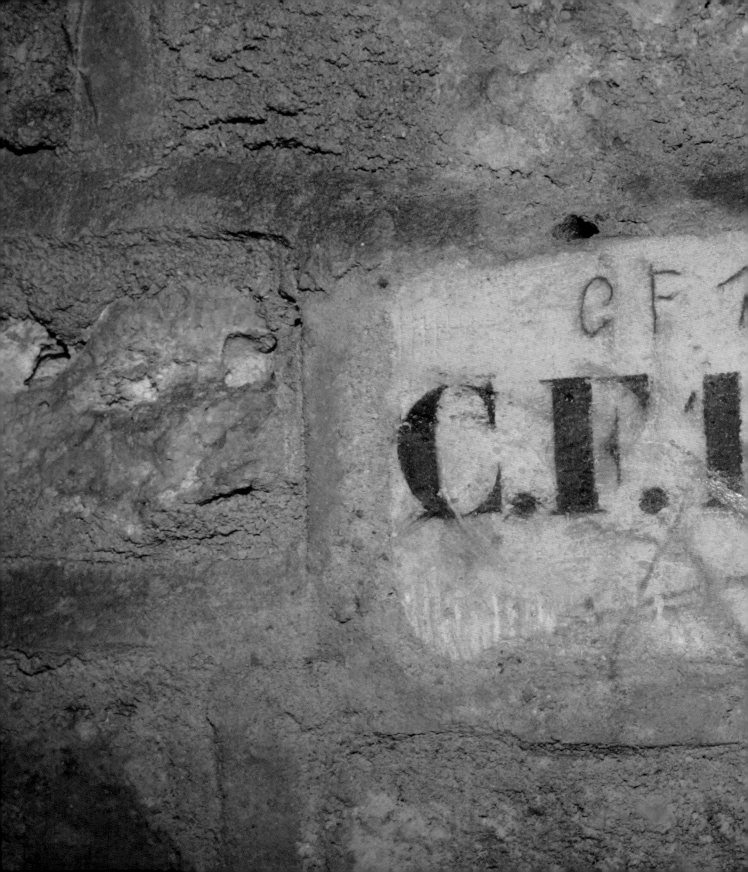

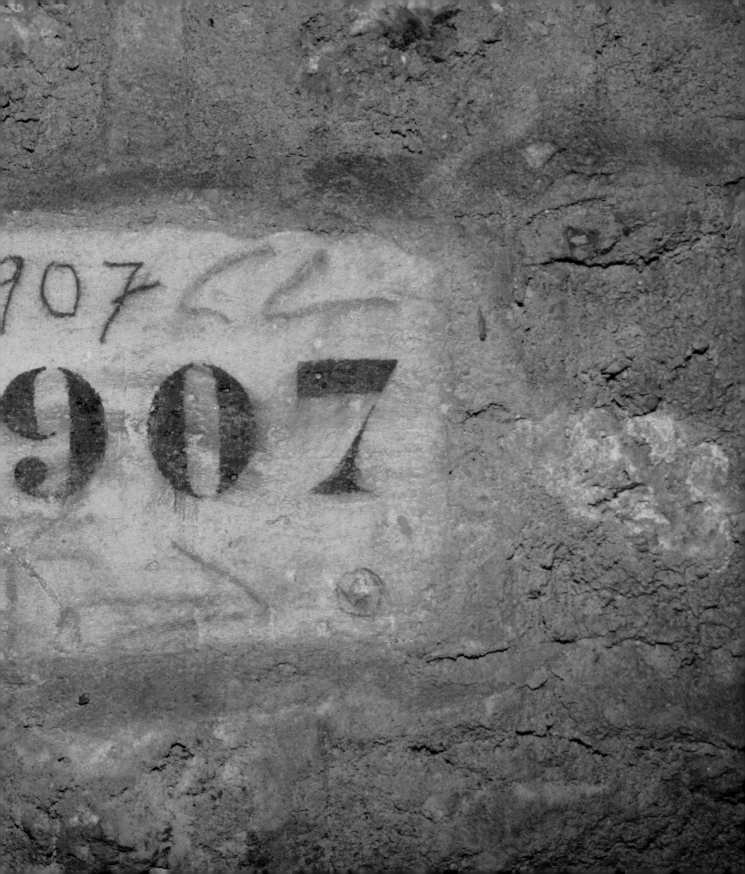

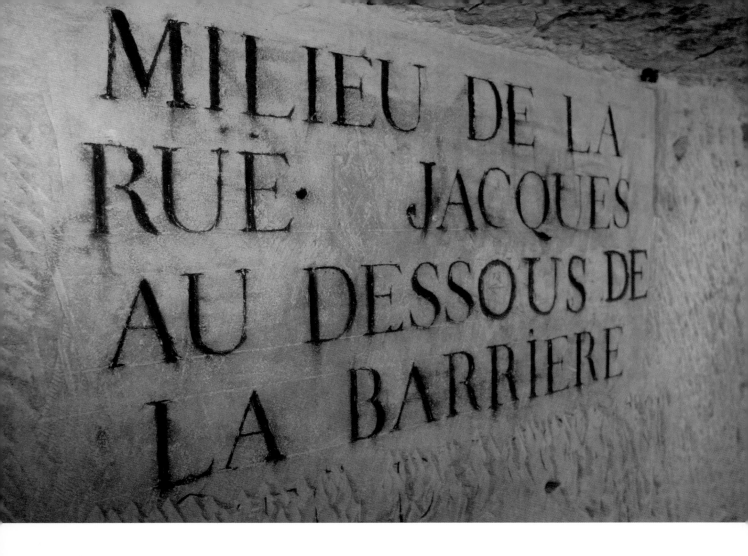

MILIEU DE LA RUE· JACQUES AU DESSOUS DE LA BARRIÈRE

appeared had been filled. A decree of 1794 included provisions requiring that the word "saint" be removed from street names. Later the abbreviation "St" was re-applied to the nameplates.

From the middle of the nineteenth century the street nameplates both above and below Paris were made from enamelled Volvic lava. It was the idea of M. Chabrol de Volvic, Prefect of the Seine, and put into effect by an ordinance of M. de Rambuteau, also Prefect of the Seine, in around 1844. The stone was a strong, light andesite extracted from the quarries in the Volvic region; it had the advantage of being resistant to the weather, heat and deterioration and could be enamelled at high temperatures.

The stones were enamelled with bright blue backgrounds and carried white type for the ease of reading and depending upon the techniques and temperatures used were produced either with a matte-satin finish or they were transparent. With their familiar sharp blue background and white sans serif lettering they give the Paris basement the same "corporate identity" as the surface. However, from about 1896, fixed enamel metal plates were used in the quarries in preference to those made of Volvic lava. Unfortunately, cement does not adhere very well to iron and a number of plates have become unstuck. Others have rusted because of the humidity.

BOULEVARD
St. JACQUES ALLANT
A LA ROUTE
D'ORLEANS.

The lettering on the consolidated quarry walls was purely functional; it was not produced in a public arena to be seen by many and where its presence might enhance or diminish the environment. The letter-carvers had neither the skill nor the civic obligation to produce anything other than utilitarian signs. However, whether the inscriptions were incised, painted, stencilled or enamelled, visitors to the quarries would not only be lost without street names, they would also be deprived of items that are a source of typographic pleasure and historical interest giving information about the area where no other evidence remains. The inscriptions serve a purpose while adding humanity, richness and sub-tlety to the quarries. Small-scale items they may be, but their pervasiveness makes a big impact.

(Previous spread) A consolidation made in 1907 order to stabilize the chemin de fer. (Opposite page) A decree of 1794 required the word "saint" be removed for all street names in the quarries. Later, the abbreviation "St" was re-applied to the nameplates. (Below) From 1896 fixed sharp blue enamel street nameplates, the same as found at street level, were used in the quarries. Unfortunately, due to the humidity of the underground, these plates were prone to rust.

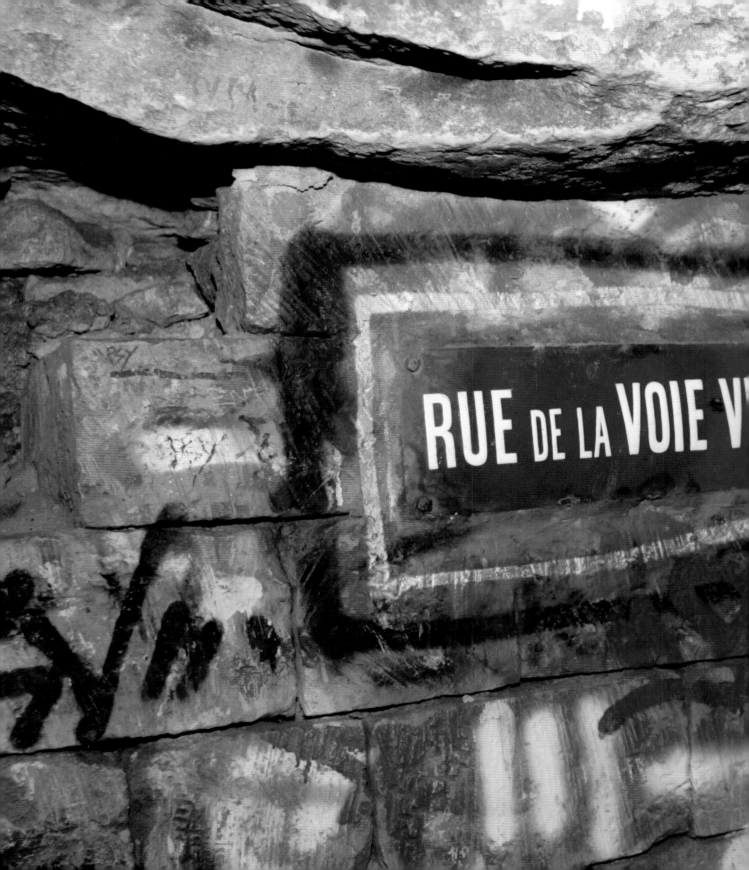

GRAPHICS

The sheer volume of graphic material that exists below the streets of Paris of cannot fail to strike any visitor to the quarries. It is impossible to estimate how much there is. Over the course of three hundred years, hundreds of thousands, probably millions of different graphic images have been made by an inestimable number of people, for innumerable reasons, on many subjects using a variety of materials. The oldest dated mark is from 1609; the most recent was left yesterday. All the marks have been made in adversity, for the quarries are inhospitable places. A visit to the underground is something akin to spelunking: there is a total absence of light, the floor is uneven and unpredictable and in some areas the roof is just six or seven feet from the ground, the walls are rough and running with water, and sometimes the floor floods and is transformed into a swimming pool. Negotiating the 177-mile network requires stamina, and it is easy to become disoriented in the frequently turning passages. Inevitably, therefore, the quarry environment has influenced the materials and techniques that have been used to mark its walls, ceilings and floors.

The graphic material falls into two distinct types: official and illicit. Official graphics serve a particular purpose and were made by the employees of the Inspection des Carrières during the course of their work, as described in "Official Inscriptions" earlier; illicit graphics do not always have a specific function and were produced by unlawful visitors to the quarries who freely and spontaneously marked the walls with images and inscriptions.

The works produced by the quarrymen are official graphic signs: technical engineering marks, topographical indicators, street nameplates and commemorative plaques. These marks are of great

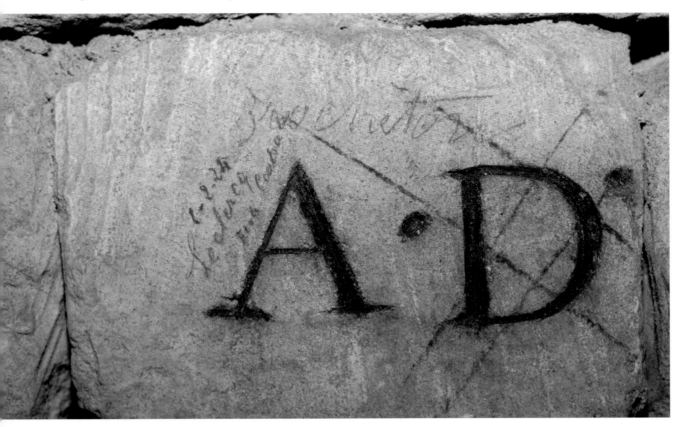

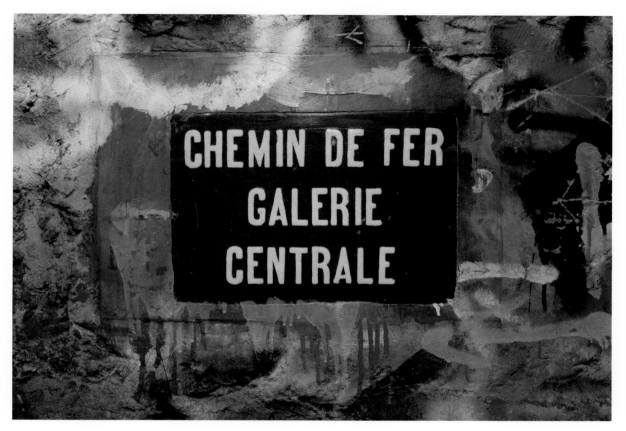

historical importance to those concerned with the development of Paris and its underground, and of typographic curiosity to anyone interested in letterforms. The present Inspection Générale des Carrières works hard to preserve this heritage.

ILLICIT GRAPHIC IMAGES

Unlawful visitors to the underground have marked the walls with illicit graphic images, which may be divided in to five categories: directional signs, which incorporate arrows and other indications of passage; kata art, which are generally large artworks (up to sixty-five feet wide) that include paintings, mosaics and sculptures, which depict work, war and the macabre, reproductions of classic art, or artistic statements on contemporary issues; small sketches (some only an inch or two wide) which comprise esoteric cartoons or drawings and abstruse symbols and scenes; graffiti that includes tags, message graf-fiti, pieces and throw-ups; and finally ephemeral paper tracts.

TOOLS & TECHNIQUES

The unusual conditions that exist in the quarries have dictated how the images have been made and the artists and craftsmen have been compelled to a particular assortment of techniques and tools.

Any excursion into the underground necessitates some form of portable light. Today's visitors are equipped either with flashlights or acetylene torches powered with calcium carbide and water. However, the quarrymen of the eighteenth century were dependent upon candles or oil lamps for illumination and for this reason the very oldest markings are made with black smoke. The marks were created by placing a flame against a wall, which produced a deposit of intense black carbon of around three-quarters of an inch wide. The quarry ceilings

were easier to mark with a flame as the candle could be held upright, which inhibited the wax from dripping. Candles lack subtlety as writing implements, and the quarryman had limited control over making their marks, and so the smoke inscriptions are bold, without detail and sizeable; the letters are between four and twelve inches high, and up to sixteen feet in length.

Most of the official letterforms in the Paris quarries have been cut into the surface. The hardness of the stone and its coarse grain require the use of special tools: a hammer or dummy, a claw for rough working, a general-purpose chisel, and an abrasive stone. There is very little unofficial engraving because without the appropriate tools simple lines scratched with a point are difficult to make and impossible to read.

Not all workers or visitors to the quarries were

equipped with appropriate tools with which to write or draw on the walls. Many merely used whatever they had to hand: crayon, charcoal, coal or pencil. Lead pencils used on rough surfaces are prone to rapid wear; those pencil marks that do exist in the quarries tend to be found on smooth surfaces such as street nameplates or on the consolidations. These images are generally very delicate, have been carefully rendered with great detail, and are frequently small. Larger images, made up of lines an eighth of an inch wide, have been left on rough surfaced walls with charcoal, coal, carpenters pencils or slate.

Felt-tip pens and other such markers were readily available in the 1970s and were a favorite with the illicit graffiti writers who visited the quarries. They were weightless and easily transportable, but not always suitable for writing on stone sur-faces. The pens were quickly superseded by aerosols, or spray-paint cans. Not only were they light to carry but the paint had been specifically designed for aerosol art and for application to a variety of surfaces. Most aerosols were adapted according to the needs of the writer. Large productions required special fat caps to be fitted so that the writers could spray a wider mark than with the proprietary caps. The broad spray enabled them to paint more quickly and with greater constancy in coverage. On the other hand, thin caps were used to render outlines and areas requiring great detail. The size and extent of the quarry walls make them an ideal canvas for exuberant graffiti writers. But aerosols are not without their problems; their fumes are unpleasant and dangerous and any sensible graffiti writer wears a mask, and has to contend with a real risk of explosions.

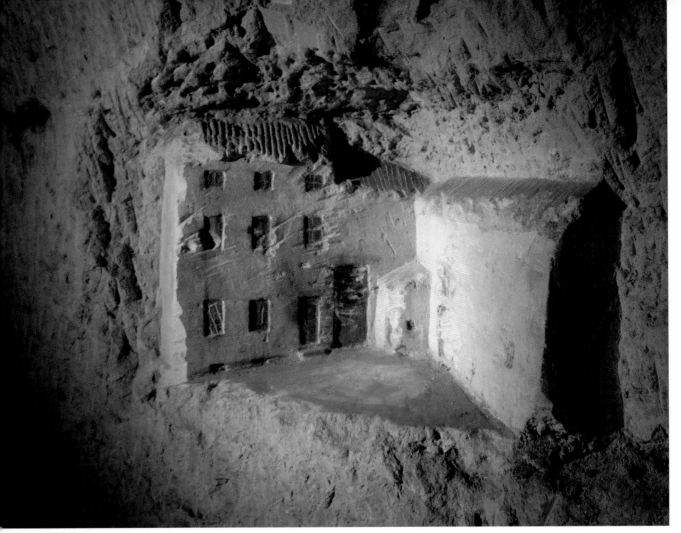

Paintings, sculptures and mosaics are all found in the quarries and their creators have shown great tenacity in executing their craft. Painters require a selection of brushes and many cans of paint, water, rags and trays for mixing paint; sculptors need a wide selection of masonry tools including hammers, mallets, scissors, gouges, chisels, planes, levels and trowels; and the mosaic artists want nippers, tweezers, levelling tools and adhesives plus ceramic, smalti or vitreous glass to make the mosaics. They all need some form of lighting, supplies of food and drink, maps of the underground and working drawings of their art. All of this material has to be transported through several miles of uncomfortable passages until the artist finds an expanse of wall suitable for his creation.

Not all the art underground is permanently written in stone. Hidden all over the quarries are ephemeral paper leaflets. They are the principal means of communication between the Cataphiles. They are produced by hand or on a computer, in monochrome or color, duplicated by photocopiers or desktop printers, and issued in quantities that vary according to the required impact. Because of the moisture in the quarries the paper tracts have a limited lifespan.

All wall writing is ephemeral, but in the quarries it has greater durability than at street level. The longevity of the underground art varies according to the techniques and mediums employed. Engraved inscriptions have an indefinite lifespan because the underground has a constant tempera-

ture of about 55°F, is totally devoid of light and has hardly any animal life; it is a favorable place for the conservation of incised work. On the other hand, those graphics made with pencil, crayon, charcoal or coal are more prone to damage and attrition, although serendipity plays its own part and some images that are more than two centuries old are easily seen and read whereas other more recent markings are practically indecipherable. Some of the damage to these graphics has been caused by humidity that encourages a progressive but relatively slow erosion of the works. Water dripping from the quarries' ceiling can also destroy the graphic material and light breezes deposit a fine film of dust on the walls that cause a reduction in the sharpness of some of the work. Nowadays, the art that lies below the streets of Paris also suffers from the degrading effects of the pollution created at road level. But unfortunately, the greatest destroyers of underground art are often careless and willful visitors who have defaced or vandalized material by superimposing their own creations over those of the past.

For those who know and love the quarries the greatest artistic creation in the underground is the rock itself and the fabulous structures raised from the limestone by the engineers and architects in the course of upholding the city surface. Each structure has its own beauty, its own reason for being and its own history that has been incised into it by the engineers responsible for its construction. However, the last thirty years have seen a dramatic increase in the number of illicit visitors to the quarries, which has resulted in an equal increase in the quantity of graphic images appearing on the quarry walls. This in not always for the good, and some people feel the illicit images are starting to detract from the architectural beauty of the underground but perhaps, as one Cataphile commented, 'This is the destiny of this scorned place!'.

"Corps Blanc" (White Corpse), created by international urban artist Jérôme Mesnager. Corps Blanc appears all over the underground, directing – and sometimes purposely misdirecting – visitors in the quarries.

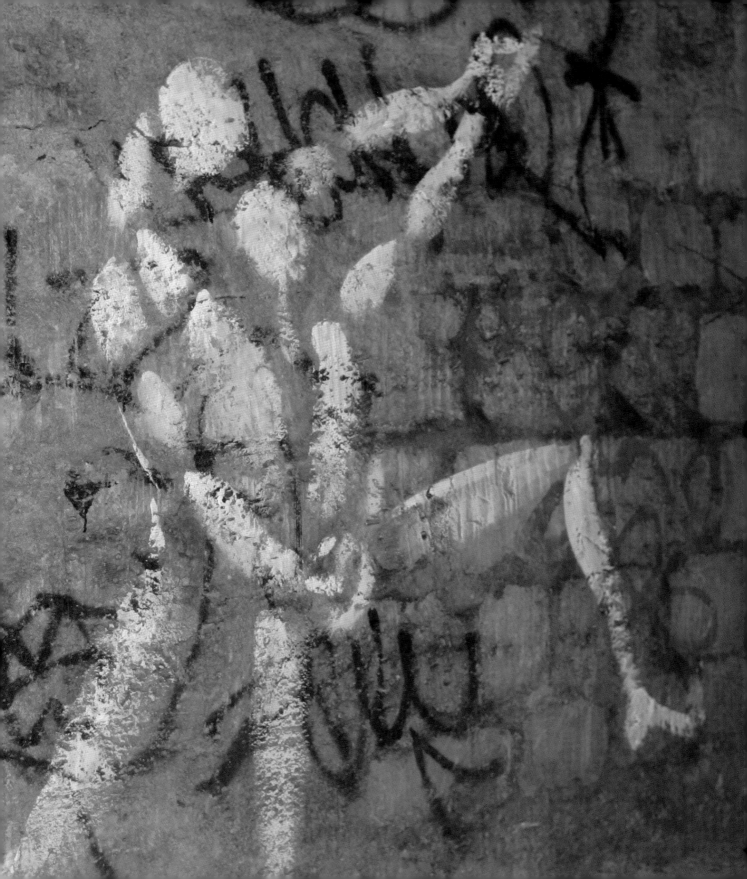

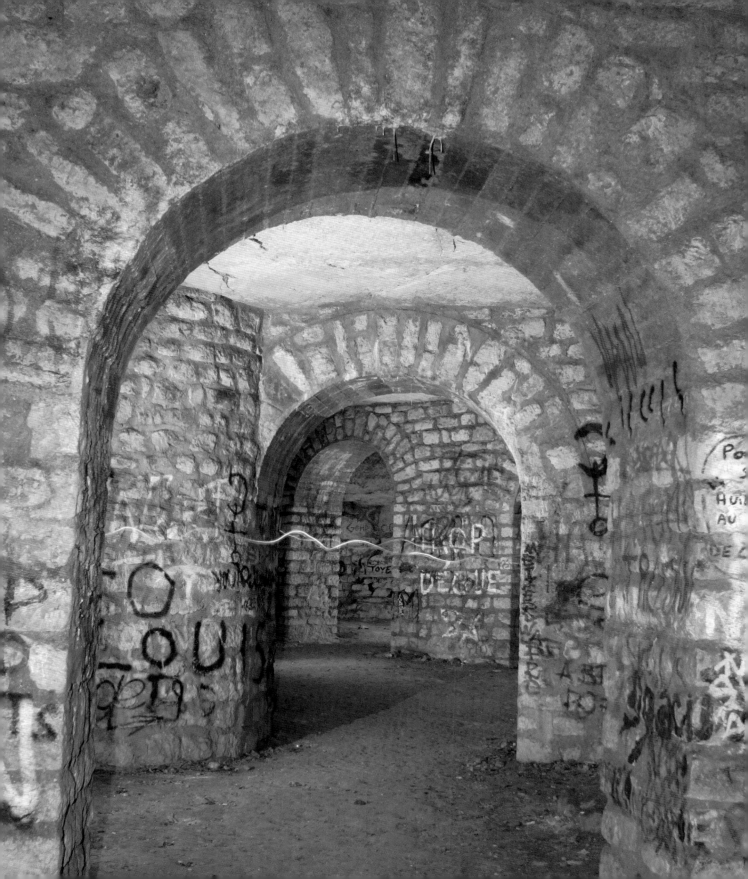

CLANDESTINE

VISITORS

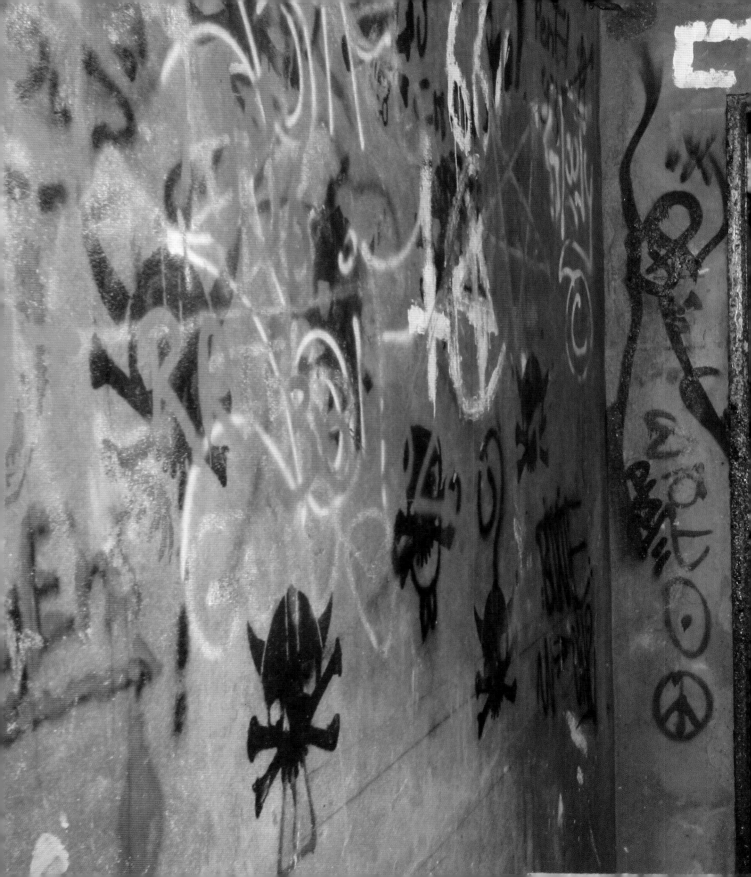

ADVENTURE, REFUGE & ESCAPE

Secrecy is our human dress, and for three centuries the Parisian quarries have provided secure and welcome apparel for many covert actions and events. It has also afforded physical and mental refuge to many, a façade for others, a challenge to some, and opportunities for adventure to countless individuals looking for an escape. Whatever their reasons for visiting the quarries, many people have been moved to mark their tracks.

There have always been clandestine visitors to the underground. In the beginning their numbers were quite small because the quarries were relatively unknown, unmapped and uncharted. Across the centuries, criminals, cutpurses and bootleggers used the underground to hide from the authorities, smugglers availed themselves of the network to transport contraband safely into the city, and there have always been those who raided the quarries in the hope of finding hidden treasure. Rather than hidden treasure, the optimistic plunderer was more likely to find beer and mushrooms.

BEER & MUSHROOMS

The Carthusian Monks in Paris produced beer of legendary quality; it was stored in the quarries below their monastery. During the Revolution, however, the monks had to flee their residence and abandon their beer. In November 1793, one particularly sanguine pillager, Philibert Aspair, doorkeeper of the Val-de-Grâce monastery, made an unannounced solo descent into the quarries in search of the cellar of the good Carthusian; he never reappeared. In the uneasy atmosphere of the Revolution, his disappearance caused little concern. Twelve years later, a group of men working on the topographical survey found his remains; some debris of clothing, a leather belt and a bunch of keys identified him as the doorkeeper of Val-de-Grâce. He was buried at the site where he was found on April 30, 1804, a tomb was erected in his memory and an incised stone tells of his fate.

In addition to being a repository for beer, the stone quarries were also the gentle protectors of the *champignon*. At the beginning of the nineteenth century the quarry floor was transformed into mushroom beds when M. Chambry, a market-gardener on the Rue de la Santé had the idea of

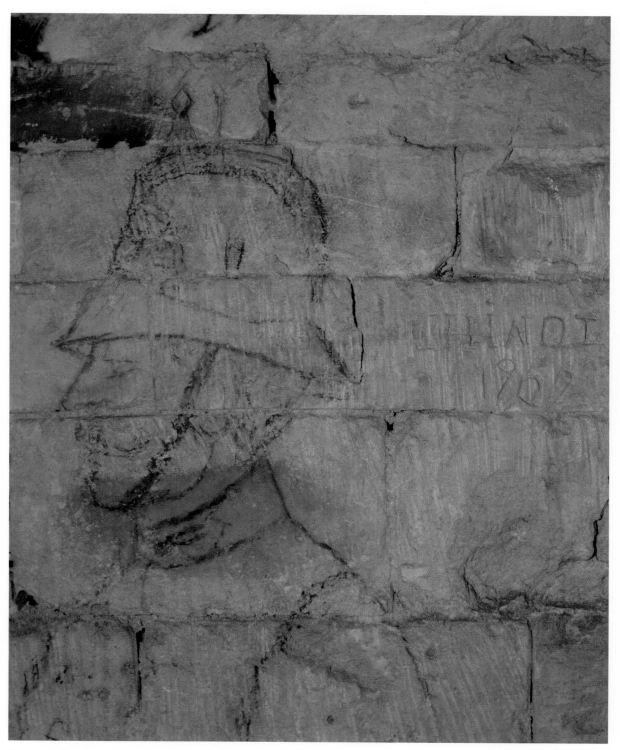

Portrait of a Prussian soldier stationed in Paris during the siege of 1870. There are several portraits of soldiers to be found in the quarries.

exploring the quarries below his garden and realized their potential for mushroom growing. The total absence of light, and ever present water vapor meant few plants could survive below ground, but once the floor had been spread with horse dung mixed with limestone, it provided fertile conditions in which the *champignon* might flourish. Following his success, other growers joined M. Chambry in his enterprise and mushrooms continued to be cultivated in the quarries until 1950. The mushroom growers whitewashed the walls (unfortunately eradicating some of the oldest inscriptions in the

The underground harbors many dramatic stories, but it is also the protector of more than one love story such as that of Lydie Kirkham and François-Etienne Bernet-Boisorette who lived and loved in the quarries under Montmartre with their four children in the eighteenth century.

More prosaically students have always been regular explorers of the Paris basement, either in pursuit of formal studies or, more recently, for reasons of personal satisfaction. Pupils from the Ecole de Pharmacie raided the underground for skulls and bones for their lessons and students from the

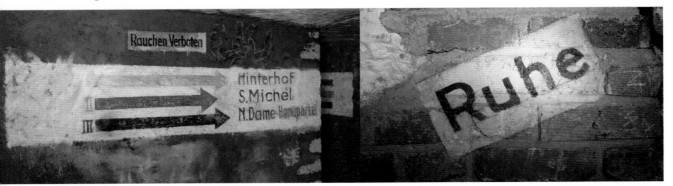

Signs produced by German soldiers during their occupation of Paris. The signs request "silence" (ruhe) and "no smoking" (rauchen verboten).

process) to provide themselves with a new writing surface on which to indicate the various stages in the cultivation and harvesting of their extraordinary crop. Evidence of their marks still remains.

WAR: THE ROMANTIC & THE PROSAIC

There have always been romantic stories associated with the quarries and rumor has it that during the revolution Marat took refuge in the quarries under Montmartre; Louis XVI was mistakenly thought to have sought their protection in 1791 and in vain his adversaries hunted for him in the quarries; Charles X had subterranean parties in the Catacombs just before the 1830 revolution; and Balzac is said to have escaped his creditors through the gallery complex. Unfortunately they all resisted the temptation of inscribing their names on the walls and no graphic evidence of their passage has been found.

Ecole des Mines had access to the quarries below their college while working on topographical projects. It became a custom for graduating students to mark their name on the quarry walls, a tradition that continues today in a more elaborate form.

But the quarries have not always been used for such peaceful or studious activities. During periods of conflict the underground has provided shelter for both aggressors and defenders. In 1870, invading Prussian soldiers made use of the quarries on the southern periphery of the city from where they bombarded the neighboring arrondissements during the siege of Paris. Some of these soldiers, far from home and in a foreign land, left both textual and pictorial records of their visits to the quarries, while defending Parisian Commune fighters, who also had recourse to the underground, daubed its walls with accounts of their activities.

The occupation of 1940-44 saw both the French and German forces taking refuge in the underground; during air raids occupied and occupying forces were sometimes only separated by a wall just an inch or two thick. The Germans converted an old quarry in the north of the city into a civil defence shelter (now known as Bunker Allemand) and prohibited the Inspection des Carrières from making normal inspections in the sectors where they were installed. It was located just below the Lycée Montaigne and access passages were built that directly linked the shelter to the Senate, which was used by Luftwaffe staff. The occupying forces re-opened old vacuums, made them safe, protected them with concrete and equipped them with telephones and electric lighting for their own convenience and comfort. They also made some of the most orderly and systematic directional marks left by any of the visitors to the quarries.

The Free French of the Interior (FFI) found sanctuary in the south of the city under the Place Denfer-Rochereau in a shelter (subsequently named Abri FFI) that was originally built before the war by the Inspection des Carrières for use by their engineering workers. It was fully furnished with power generating units, dormitories and medical rooms: all the equipment necessary for a long-stay headquarters. Rol-Tanguy, Head of the FFI of the Ile-de-France, sheltered there with his team in 1944 and directed the liberation forces.

In 1939 an old quarry below the Rue des Feuillantines was re-opened and made safe with the intention of sheltering school children from any possible attack. In 1944 the Inspection des Car-

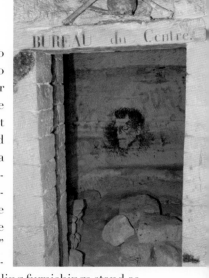

rières was instructed to convert these quarries into habitable safe-houses for the collaborators, Pierre Laval, Abetz and Brinon. It was a very sophisticated complex equipped with a kitchen, showers and toilets. However it was completed just days before the liberation and never gave shelter. Named "Abri Laval" by the Cataphiles, the various rooms and their crumbling furnishings stand as testimony to the past and are bespattered with the graffiti of the present.

Of course those civilians who knew of their existence also made use of the quarries during the Second World War either to protect themselves from Allied bombing and German patrols or to shield their nefarious dealings in black market contraband. In idle moments these sheltering civilians also left their inscriptions and sketches on the quarry walls.

CATAPHILES, ADVENTURE, BELONGING & REBIRTH

With the cessation of war the number of illicit visitors steadily increased; they came to the quarries not out of necessity, rather through curiosity or adventure. The rise in underground explorers started in the 1950s and 1960s when students from the Ecole des Mines de Paris started producing hand-drawn maps that were circulated to initiate friends. Gradually the number of initiates increased and an informal community of illicit visitors started to form, which came together to smoke, drink, party and listen to music. A favorite meeting place was under the Val-de-Grâce, which was easy to access and spacious with plenty of insulation: an ideal venue for music festivals. The venue was called "Salle Z" and by the 1970s the parties had reached their zenith with astonishing numbers of people attending some concerts. Gradually the explo-

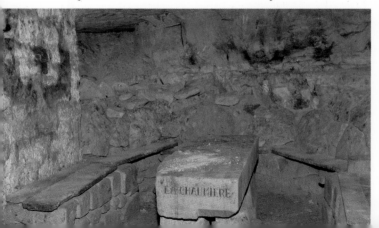

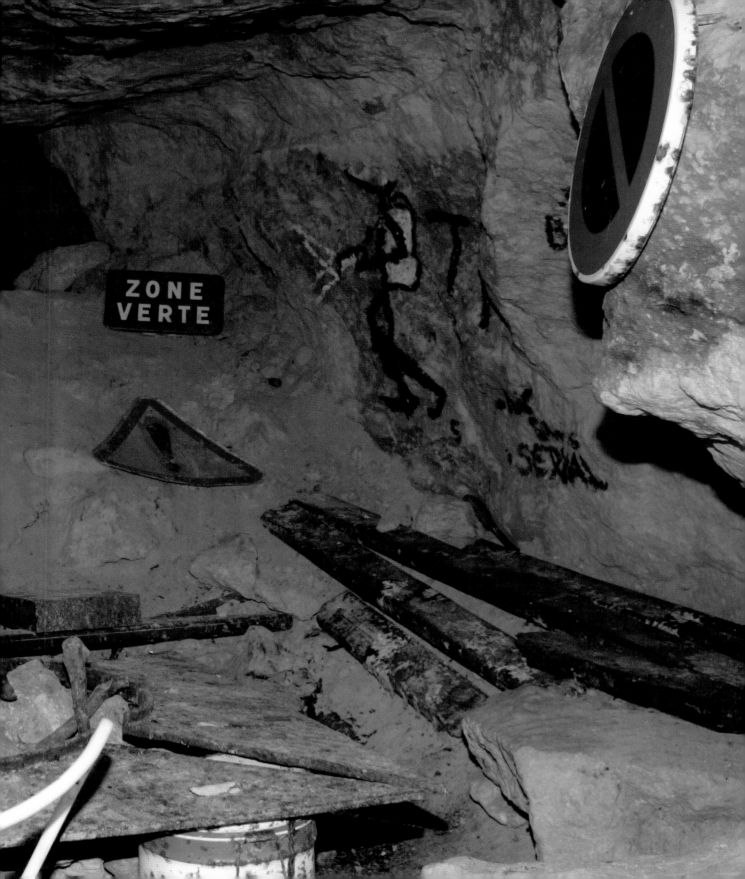

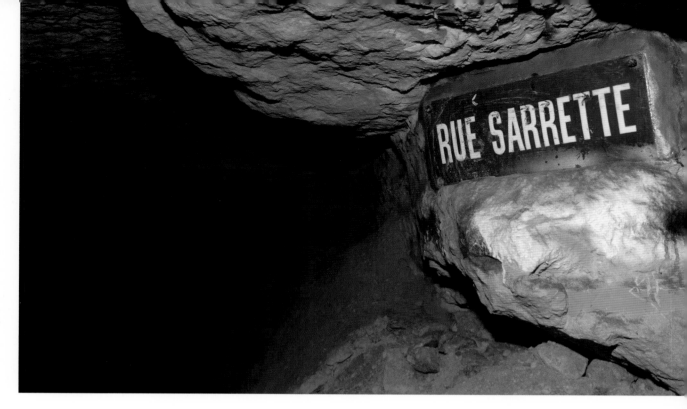

rations widened and more of the network was discovered by the initiates who claimed an increasing number of the underground quarries as their own, decorating them with paintings, mosaics, sculptures and unlikely art installations, hiding ephemeral paper tracts in the walls and, of course, filling the quarries with the sound of music.

Today it is estimated there are in excess of 8,000 clandestine visitors venturing below ground each year, generally on the weekend or at night. Many of them make regular descents. This is despite the fact that entering the quarries is illegal and that over the years there has been a systematic and widespread closing of access points. The illicit visitors are known as Cataphiles; they are young (about seventy percent of them are under twenty-five years old) ,predominantly male (an estimated fifteen percent are women) and many, but by no means all, are students. Their reasons for exploring the quarries are diverse: some like the geology of the place, others its history; the architecture and the aestheticism is what attracts yet more. The curious come to see if the myths are true, and others enjoy the macabre

aspect of the place. Some go down for the physical challenge and others enjoy speleology. A number of Cataphiles go to exercise their talents as artists, while less discerning individuals merely want to have fun, play music, and drink and smoke in this novel party venue. Many are tempted down because of the prohibition; it is an act of defiance on their part and the element of risk lends an additional frisson. But whatever their reasons, it is the singularity of the place that is the greatest attraction and many Cataphiles descend simply to 'enjoy the ignored inheritance of Paris,' which most people do not know exists and which few 'are privileged to have seen.'

Cataphiles are marked by their individualism and anonymity. Below ground many take on another persona and go by pseudonyms that are borrowed from mythology or literature or which reflect their interest in the occult, the supernatural or death, or which show anarchic sympathies. But amid the singularity there is also unity and solidarity; once initiated into the quarries, the Cataphile becomes integrated into an underground commu-

nity that communicates through paper tracts, and which congregates in certain chambers of the underground, each of which has been allocated a particular name by the Cataphiles.

While the physical attractions and challenges of the quarries may be easy to identify, many Cataphiles have more profound, hard to quantify motives and derive spiritual sustenance and emotional balance from their underground forays. For many the protective walls of the quarries provide a refuge from twenty-first-century living; it is a safety valve that controls the pressures of life. Nearly all of the Cataphiles are attracted to the peace and silence of the place that provides a counterbalance to the hustle and rigors of the streets. With the quarries' association with creation, death and history it is inevitable that some Cataphiles view it as a transcendent environment where they go to see the world and 'experience a real voyage in time and space.' Many Cataphiles talk about their descents as a return to the womb or as a re-birthing experience whereby every return to the surface is akin to being born anew. For some, being plunged into the dark and the silence is a return to a primitive joy, which produces a spiritual, almost religious response and

they give thanks to a city that has 'made us a gift by revealing the unknown.'

But visiting the quarries is dangerous and prohibited. A good knowledge of the network is essential, and a visitor needs to be properly equipped and appropriately dressed; the risk of contracting lepospirosis (a fatal disease transmitted by rats) is real; there is always the danger from collapsing quarries; and the instability and unevenness of the ground provokes accidents. But this does not deter the genuine Cataphile. However, interest in the quarries has spread beyond the Cataphile community and the underground has latterly become the focus of interest of uninformed visitors – "tourists" as they are termed by Cataphiles – who are unfamiliar with the underground, unsympathetic to the environment and who are responsible for many of the degradations and accidents.

In reaction to the increased underground population police patrols were initiated. The police commander in charge of public safety and monitoring the quarries works in collaboration with the Inspection Générale des Carrières and is responsible for implementing the *Decree Préfectoral* of November 2, 1955. The decree prohibits anyone without authorization from the Inspection Générale des Carrières from opening the doors and trap doors to the staircases and wells of the old quarries, and from descending into these works with the intention of penetrating and circulating in the quarries under the public highways of Paris. Any infringement of the decree can be noted by verbal lawsuits of the chief of police or other senior police officers and by agents of the Inspection Générale des Carrières and will be submitted to the courts of jurisdiction. The Director of the municipal police force, the General Engineer of Mines, and the General Inspector of Quarries of the Seine are in charge of carrying out this decree. Any violation of the decree is an infringement of the first class and carries a monetary fine.

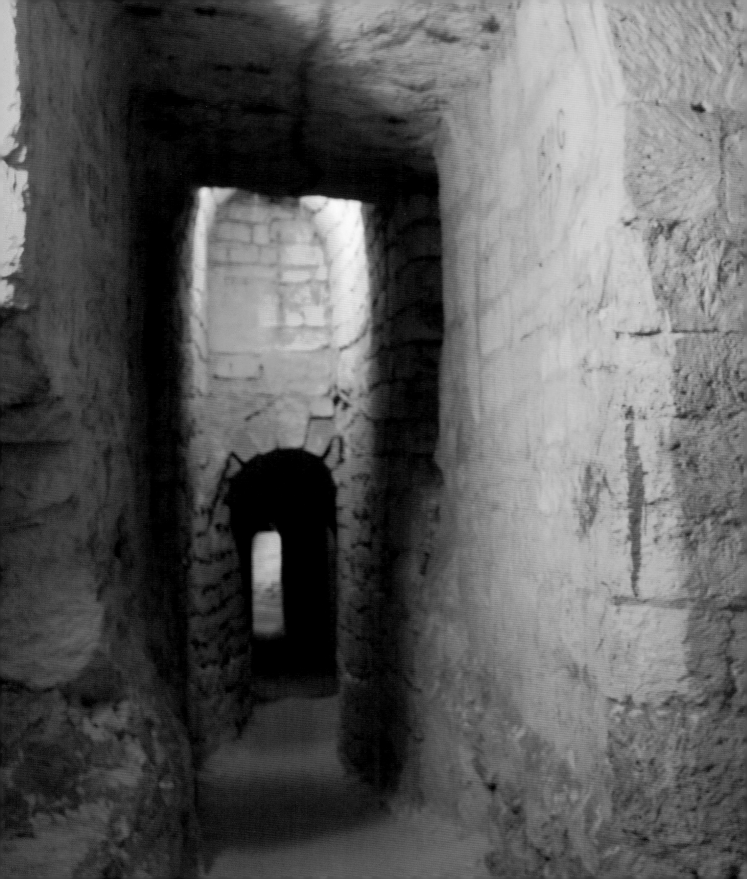

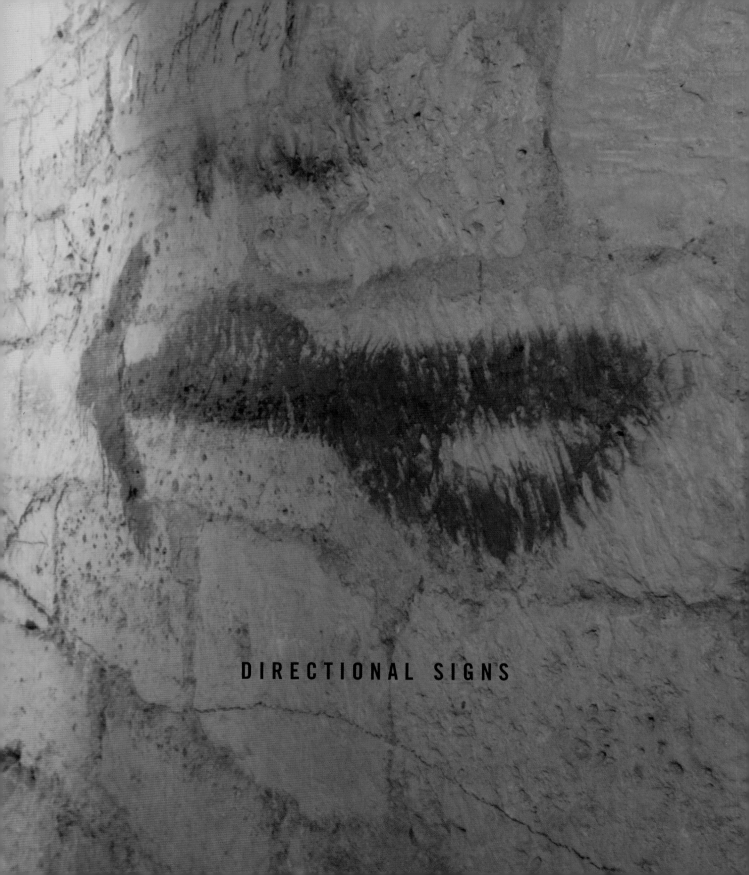

DIRECTIONAL SIGNS

A trip to the quarries is certainly no stroll in the park and it is easy to become disorientated in this underground maze. However, innumerable illicit visitors both past and present have attempted to explore the quarries without the assistance of maps or any understanding of the signs left by the Inspection des Carrières.

GETTING AROUND

To help with navigation many people have found the simplest solution is to mark the walls either with arrows showing direction, or with other symbols indicating evidence of their route. There are an abundance of these signs made by all methods of inscription; they are prominently placed and found on the quarry walls and ceilings at both crossroads and intersections.

Despite familiarity with their working environment, the laborers employed by the Inspection des Carrières needed to mark the walls from time to time with indications of their route or the nearest access point. The signs were unofficial and were made with red paint or black smoke on the quarry ceiling. They were usually directional arrows that corresponded to a particular destination that was indicated by painted initials.

Unofficial visitors to the quarries made less obtrusive marks with pencils: arrows relating to their progression were left on one side of the

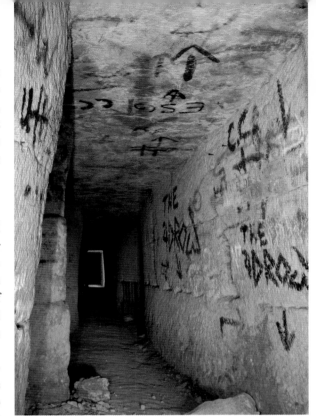

Arrows have appeared in the quarries since 1777. While some indicate entrances or exits, most simply indicate forward motion. Many of the arrows have been adapted, some have been personalized, others have been modified with a variety of devices.

Sketches of liberty birds were used in the quarries to indicate the way out; the beak of the bird points in the direction of the nearest exit.

gallery wall, while arrows on the opposite side indicated the return journey. Most of them were straight but others bend when there is a change of direction and some arrows also comprise the initials of the visitor, a date or a chronological order to avoid any confusion or the risk of getting lost. They were all positioned so as to be quickly visible.

Over the past thirty years the number of clandestine visitors to the Paris quarries has increased significantly; those without maps make their own marks of direction or passage. Some contemporary visitors inscribe in pencil but these are difficult to see amidst the chaos of signs already in the quarries, and increasingly visitors use aerosols to mark the walls as spray paint is easy to transport, simple to use and highly visible. Nowadays a whole host of multicolored arrows and signs form a miasma of directional or indicatory symbols on the walls of the galleries. Each mark is superimposed over the

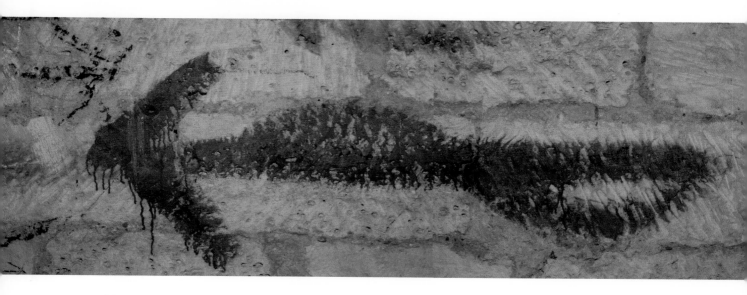

graphics and graffiti of its predecessors and there are so many signs in some places that it is a wonder the authors can recognize their own.

ARROWS & SIGNS

The use of an arrow as a directional sign consisting of a horizontal stroke finishing in the middle of a "v" shape has only existed from the beginning of the eighteenth century and has been appearing in the quarries since about 1777. Some of the arrows point out particular items such as doors or stairs, but most specify motion: straight arrows indicate a movement in one direction, circular ones for turning actions or complex arrows indicating combined movements. There have been many adaptations to their shape and in order to distinguish one from another many have been personalized. The basic shape of the arrow has been taken and then modified or supplemented with a variety of devices: some have the addition of diagonal crosshatching or a single vertical line through the shaft; a circle or a spiral may replace the traditional feather flight; two or three heads substitute the customary one; occasionally a head appears minus its shaft; flights have been embellished in many ways; and shafts can be straight, bending or intersecting themselves; and the standard arrow can be accompanied by ini-

tials, dates or place names.

But not all the symbols used by the visitors are arrows and not all the signs are used to indicate direction. Frequently other non-specific symbols are employed to indicate passage: it maybe a tag, or a personal trademark such as a star, a peace symbol, a face or geometric shape; alternatively it may be simply a random mark, a dot, a line or doodle made in a specific color or left in a particular location so that the maker can recognize his own path.

While the post-war visitors to the quarries may have left a collection of vibrant if disorganized directional signs, by contrast the occupying German forces of 1940-44 made the most orderly, measured and well-executed exit signs to be found in the quarries. The signs were produced with consideration and expertise and not without understanding of letterforms. They also had a uniformity

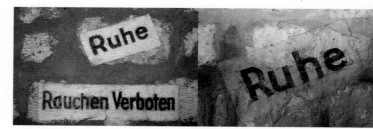

Signs left in 1940-44 by occupying German forces. They are among the most methodical and considered signs in the quarries.

Rauchen

...erboten

→

→ Hinterhof
S.Michel
N.Dame-Bonaparte

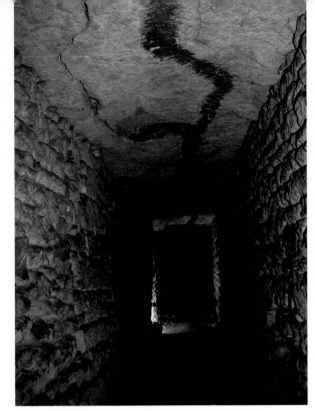

The "String of Ariane" was made with candle smoke and is found on the quarry ceiling. It was made for Catacombs' visitors who just had to follow the "string" to go on a fascinating tour of the underground.

a continuous line approximately four inches wide that appears all over the quarry ceiling. Commonly called the "String" it transverses the galleries of the Ossuary and the neighboring quarries and was made for tours of the Catacombs. Héricart de Thury, Inspector General of Quarries, had envisaged tours of the underground that would pass the most remarkable places: mineralogical showrooms, working water wells, and attractive galleries; all that the visitor had to do was to follow the "String" and they would be led on an extraordinary tour of the underground. The "String" is found regularly in the galleries, but is now difficult to pursue as the consolidation work disrupts its path. The "String of Ariane" takes its name from Greek mythology: Theseus entered the labyrinth to slay the Minotaur and Ariane gave Theseus a ball of thread to unwind as he progressed through the labyrinth and by which he could retrace his path once he had found and killed the Minotaur. Theseus was successful in his quest and escaped the Labyrinth by following the String of Ariane.

Before the development of the arrow as a symbol of direction, more "realistic" representations were used such as hands, feet and sticks. Some of the directional signs in the quarries find their origins in these more pragmatic images. "Liberty birds" were drawn on the quarry walls by the laborers as a rather poetic means of indicating exit points: the way the bird was facing indicated the way out. The idea of the liberty bird came from the early navigators who, when at sea for many months,

of presentation that created an instantly recognizable corporate image. The background wall to all the German directional signs was whitewashed. This served three functions: firstly it produced a luminosity that allowed the signs to stand out in the darkness of the quarries; it formed distinctive signs that could not be confused with any other signs in the quarries; and it created a fresh writing surface by obliterating, but not destroying, the old material. The German signs were unusual in the quarries as the lettering was sans serif and predominantly lowercase and color coding was introduced to indicate particular exit points that were numbered, named and colored. The signs were large, prominently displayed and placed in all parts of the Lycée Montaigne's shelter where confusion over direction might occur. But not all the German signage is directional; some is didactic such as "Rauchen verboten" (no smoking) or "Ruhe" (silence).

The String of Ariane is an arrow in the form of

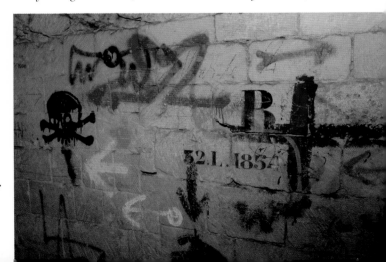

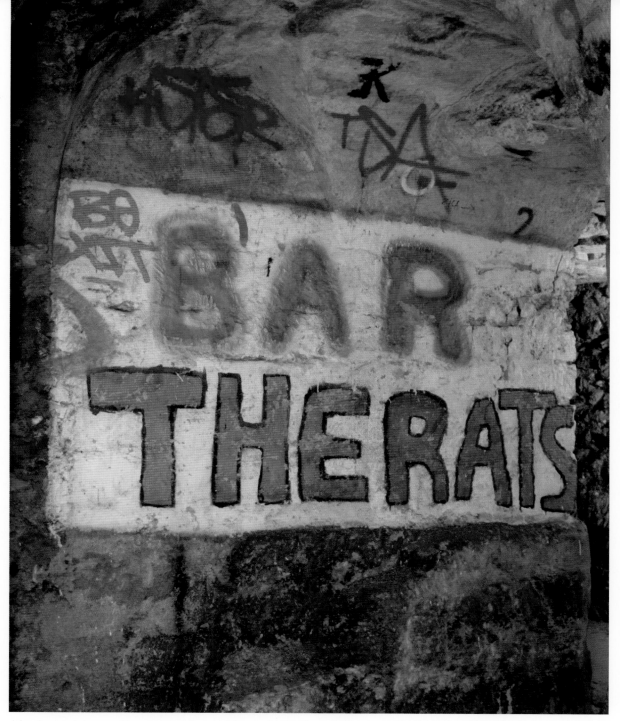

A hand-painted sign, roughly executed, welcomes visitors to the Rats Bar, a small room used by Cataphiles, and which derives its name from a popular kata artists group.

longed for the sight of a bird to indicate the approach of land. The quarry workers adopted this symbol to indicate the way out and thus freedom from the quarry. This association with the sea arose because quarry employers often recruited men with a maritime background, as ex-sailors were cheap to

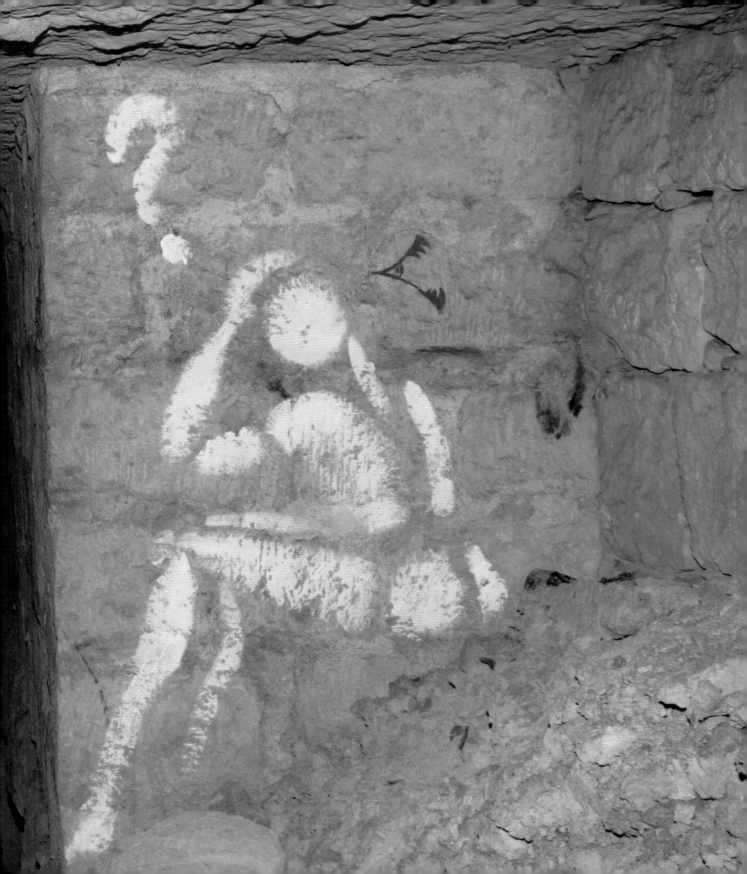

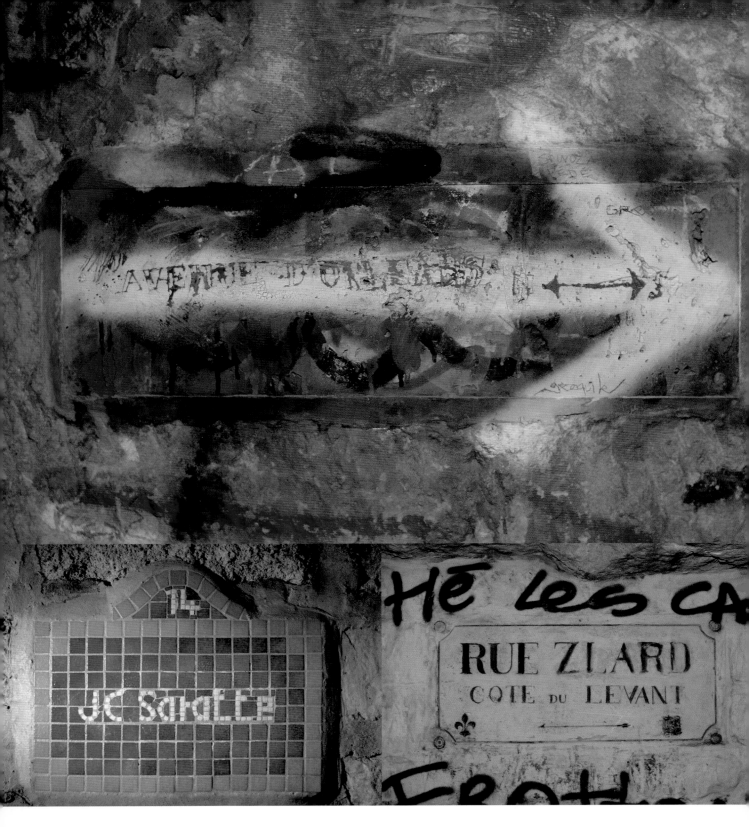

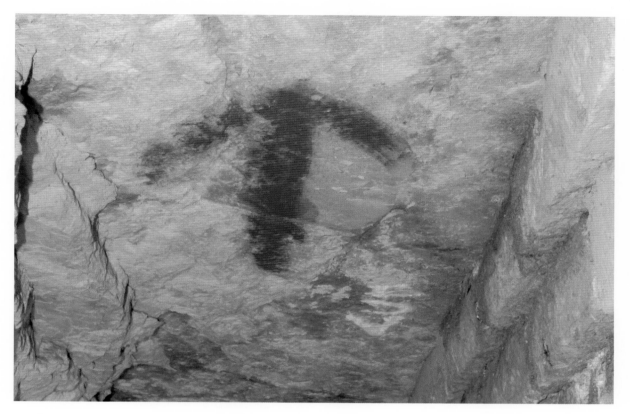

employ, accustomed to harsh conditions and had limited employment choice and expectations.

Jérôme Mesnager is a well known urban artist with work that can be found on walls, façades and hoardings across Paris and major cities around the world; he is also a Cataphile and his familiar creation "Corps Blanc" (White Corpse) appears throughout the underground network. "Corps Blanc" was the means by which Mesnager left his own unique and unmistakable directions in the quarries: "at night, I was often going down into the catacombs to explore the huge labyrinth, I 'arrowed' my path so as not to get lost, I used the Corps Blanc to show the way with his stretched out arms." The "Corps Blanc" wanders the quarries, climbing, resting, dancing leaving its imprint on doors and walls, pointing the way or, on occasions, mischievously misdirecting people. Mesnager choose his sites with precision and had an eye for locations where his "Corps Blanc" would surprise,

amuse or confuse visitors to the quarries.

But not all signs in the underground indicate movement; others signify place. There are 'fake' road signs: "Rue Zlard," "Galerie Lucien" and "Passage des Druides" that have been incised in stone on a smooth surface emulating the original name plaques produced by the Inspection des Carrières. Then there are signs such as "The Rats Bar," which is painted in outline letters of bright primary colors welcoming visitors to a small quarry room that is used as a meeting place by Cataphiles, and which takes its name from a group of Cataphile artists. And creative signs commemorating individuals such as the "JC Saratte" mosaic tiled sign. Jean-Claude Saratte was for many years in charge of the Paris police unit responsible for patrolling the quarries. This sign was erected by the Cataphiles to commemorate Saratte's retirement.

Of the making of signs in the quarries there really is no end.

CHEMIN DE FER
GALERIE
CENTRALE

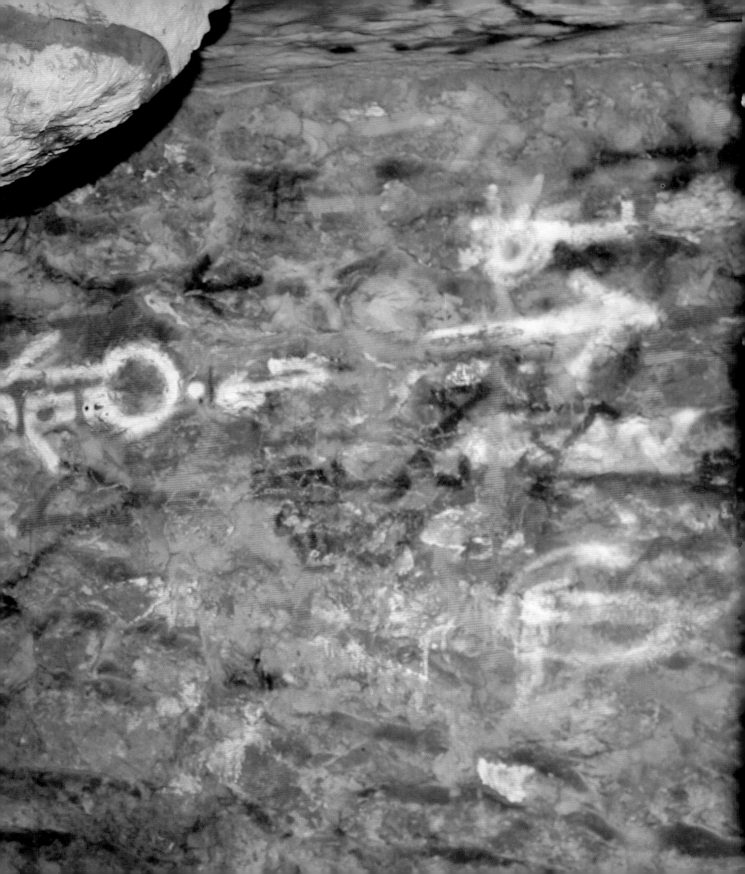

SKETCHES

In fact and in fiction the underground quarries of Paris are substantial: physically they cover a large area and support a vast city; they have witnessed momentous events, participated in great dramas and protected remarkable people; they have been the inspiration for lofty words and grand music and their walls are covered in vast paintings and expansive gestures. But hidden among the big histories and large artworks there exists an abundance of sketches that are small and fragile, discrete and generally unobserved. They are of interest because of their omnipresence, age and historical significance. These obscure little drawings record the presence of unknown and forgotten individuals at events that shaped the face of Paris and testify to more than two centuries of activity in the quarries.

Throughout the underground there are roughly made sketches and rapidly executed cartoons. Quarry workers, engineers, invading and defending soldiers and those who merely visited the underground out of curiosity have made drawings using whatever instruments they had on hand. Sketches and cartoons produced in pencil have been left on the smooth surfaces of the walls or on street nameplates. These images are frequently small, generally very fine and have been carefully rendered with great detail; they are scarcely visible because graphite on stone in an unlit environment is hard to see. Larger images made up of lines about an eighth of an inch wide and produced with charcoal, coal or slate have been left on rough surfaced walls. In addition there are some drawings and sketches that have been created with black smoke on the quarry ceiling. Their dimensions vary from

an inch or two to more than three feet wide. Most of these sketches date from the eighteenth and nineteenth centuries and predate the introduction of bolder and more colorful writing instruments.

According to the mood of draftsman, his artistic abilities and availability of writing implements the images range from silhouettes made from black smoke to the drawings finely realized with the pencil. Among all the sketches and cartoons there are a multitude of subjects. Some are representations of men at work in the underground; many of the images are rapidly made observations of topical events – the *Grand Terreur*, the Prussian siege or the Commune; some of the drawings use religious or Masonic symbolism, others are quite esoteric and their significance and intent have faded with the years. While many of the drawings are made with sobriety, humor and satire can also be found and the occasional pornographic image adds titillation to the underground. Some of the drawings are technical and have been made by engineers during the course of the consolidation process.

Some quarries, due to their location, complexity or uniqueness, were made safe in ways that differed from the norm. Specific architecture and stonework was also required to link certain galleries to water wells, to create underground fountains and for the design of special works such as the tomb of Philibert Aspair. So that the stonework could be cut efficiently and accurately, engineers made 1:1 scale drawings that allowed the stonemasons to take precise compass measurements, and ensured time was not lost by having to re-cut inaccurately carved stone. The drawings were as large as the stonework itself, and usually located close to the area in which the work was to be done; however, some drawings were situated at a distance from the work as the site of the job was too small to accommodate the drawing. Some of the sketches bear the marks of the stonecutters that allowed them to be paid for each stone they produced.

Those sketches that do not relate to the work of the quarries frequently depict the familiar and the

A small sketch of a guillotine, which stands as testimony to the French Revolution, when executions were commonplace and death an everyday occurrence. (Below) Many ex-mariners were employed in the quarries and there is a preponderance of images with nautical themes. Here is a small sketch of a military boat complete with gun towers.

mundane, the unexciting and humdrum events and sights that occupied the lives of the individuals who produced them, prosaic subjects such as birds, houses, anchors, boats, fleur-de-lys, escutcheons and portraits of unknown individuals. People drew what they saw in their daily lives and what was of public concern. However, what was routine to the sketch maker is often extraordinary to contemporary eyes. Little drawings of guillotines and gibbets stand testimony to the Revolution and a time when public executions were commonplace and bloody death a feature of everyone's lives.

War has always played a major part in the life of the underground. During the 1870 siege of Paris, invading Prussian soldiers made use of the quarries on the southern periphery

of the city. Some of these men left defiant pictorial records of militia firing their guns and descriptive images of regular Prussian soldiers; anonymous hands realized most of them, but some are credited with the name of their creator. But whoever was responsible for their creation was not without talent and while the siege may have been short-lived, the underground sketches stand as an enduring memorial of the event. Parisian Commune fighters also had access to the underground and inscribed its walls with visual accounts of their activities in order to flout the enemy, mark their determination, and stake their claim on the city. During World War II the occupying German forces had shelters in the quarries; however, it was left to post-war Parisians to mark the walls with

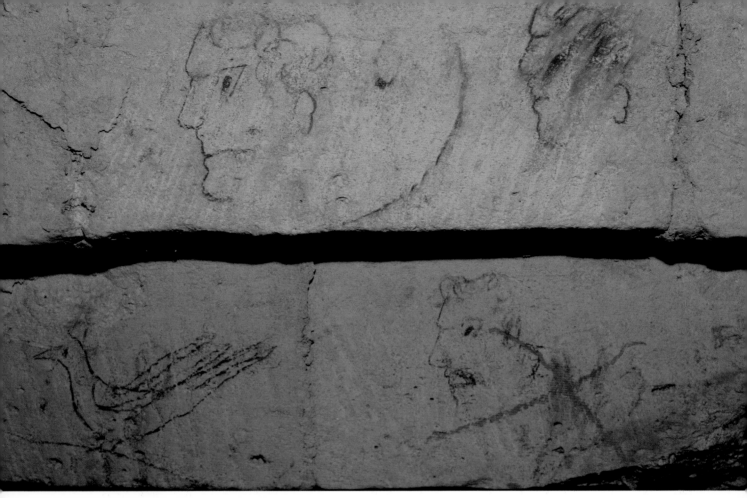

Sketches in the quarries are often ineptly drawn and reflect the ordinary and familiar sights of everyday life. Popular subjects for the amateur artists are people, birds and religious emblems.

hostile depictions of that period in the history of the city.

FAITH & SYMBOLS

For some people the quarries are frightening places: they are divorced from life on the surface and detached from all references to time; human comforts are lacking; the atmosphere is dark, wet, silent and airless; the walls protect a vast number of dead; and many outlandish myths abound. In such an environment it is perhaps unsurprising that many religious symbols can be found. The symbols may have been made in order to Christianize a godless place and to bring light into the dark, or they may have been left as talismen in order to provide protection for those that drew them.

The most frequent religious symbol is the cross, which is sometimes portrayed in its simplest form and on other occasions it is mounted on a base or steps, or surrounded with objects of the

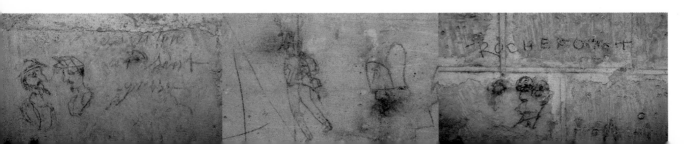

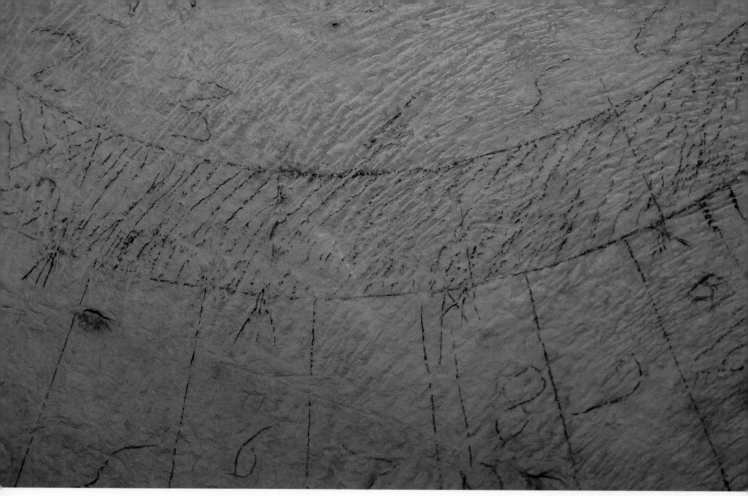

This is an engineering sketch for the production of a staircase. It provides the stone carver with all the necessary dimensions for the cutting of the stones required for the construction of the steps.

Passion of Christ. There are also images of anchors, one of the original symbols used in Christianity (Hebrews 6:19: "This confidence is like a strong and trustworthy anchor for your souls."). Sketches of boats or ships are not uncommon; ships represent the church, which weathers the storms of life and persecution. There are also fish and doves symbolizing the Holy Spirit, and stars made by interlocking triangular sections, circled and initialled. The monogram I H S, *Iesus Hominum Salvator* (Jesus Savior of Man) is often seen either simply drawn or adapted with crosses superimposed on the "H" and a reversed "S". Religious symbols are most frequent in parts of the quarries that have been accessed through religious buildings. Many of these signs are made with the black smoke on the quarry ceiling in areas that have not been consolidated and their faded quality indicates that they are several hundred years old.

SUBTERRANEAN MYTHS & FREEMASONRY

There has always been speculation that the quarries have been used as a meeting place for secret societies such as the Knights Templar or Freemasons. On the Rue Mouffetard and in the Saint Marcel district, stairs have been found that gave direct access into areas of the quarries and that could have been used for secret meetings. Just below the Bois de Vincennes there is a section of the quarries called the Rue Adoniram (named after a Biblical character

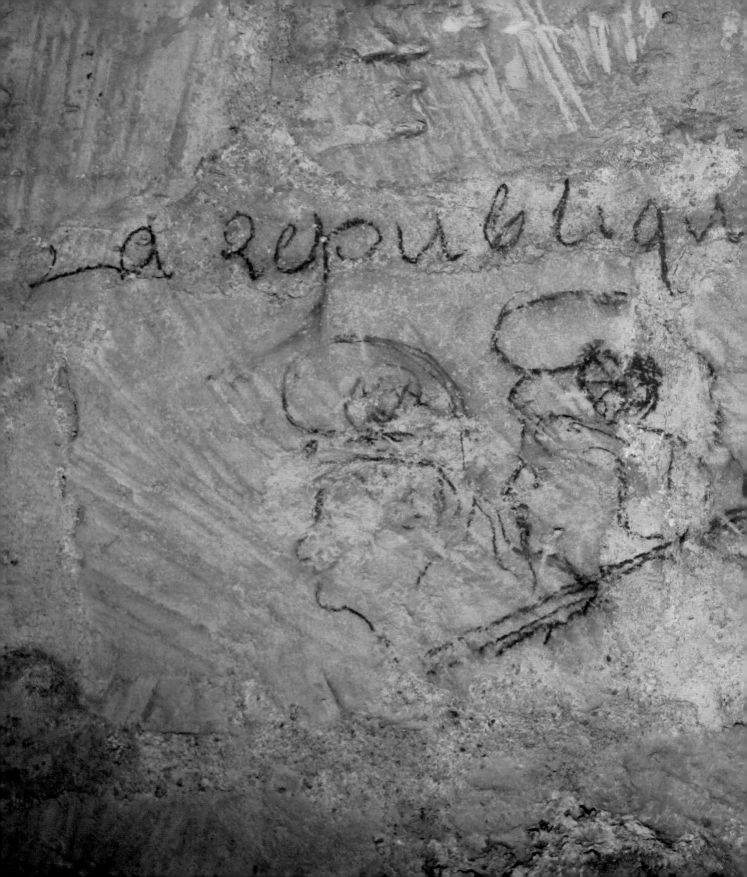

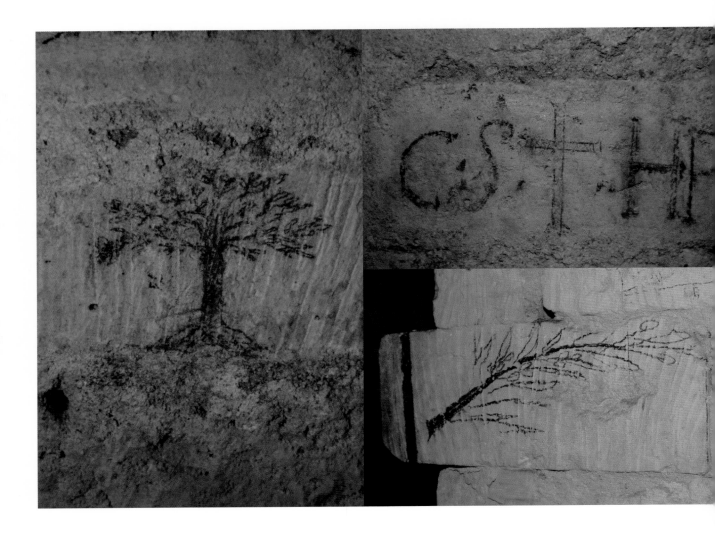

with significance in Cryptic Masonry) where there are sketches of acacia trees on the quarry ceiling that are accompanied by the words "masson 1838". Acacia trees appear on the tomb of Hirma, architect of the temple of Solomon; they are the symbol of the French Masons. Similarly under the Parc de Saint-Cloud there are drawings of acacia trees, a sun and other Masonic emblems which are spaced out at regular intervals. These sketches appear in a gallery that was made safe in about 1840; the signs seem to mark a route through the quarry; unfortunately the destination is unknown because the work of the consolidation interrupts the passage. Certainly there were Masonic visitors to the quarries; possibly they used its rooms for meetings, but whether initiatory rites were held in the underground is still a matter for speculation.

The Paris underground has a rich mythology and has given rise to many strange stories. In 1615, it is said that in exchange for money a visitor to the

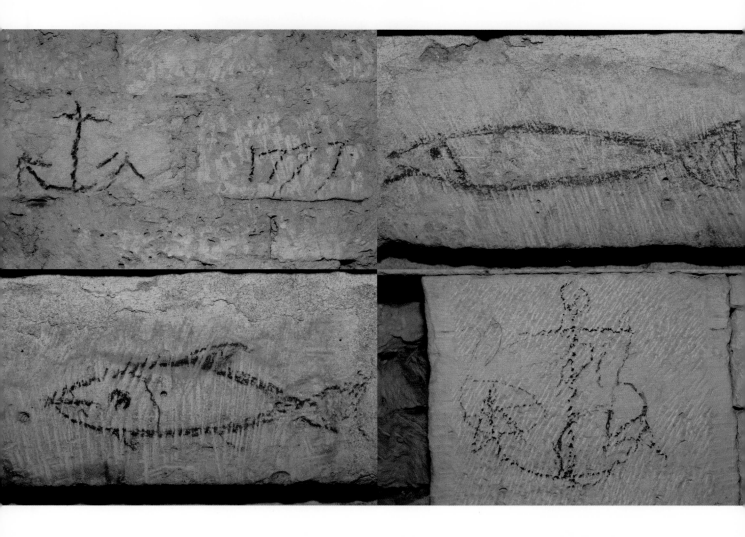

underground made a display of the devil in an area of the old quarries known as the Fosse-aux-Lions. A goat played the "devil," and some friends masqueraded as evil characters. The event was uncovered as a trick and the perpetrator was condemned to the Bastille. Two centuries later a similar deception was made and the individual behind the fraud was sued and damned. Perhaps as a response to these subterranean myths, sketches of devils made with black smoke can be found throughout the quarries. Some are partially obscured by the consolidation and predate 1780, while others were made after 1840.

The sketches and drawings in the Parisian quarries may have been made in haste by inexperienced hands, but they form an historical essay on the life and times of this unique underground world, and highlight the concerns, fears and superstitions of the people who drew them.

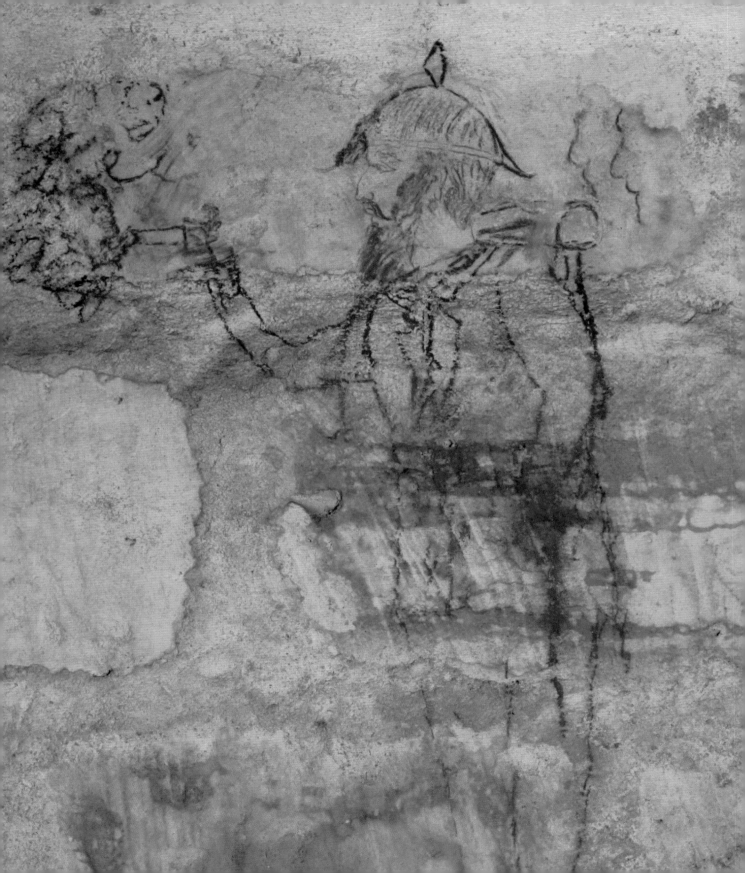

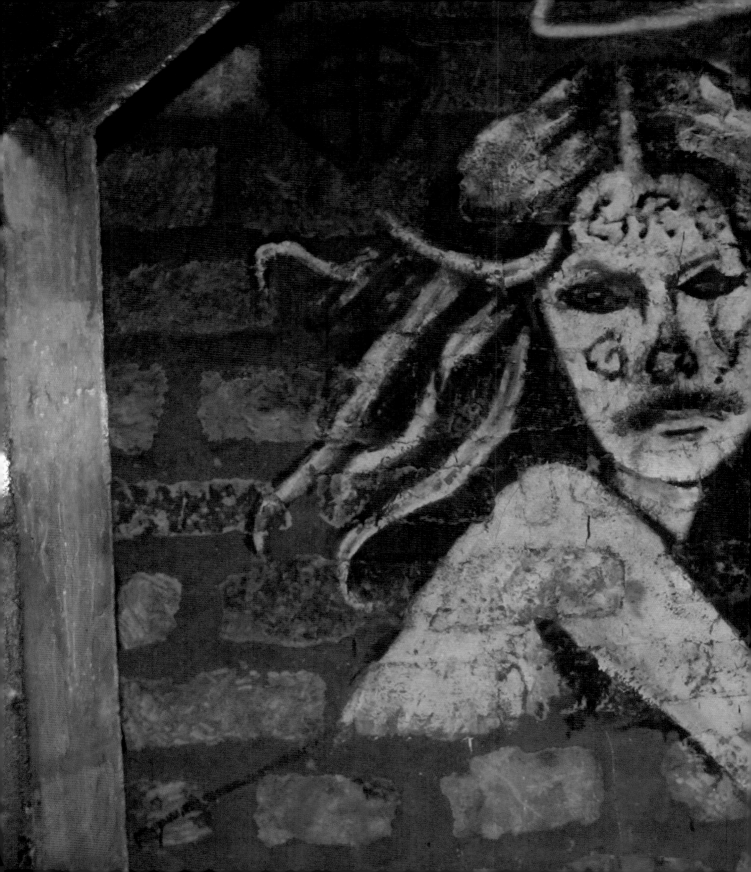

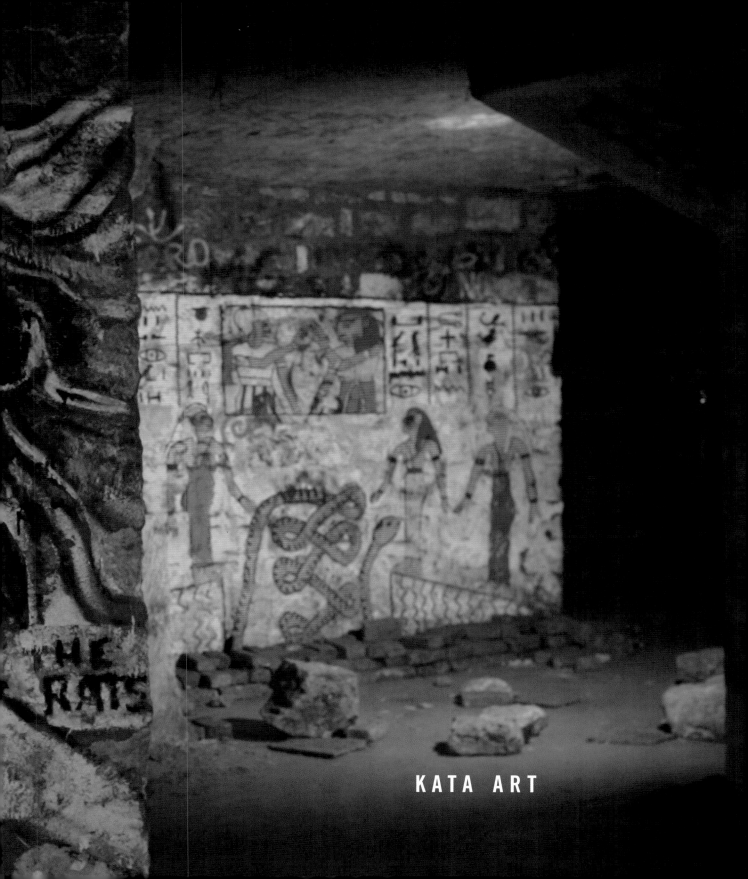

KATA ART

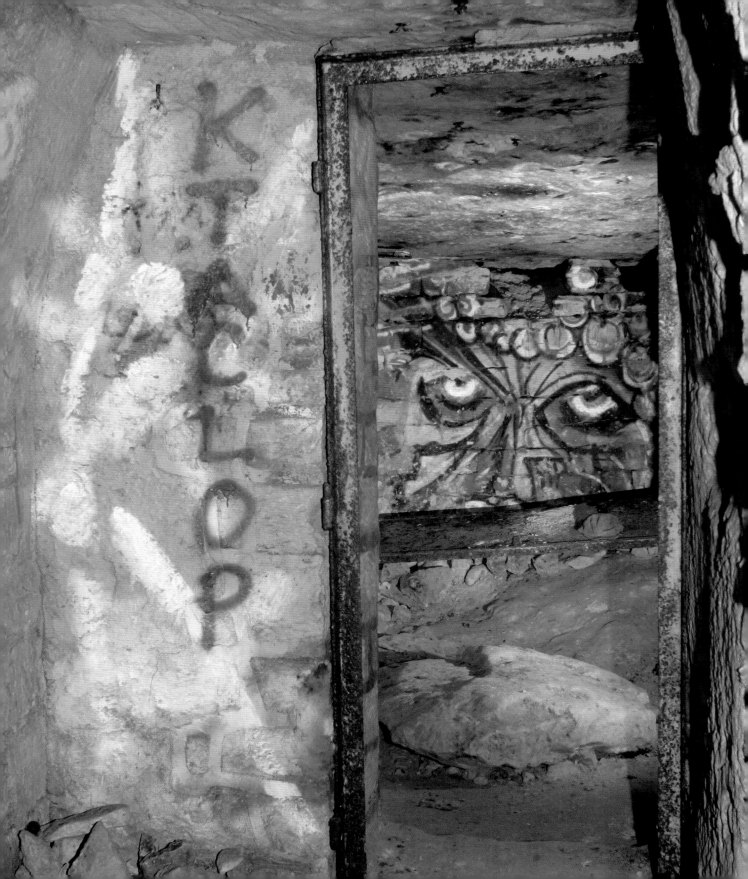

Picasso once wrote: "Painting is a blind man's profession. He paints not what he sees, but what he feels, what he tells himself about what he has seen." This is particularly true of the artists of the Parisian quarries. Their work is called Kata Art by some, simply art by Cataphiles.

Cataphiles have been illicitly producing art in the underground since the early 1980s and their paintings, mosaics, sculptures, ceramics and installations are found over a large area of the quarry network. The underground has also given rise to much artistic photography. It is an environment that has encouraged many artists to look inwards rather than outwards to produce introspective, contemplative and decidedly personal impressions of subjects that are always extraordinary and frequently bizarre: monsters and beasts, phantoms and ghouls are favorites; futuristic topics recur; and politics, religion and sex inevitably find wall space.

ART & STYLE

The painters produce work that is highly stylized and graphic and which has been inspired by many genres: some have adopted the manner of comic-book art, others have been stimulated by Egyptian hieroglyphics or North America Indian symbols, punk has had its influence, while classical art has shaped other paintings. Some of the art is purely decorative, and colorful geometric and amorphous shapes abound. The sculptors and ceramicists choose gentle themes and are often influenced by architecture and produce work inspired by masons of an earlier age. Alternatively, fantastic and mysterious creations of the imagination result in whimsical castles or extravagant gargoyles. The mosaic artists create the most delicate work in the quarries and their small pieces of colored glass and stone are used to produce charming birds, butterflies and flowers. The photographers enjoy lighting the quarries with candles and capturing the light and rich colors of the stone with their lenses. For those with no aptitude for art but who wish to make a creative statement, installations are the solution: one room is strewn with artificial flowers; another filled with CDs; and yet one more is equipped with an inflatable doll, sex toys and pages torn from pornographic magazines. But whatever the subject matter or method of production, Kata art is always executed with passion, humor and wit.

The materials needed to produce Kata art are varied. The sculptors and ceramicists use hammers, mallets, scissors, gouges, chisels, planes, carriers, spirit levels, rulers, setsquares and compasses. As well as exploiting the natural stone of the quarries, some also bring their own rock, clay, plaster, tiling, cement, limes, pigments and wire. The mosaic artists use similar tools and materials with the addition of smalti, glass or ceramic. Painters need acrylic paints, spray-paint, charcoal and brushes of various sizes. Some artists use material salvaged from the streets and work with whatever they find. But the most indispensable piece of equipment for all experienced kata artists is a three-wheeled caddy for transporting large amounts of tools, materials and sustenance.

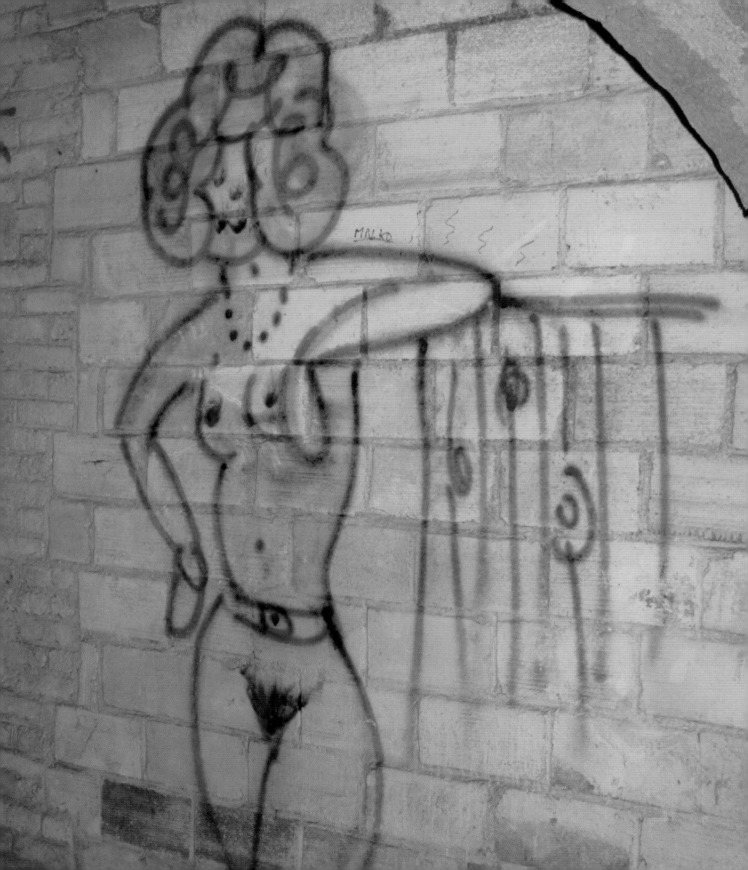

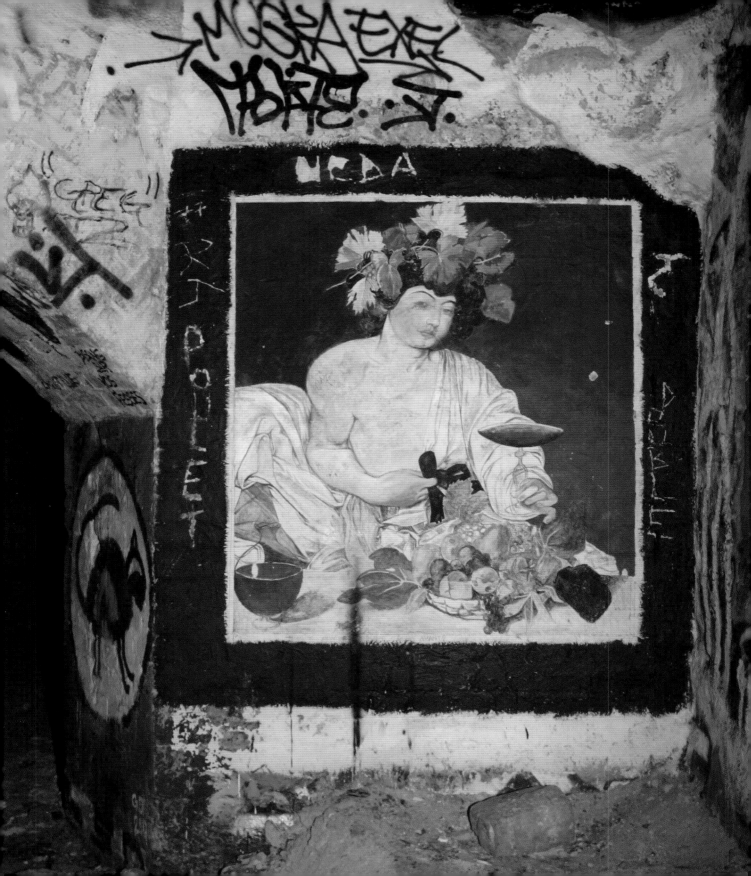

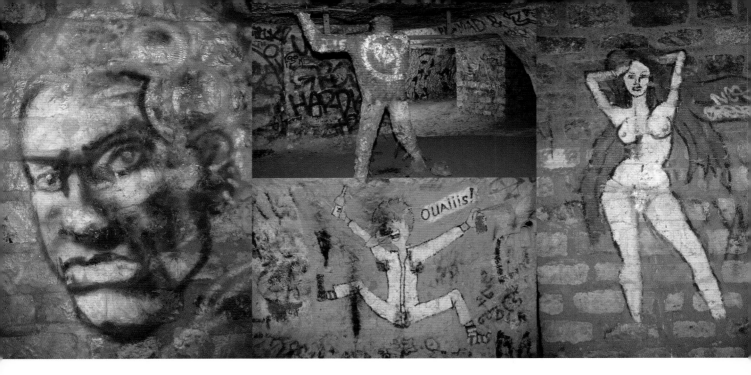

THE ARTISTS

Most of the kata artists are amateurs; only a few are professional. Nearly all started producing while in their early twenties. Some artists perform only once in the underground; others are prolific and are continually working. While most of the artists also practice their craft elsewhere, there are a few who reserve their creativity especially for the quarries. But none of the artists became Cataphiles with the intention of performing in the underground:

> If the idea of leaving a trace of my passage through the quarries immediately crossed my mind at my first descent, it was necessary to wait two years (on the insistence of few close friends) so that I could really think how to realize what was at the beginning but a dream: how to combine my trade and passion (masonry) with the stone of the quarries: what a natural marriage . . . !

It was a sense of adventure that attracted most of the kata artists to the quarries and the production of art was secondary to that pioneering spirit but, as one artist remarked: "the stone is always there, one cannot resist for long."

LOCATION, ACCESS & PLANNING

With 177 miles of passages beckoning to be painted, sculpted and covered in mosaics, the artists are spoilt for choice when it comes to selecting a location in which to work. The criteria for selection are as much practical as they are aesthetic. The walls need to satisfy the artists' concept of beauty in form, color, lighting or setting; seeking the appropriate wall is an intellectual quest and many spend much time looking for the right place. Painters prefer dry walls with a naturally level surface. The stone carvers are concerned with the quality of the rock: not too hard and not too rough, a healthy stone that maintains its quality over an area large enough to accommodate the planned

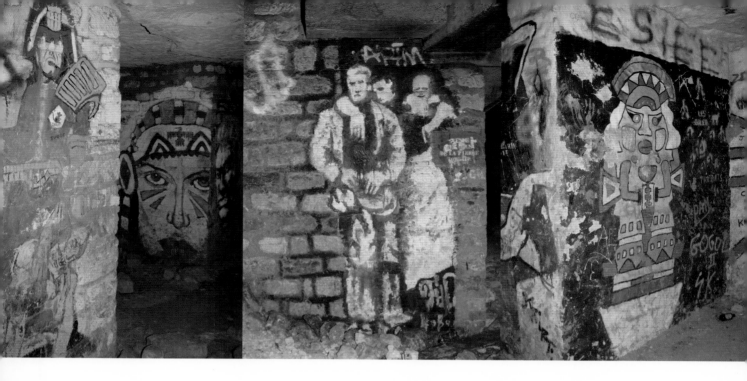

sculpture. Although the quarry walls may provide an extensive canvas from which to choose a location, the stone is not always in an ideal condition. Sculptors often need to flatten the walls to create sufficient space for their work and to make a smooth surface on which to trace the outline of the piece to be carved. Some painters prefer to brush the walls to remove the saltpeter before they start; others prepare the surface with a base solution to take the paint to ensure the longevity of their work. But there are also some who elect to work with the raw materials in their natural condition and the swiftness of execution and the anticipated brevity of the artwork's life means some artists regard stone preparation as unnecessary.

But whatever their methods and mediums, most serious artists seek to work in locations away from the main galleries to avoid being disturbed by passers-by, but close enough to a point of entry to ease the logistics of transporting materials, equipment and provisions through the quarries. They also need proximity to a supply of water for mixing paints and washing tools, and if it is anticipated that a piece of work might take hours, days or even weeks to complete, a location where there is adequate standing room is of prime importance. Some artists stay underground for the duration of the work; others perform in short sessions of three or four hours, returning frequently to the quarries until their work is concluded.

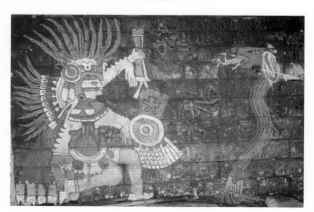

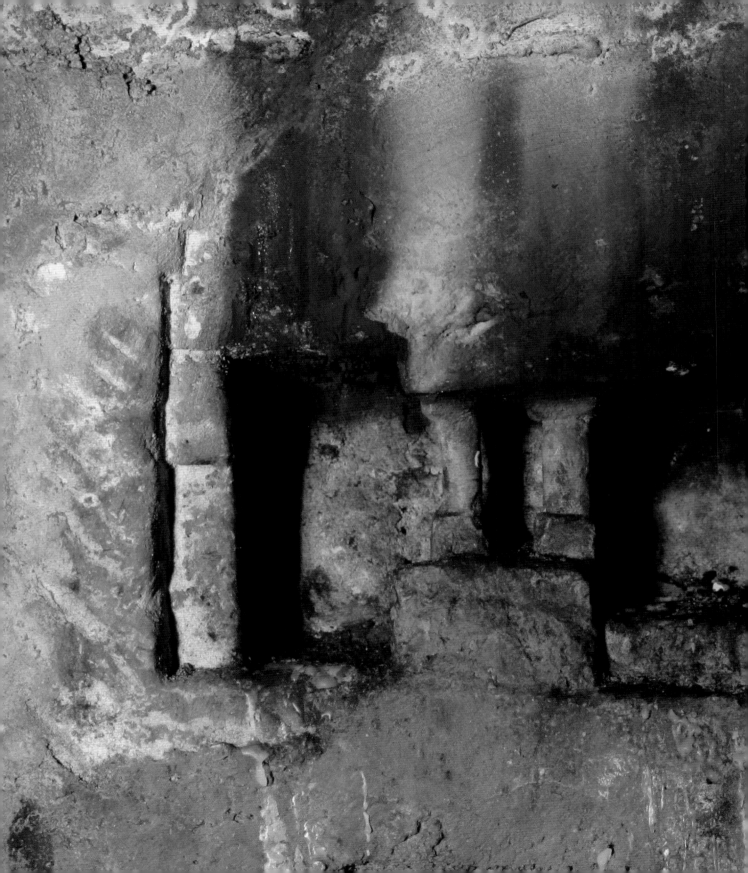

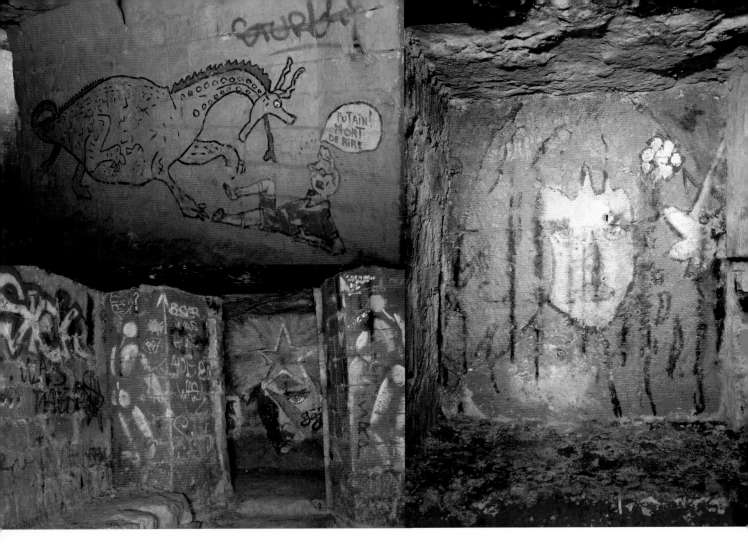

For many of the kata artists, performing in the quarries requires careful planning and the sculptors in particular produce detailed plans on paper before work commences. Sometimes artists work in teams or with the help of assistants in which case drawings are made in order to control construction. There are other artists who work with great spontaneity and with no planning, just a knowlege that they will act if an inspiring location is found. In these instances an artist will just throw himself into the wall; there is no time for sketches because "art is alive while it is being produced, in one night it is done; the next day is another day."

The dimensions of the kata art range from small mosaics that are no more than four inches in diameter, to large ceramics of six and a half feet high, or huge paintings that are in excess of sixty-five feet wide. How long a piece can take to make depends not only upon the size of the work, but also the techniques of the artist and the mediums in which they are working. Some pieces take as little as sixty seconds to complete, while paintings that use many colors may take hours because it is necessary to wait until one color is dry before continuing.

The installations in some rooms can take several days because of the need to clear the space of its debris. In extreme cases, such as the Salle de Ceramics, two years were required to complete the whole installation.

The quarries can be uncomfortable and cramped, wet and dark; they are also difficult to access, problematical to traverse and physically demanding, but the challenge of the underground is seen to be both an advantage and a disadvantage by the kata artists.

Some of the advantages are practical: for the kata sculptors the greatest benefit of working in the quarries is the availability of raw material; there is no better place to find stone than in a stone quarry. The other big advantage is location: "You can't disturb anybody in the quarries, and God knows that sculpting is noisy!" For others, the advantages are derived from the uniqueness of the place itself: its architecture provides an original setting for the art, its labyrinth gives opportunity for surprise locations, and its stone gives beautiful colors to the paintings. But above all the perceived advantages of performing in the quarries are the peace and quiet, the tranquillity and calm: "the softness of the climate, the absence of wind, the total silence that reigns in the quarries..." Being below the street and its buildings creates a feeling of security and the lack of references to the time of day allows the artists to find a rhythm of work that is more in har-

mony with their own nature.

Working in the quarries is a unique experience with a special feeling and many kata artists regard producing art in the quarries as a special privilege, but it is a privilege that comes with problems: steadfastness is required to overcome the many physical hurdles and tenacity is needed to conquer the numerous technical obstacles that present themselves.

The first problem is one of access; once that has been conquered the illegality of the situation has to be confronted: kata artists are all too aware of the possibility of being caught in the quarries equipped with the tools of their trade; there has been more than one person who has spent the night in police cells. Then there are the difficult conditions presented by the quarries themselves: the presence of moisture, the absence of light, the confined spaces, and the possibility of work being destroyed either by natural conditions or the recklessness of unsympathetic visitors.

Moisture is the biggest handicap for the painters as wet walls are not the ideal basis on which to paint and the humidity ultimately causes the degradation of the works. However, the ever-present water is useful for mixing paints and eliminates the need for importing it into the quarries, but the total absence of natural light makes it diffi-

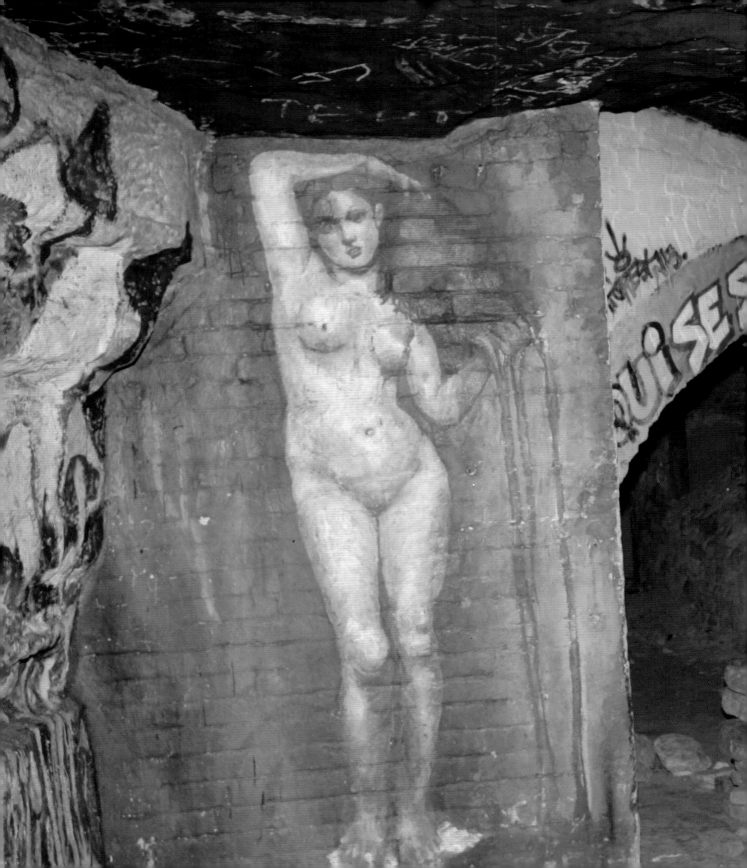

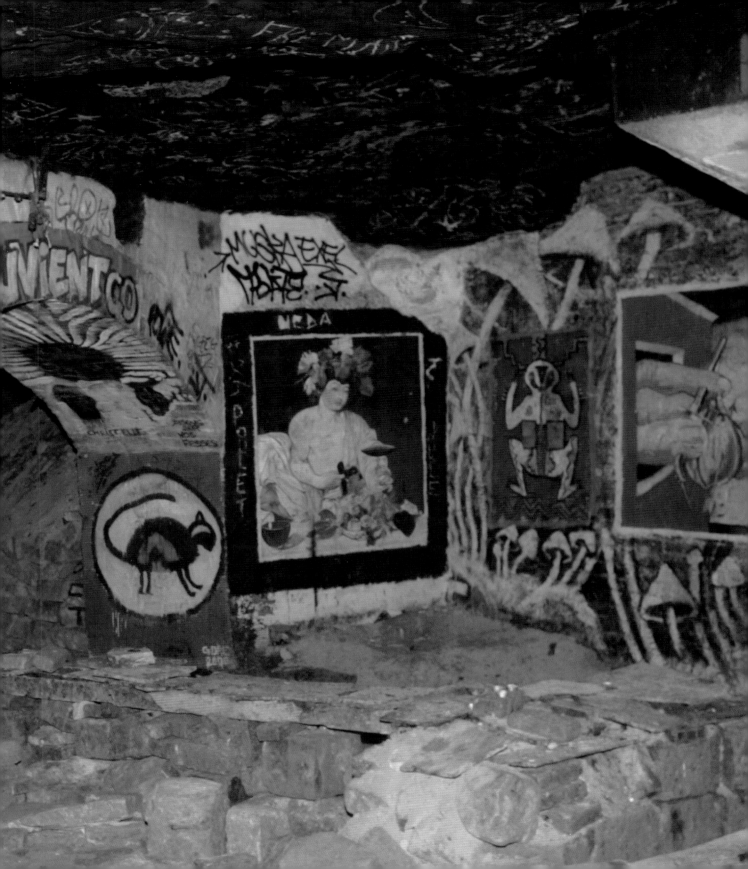

cult to mix the right colors and most of the painting is done by candlelight. Logistics remain the biggest problem, especially for those productions that require a lot of tools and materials, plus provisions and camping equipment for those jobs that take more than one day:

> We decided to remain underground for three days because of the amount of tools necessary to do the job; we couldn't just leave the tools in the quarries over night, they would have been taken. You can imagine the conditions and the problems that confronted us. Firstly we had to find a place where the stone was adequate for the job, it had to be close to an access point so that it was not too far to move our 45 pounds of tools, and food sufficient for two or three days.

The duration of the exercise also caused us physical problems because seventy-two hours without daylight, wearing the same clothes, and being covered in dust is an uncomfortable experience. But the most awkward problem is the absence of natural light: when we created light with the acetylene torches they projected shadows that obstructed our work, we were not accustomed to that, and work became difficult.

While many of the obstacles may be natural, an increasing number of the problems are the result of insensitive visitors who have little respect for the artworks and deface the paintings. "This damage," as one kata artist commented, "just adds confusion and is pointless."

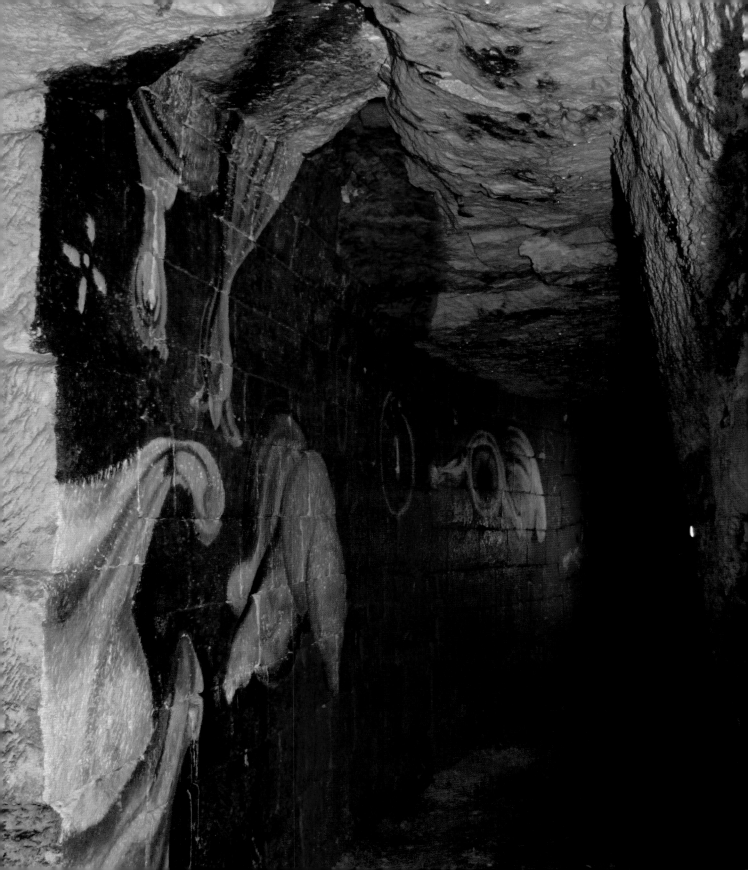

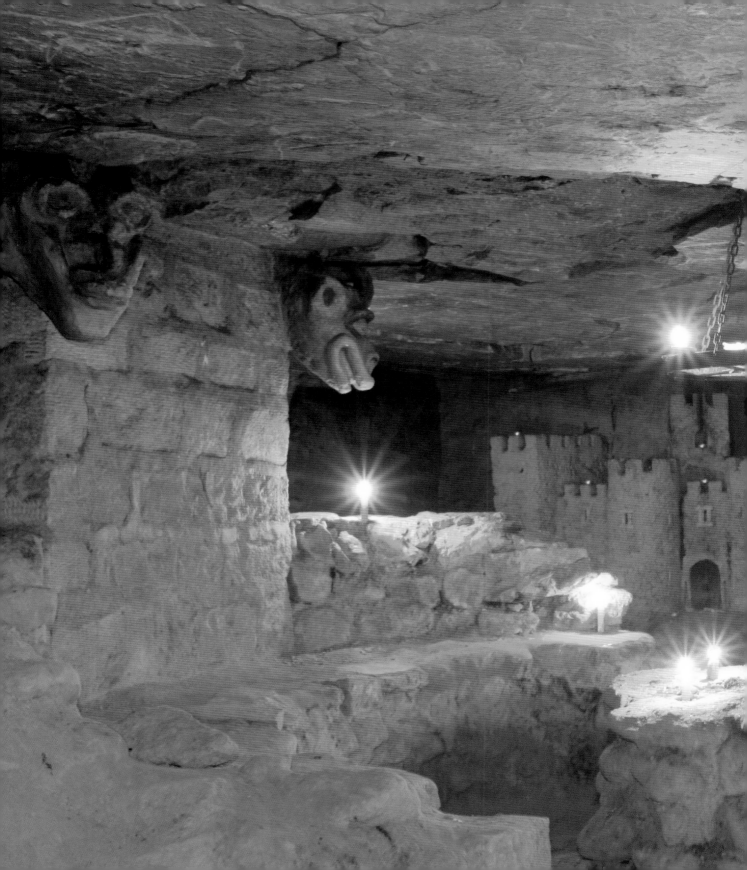

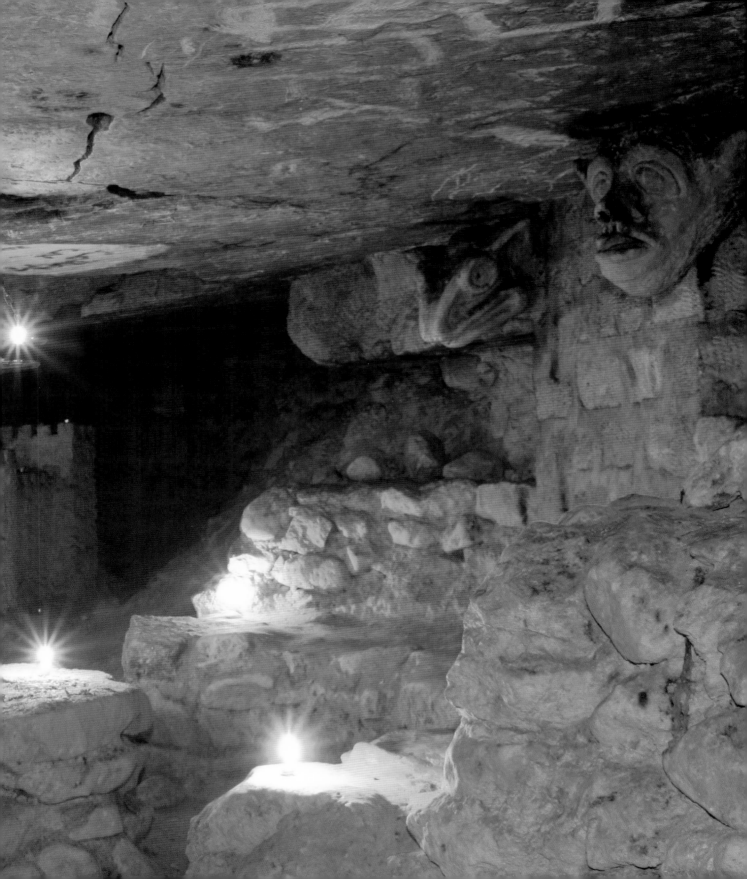

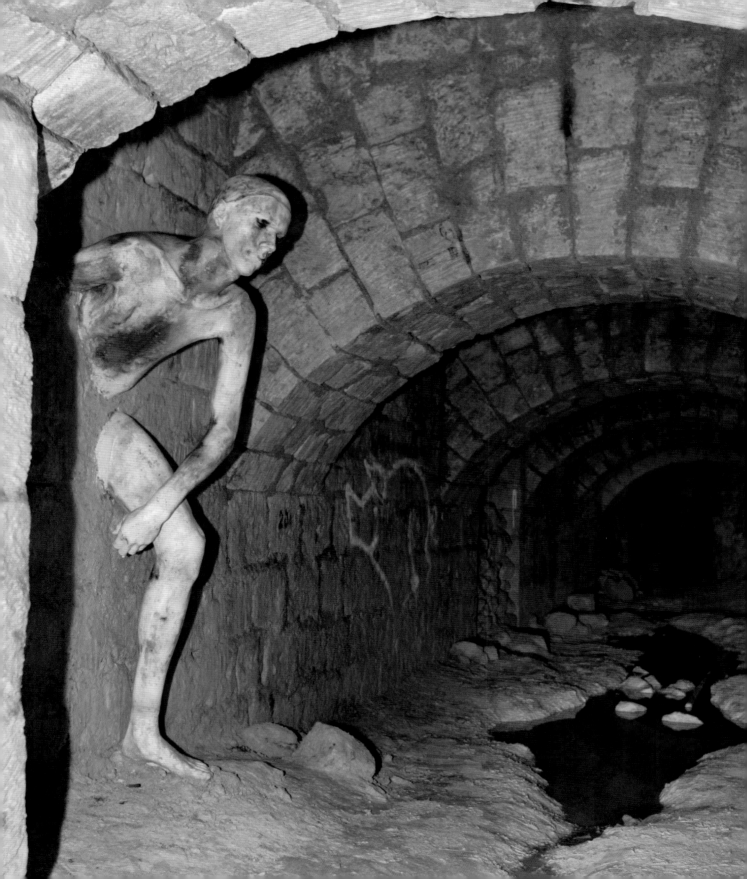

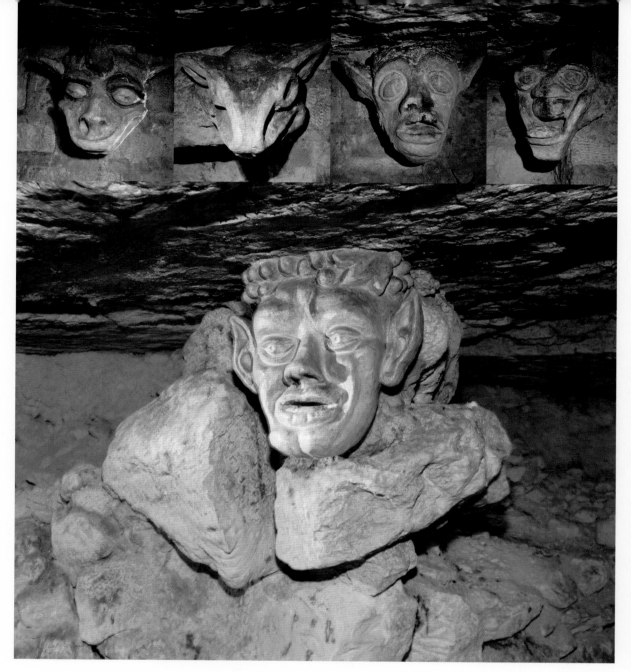

Much effort, trouble and risk goes into the making of kata art underground, therefore it might be thought that the artists would wish for an audience commensurate in size with their labors. However, few are troubled by the paucity of audience because the search for fame and notoriety is not part of the objective. The work of most kata artists is done as a private performance made for personal enjoyment. However, their work can be viewed by those few individuals who have endured and conquered the same austere conditions as the artists themselves. The exclusivity of the audience is part of the appeal of performing in the quarries; "our goal is not to be seen by everyone, we work for those who will come to see them."

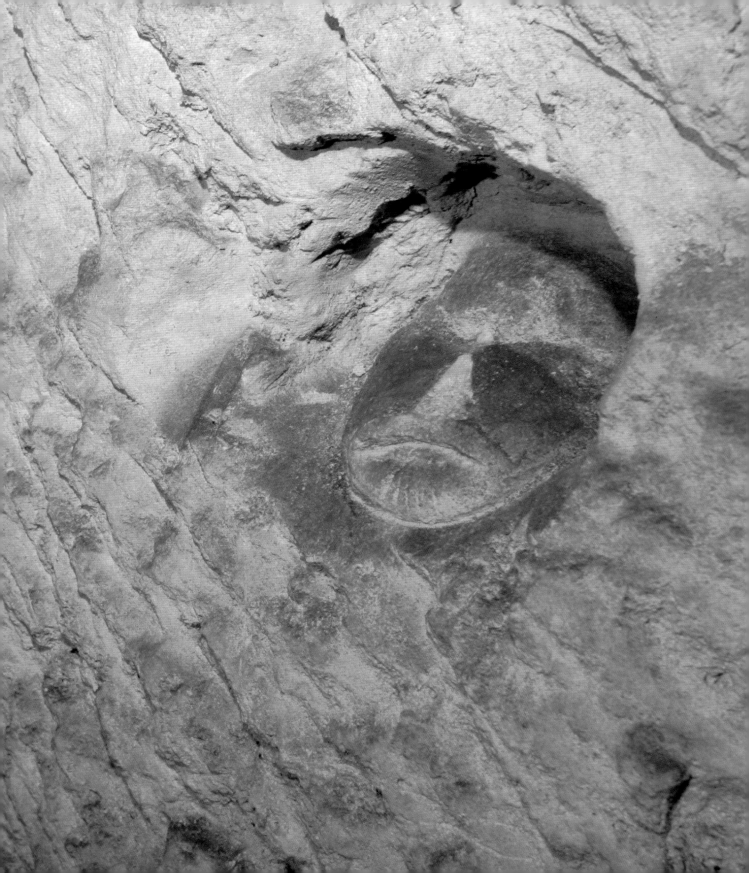

FAME, STATUS, ANARCHY & OTHER MOTIVES

Kata artists have fame and status within the Cataphile community and most artists enjoy communing with those Cataphiles who come to watch the progress of their work. For some artists it is merely flattering to be recognized by their peers, but for others the acknowledgment of the Cataphiles is an essential part of their motivation:

> I am an egoist, and I produce my paintings both for myself and for other Cataphiles. Through my work I create a community of Cataphiles, I also paint on the Metro so that my work has an extended life from the quarries all the way to each Cataphile's home. Part of my motivation is to be recognized. I admit that I like to be recognized by other Cataphiles.

In some instances recognition has been shown by naming rooms in the quarries after the painting, the artists or after the team who produced the work. It is the sort of appreciation that comes as a surprise to the artists who often do not regard their work as a significant thing: "It is only a small trace of my passage, I did not think that it would be of interest fifteen years later."

The motivations of kata artists are inevitably wide-ranging. There are those who regard working in the quarries as a challenge that helps develop them both as individuals and artists. It provides a unique environment that enables them to learn from the new techniques. For others their relationship with the underground is a two-way process: those who take from the quarries (knowledge,

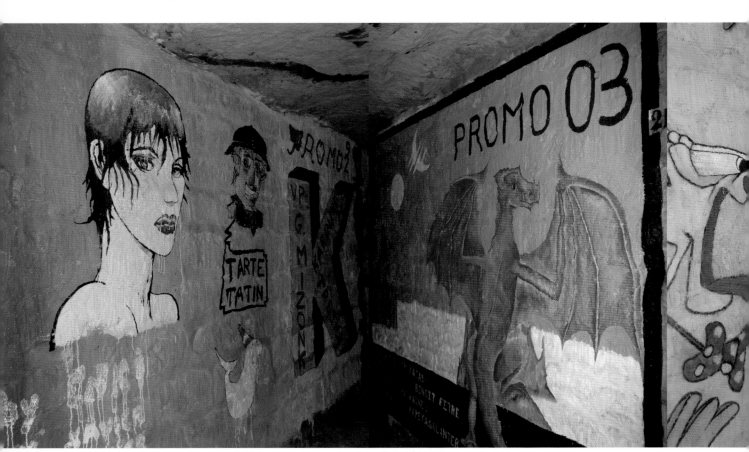

peace, security) feel the need to give something back, by leaving traces of their art, and the underground "is now more beautiful thanks to my work, and I am more developed thanks to the quarries." There are also those who wish to add something to the underground for the benefit of their fellow cataphiles and create decorated rooms in which people can find space to contemplate and to admire. For some people working in the quarries is an intellectual exercise that allows them to explore issues of their own particular concern: "I am interested in the interaction between the underground and the street, painting in the quarries allows me a constructive way of understanding." Inevitably, some kata artists are politically motivated and enjoy the opportunity to change the eyes of the spectator: "I am a revolutionary and an anarchist, I liked the commune of 1781 and I want to continue with the revolution from underneath Paris. The history of the underground is also important. I want to change the world that is why I am painting." The quarries allow the artists a liberty of action and tolerance of creation that is not easy to find on street level Paris.

But most kata artists are afflicted with the same compulsion as all visitors to the underground: the need to leave a trace of their passage. Their traces may be more flamboyant and accomplished than those left by most other visitors but their motivations are fundamentally the same: "We did it for fun, we did it only for that."

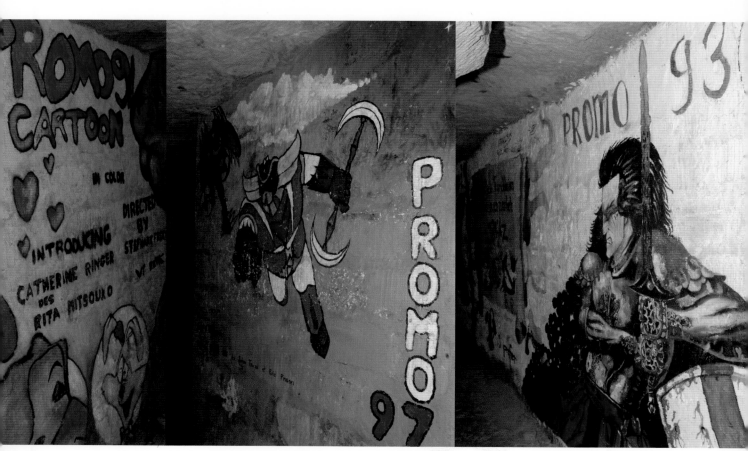

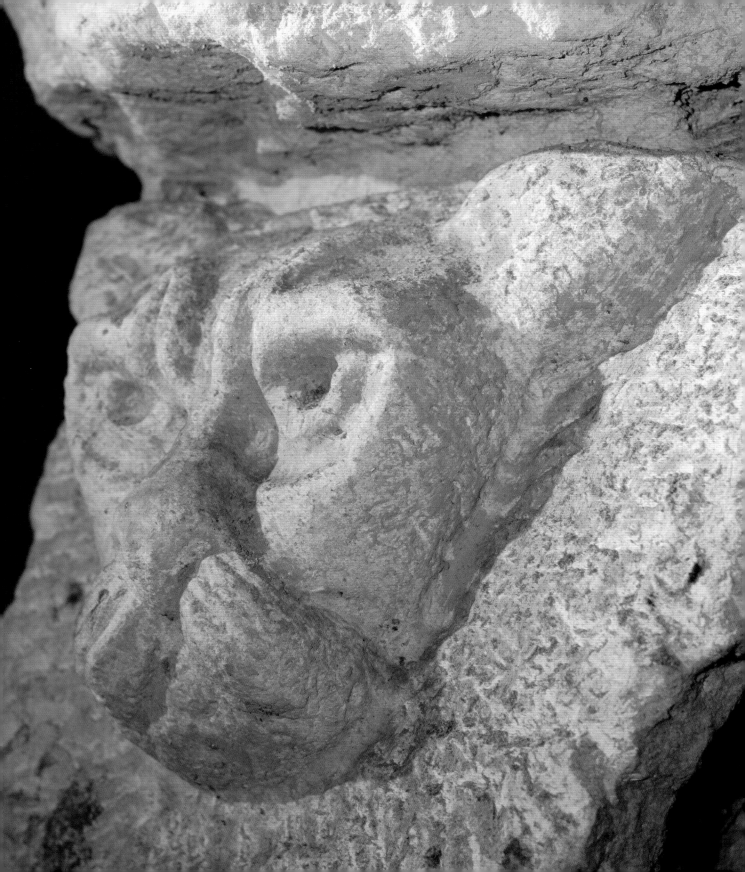

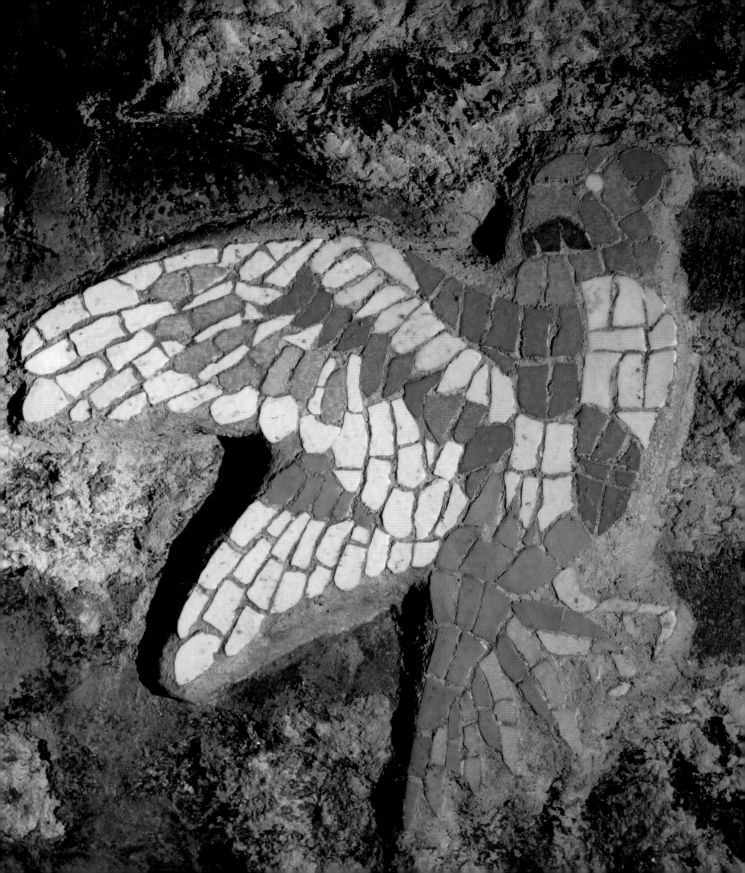

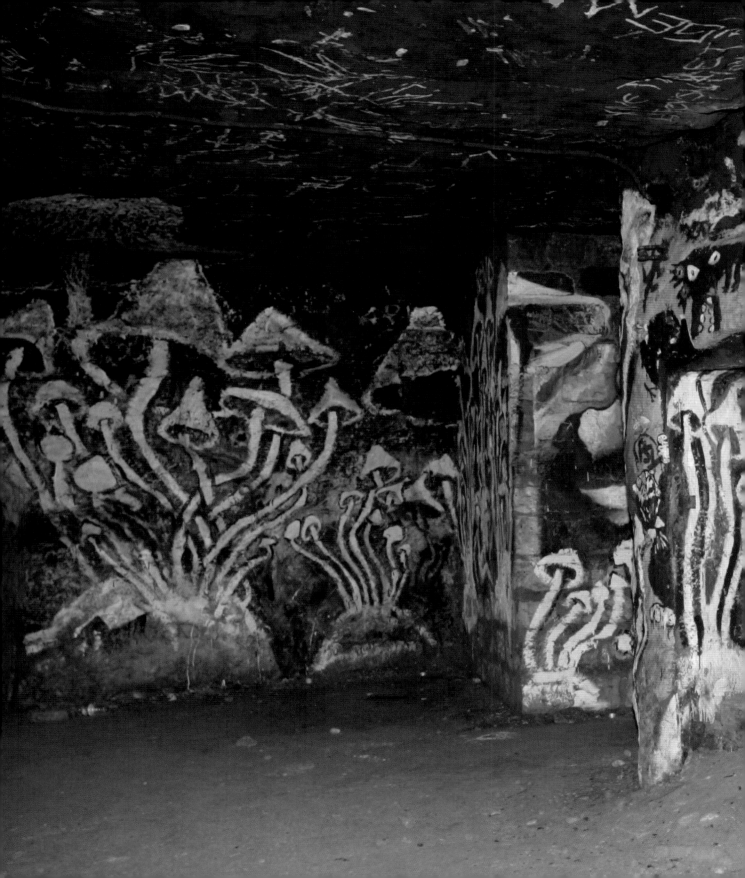

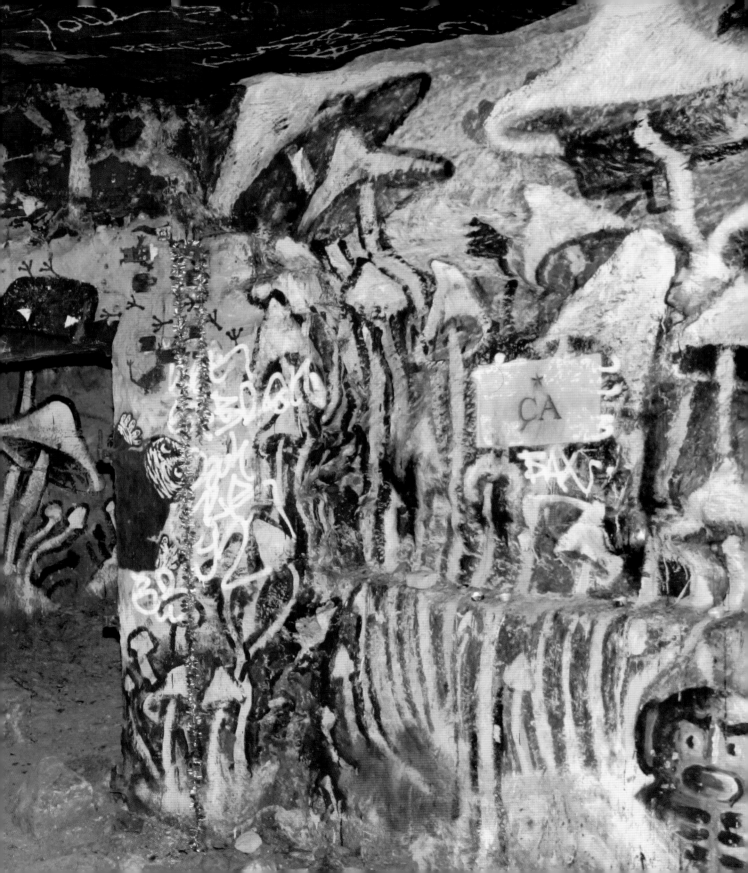

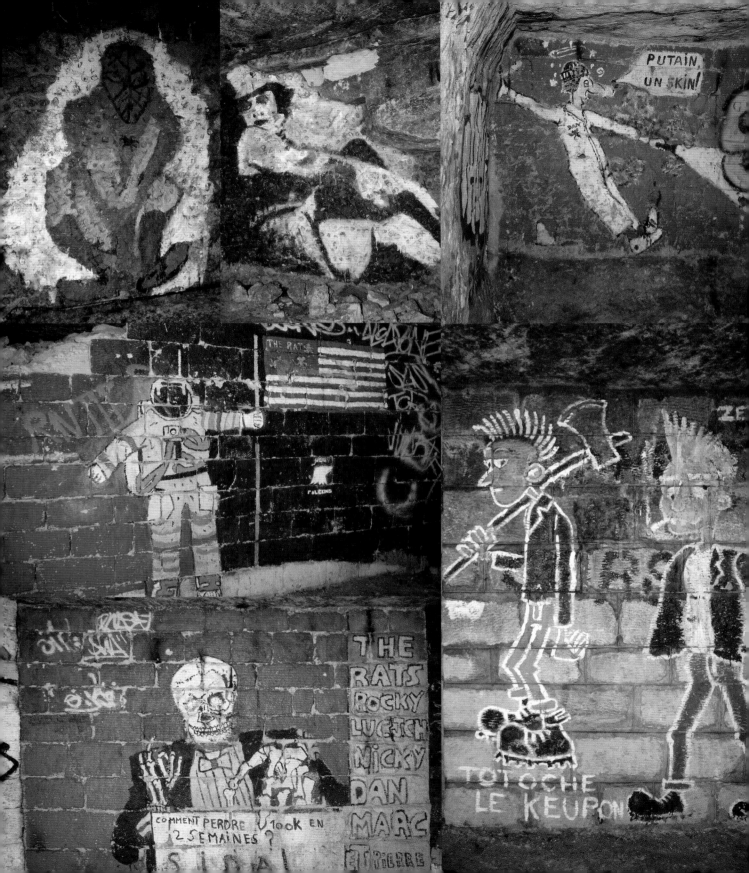

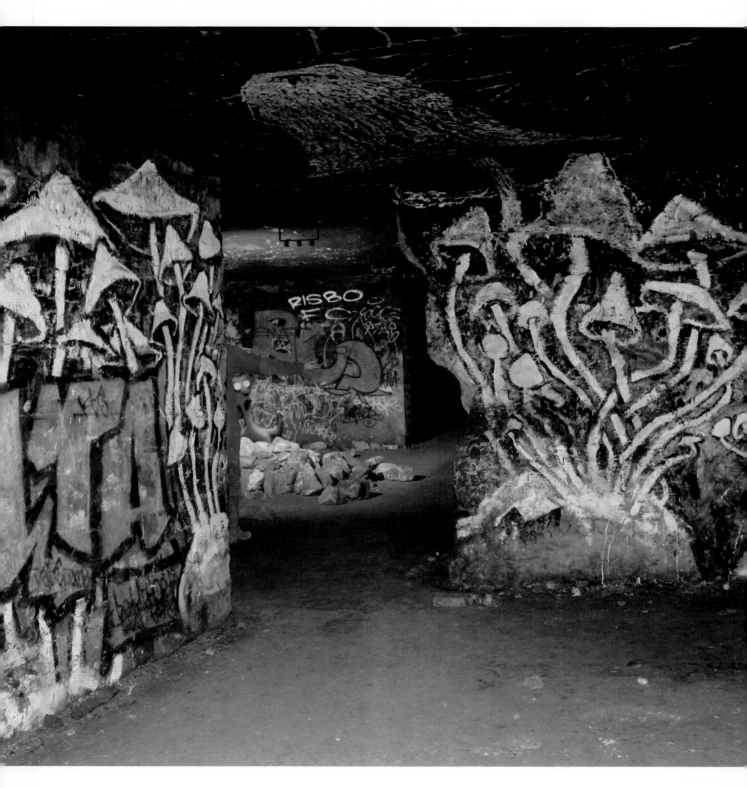

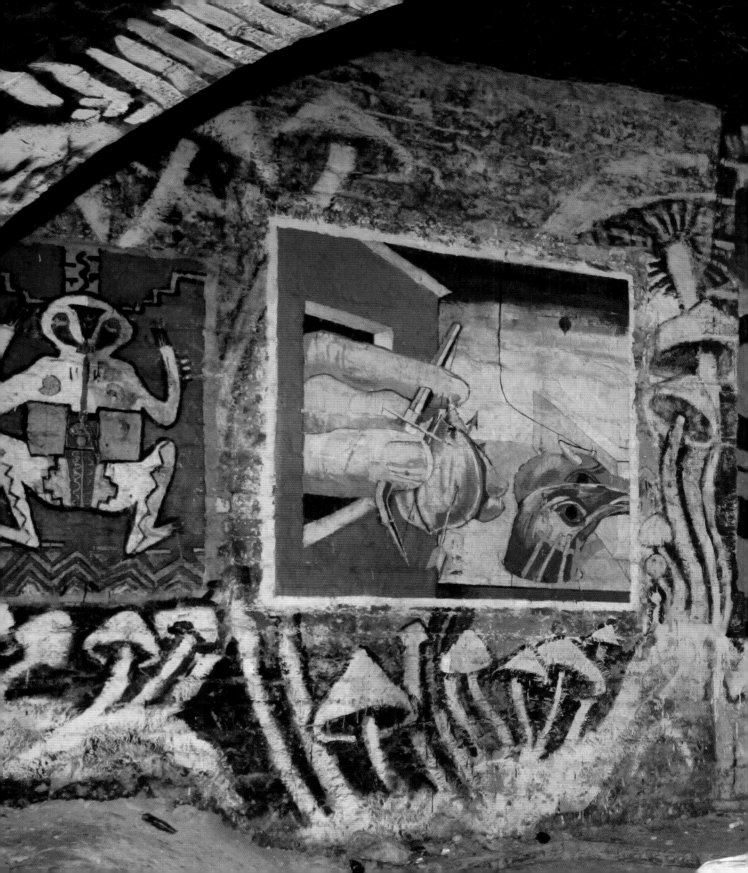

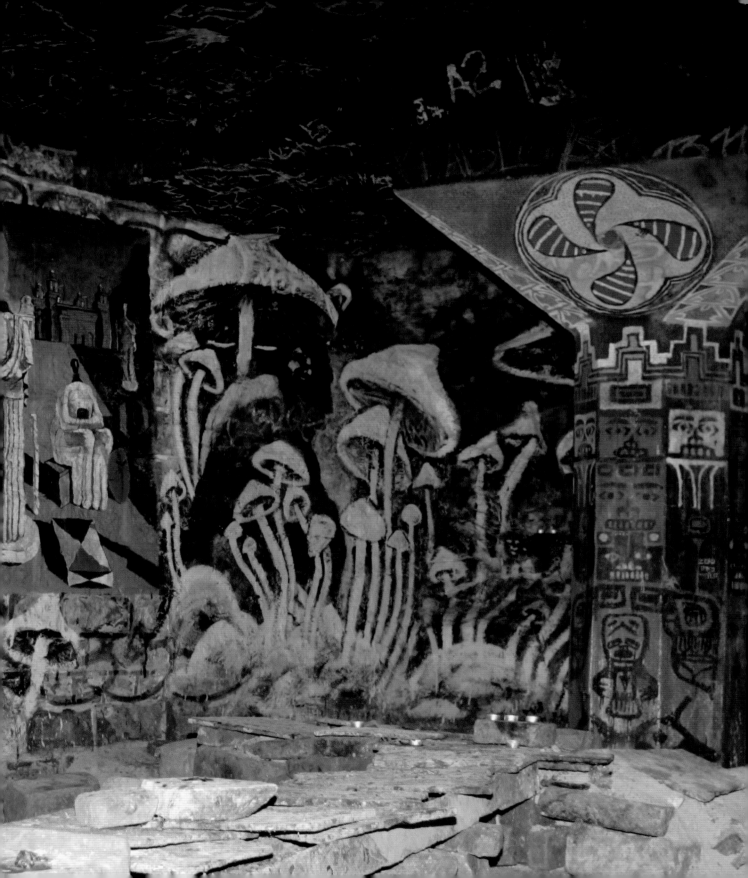

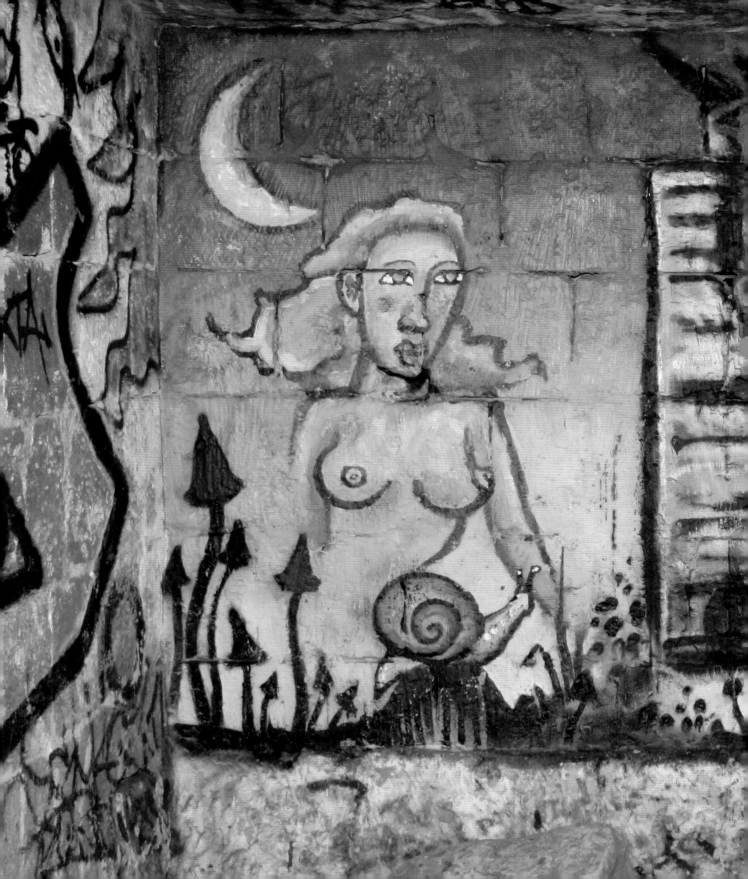

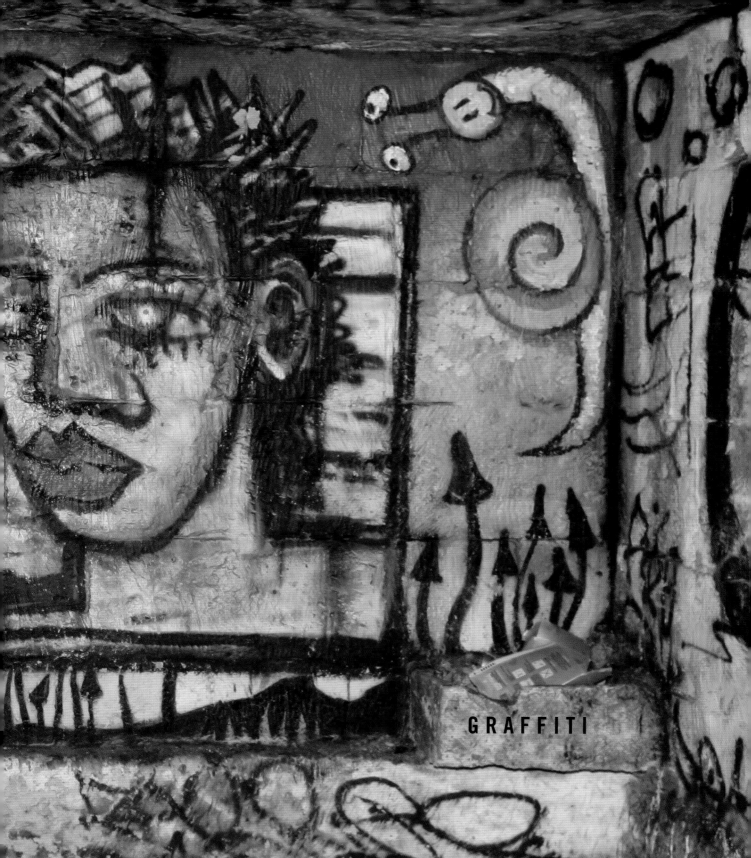

GRAFFITI

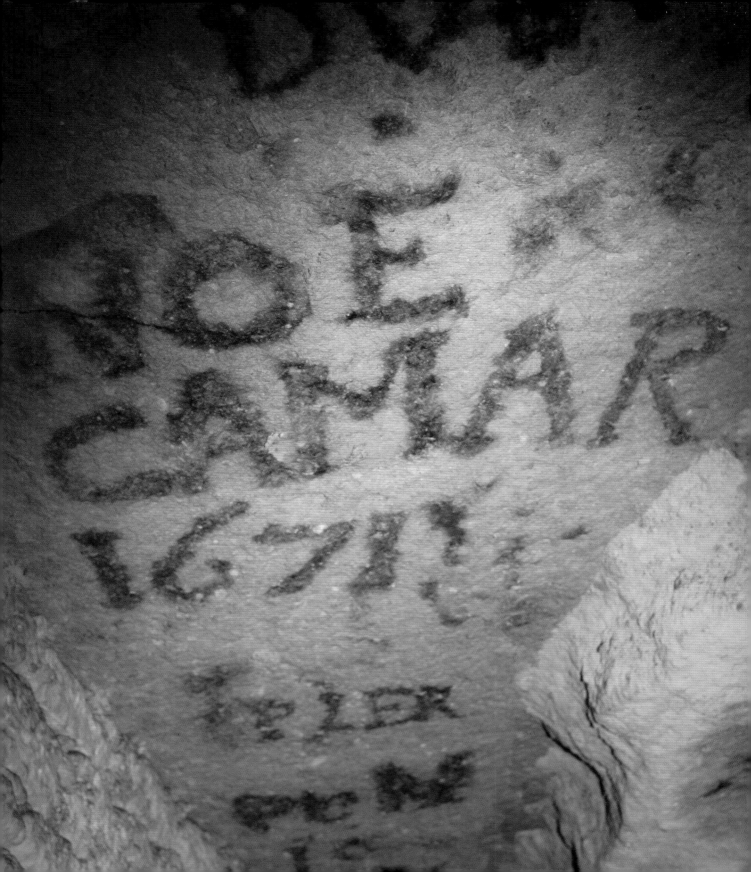

To paraphrase Henry Ward Beecher: there are many instances of men writing letters and forgetting to sign their names; but graffiti is the only instance of men signing their names and forgetting to write the letter! The Parisian quarries are covered in autographs that have no message attached. Wherever human beings go they seem to have an irrepressible desire to inscribe their names

was the common substrate and writing on the fabric of a building was encouraged, not prohibited.

The oldest known dated graffito in the quarries is "noe camar 1671," which is found under the Observatory in the xiv arrondissement. Much of the early writing was made either with black smoke on the ceilings or with pencil on the smooth parts of the quarry walls. The graffiti usually records the

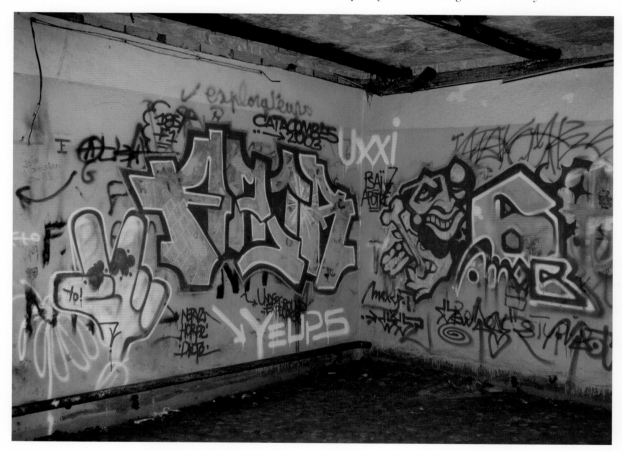

in order to commemorate their presence, and for three hundred years the need to write ambiguous details, frequently repeated in obscure places and for no obvious reason appears to have been a common urge among quarry visitors. Their motivations can only be guessed at, but by writing on the walls they are following a practice as old as lettering itself, back to a time when stone rather than paper

name of the writer and possibly a date and a place. The letters are sometimes capitals frequently all lower case and they have an intimacy and friendliness that is devoid of ostentatious display. Pencil graffiti is difficult to spot in the underground: graphite on stone is barely visible, and the delicate lines are easy to miss as they are regularly obliterated by the marks of subsequent generations.

(Opposite page) "Noe Camar 1671" is the earliest dated graffito in the quarries and it is made with smoke on ceiling.

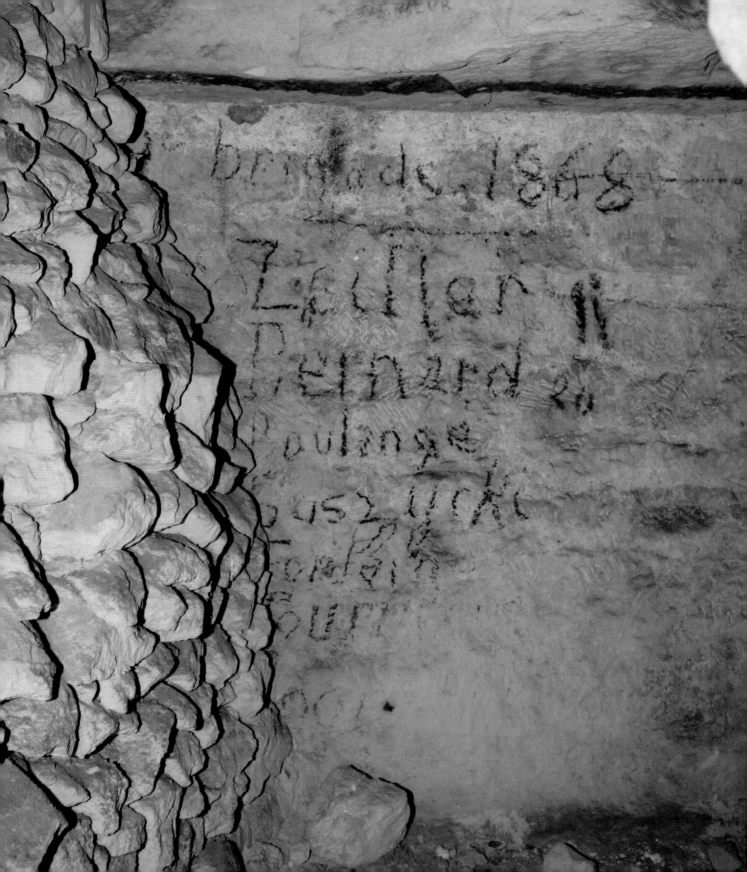

3.et Brig.
(epitome)
Saladin 1874.
Dolfus 180.
Lebris 170.
erand 168
ve 143
va 139
ecorona 173
Mercu 176
Italia 176

DOCTEUR
TINTIN

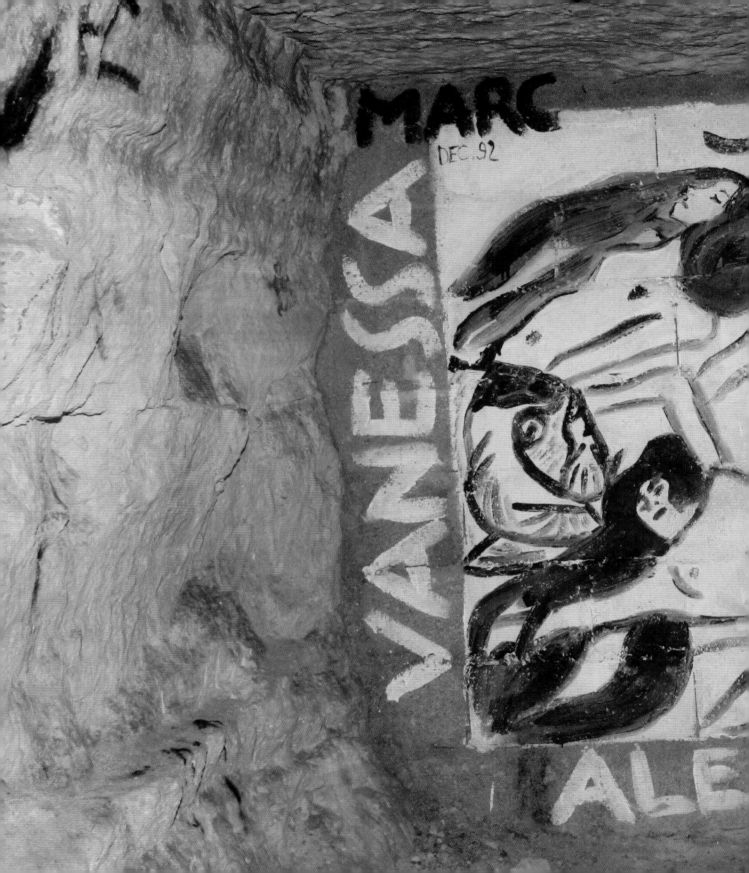

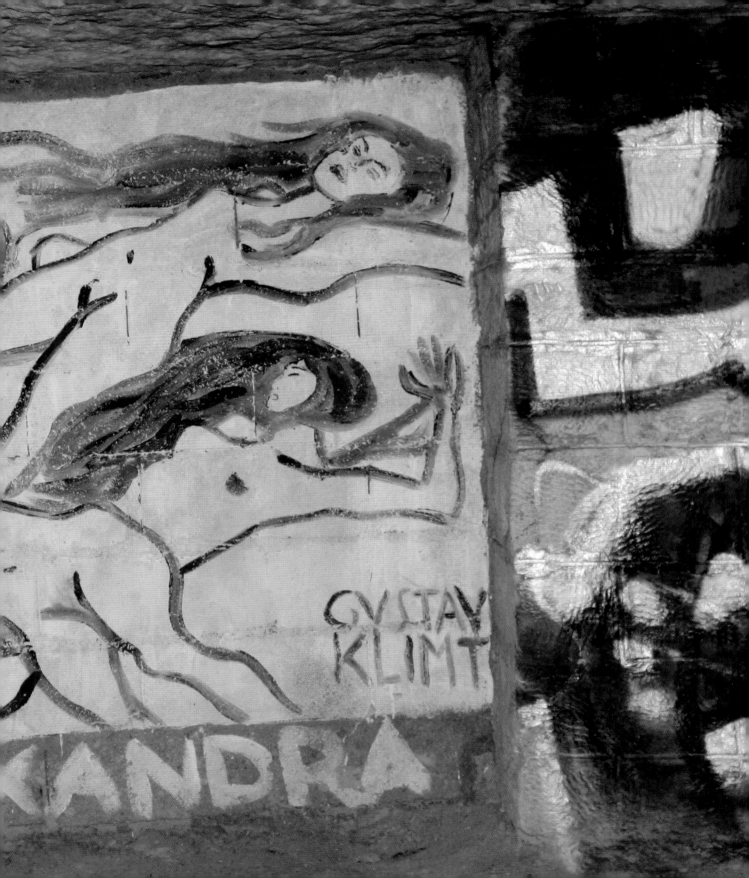

Often the graffiti are clustered in small areas and their presence seems to encourage others to leave their mark also. This has resulted in an accumulation of signatures made by successive generations of adventurers wanting to make known their thoughts without uncovering themselves. The volume of superimposed material makes the old inscriptions difficult to decipher and they are frequently illegible, however, the visual jostling of these casually drawn pencil letters makes them typographically appealing.

Amid the multitude of early graffiti are those of Prussian soldiers stationed in Paris during the siege

used the quarries below for topographical exercises. Students that worked together on group projects were known as "brigades" and it was the habit of each brigade to mark the name of the individual students on the quarry walls with their date of graduation: Adrieux (ET-1869). In some instances note is made of the student's fate, such that of M. Rigaud who "parti pour l'armée du Rhin 12 juillet 1870" (left for the Rhine Army, July 12, 1870).

During the occupation of 1940-44 Paris residents used the quarries as civil defense shelters and marked the walls with their name, address or initials. In idle moments the civilians sometimes made

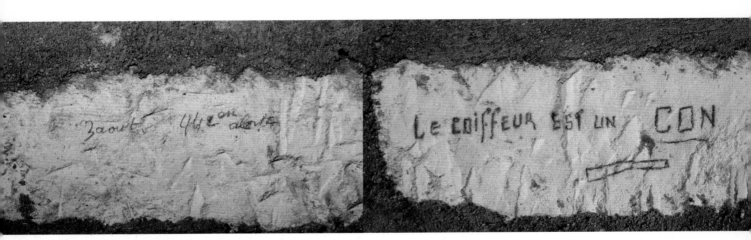

of 1870. Positioned in the south of the city in garrisons with access to the quarries, the soldiers made forays into the underground and left pencil marks of their visit: "Sachmeir 1870"; "Von fels zu Meer, L Baus I Comp 47 Reg, November 13, 1870"; or the exultant "Vive la Bavière!". The defending French Commune fighters established transport links in the quarries and their graffiti can also be seen: the simple "guérilla 1870"; or the romantic "souvenir des Communards" (in memory of the Communards); and the defiant "Les Prussiens ne passeront pas" (the Prussians will not pass).

In the same period, students from the Ecole des Mines de Paris left their marks on the quarry walls. Based in the Hôtel de Vendôme the school

brief and amusingly wry comments accompanied by their signatures: "au remerciement du genie qui nous fit avoir une alerte pendant les sciences. Les martyrs du brevet" (With thanks to a genie that made the alarm sound during science. The martyr of certificates).

FROM TIMIDITY TO AUDACITY

After World War II graffiti in the quarries proliferated and developed from timid and inconspicuous pencil marks into audacious, self-assured and often beautiful letter forms whose success is the result of qualities that run counter to normal typographic principles: incongruity of placement, illegibility of form, and vulgarity of execution.

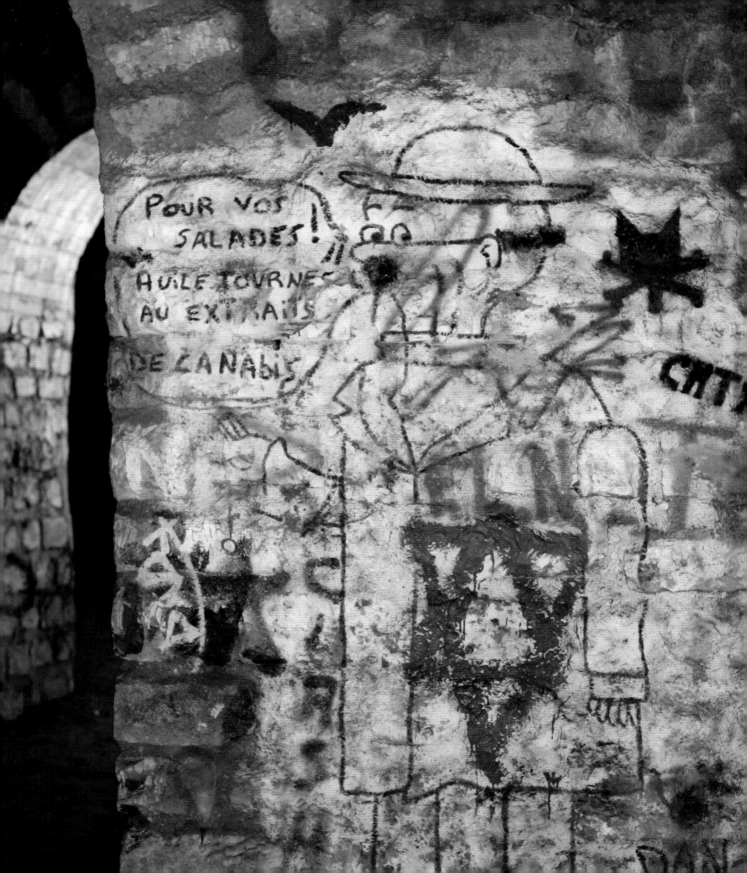

20.J. 1848.

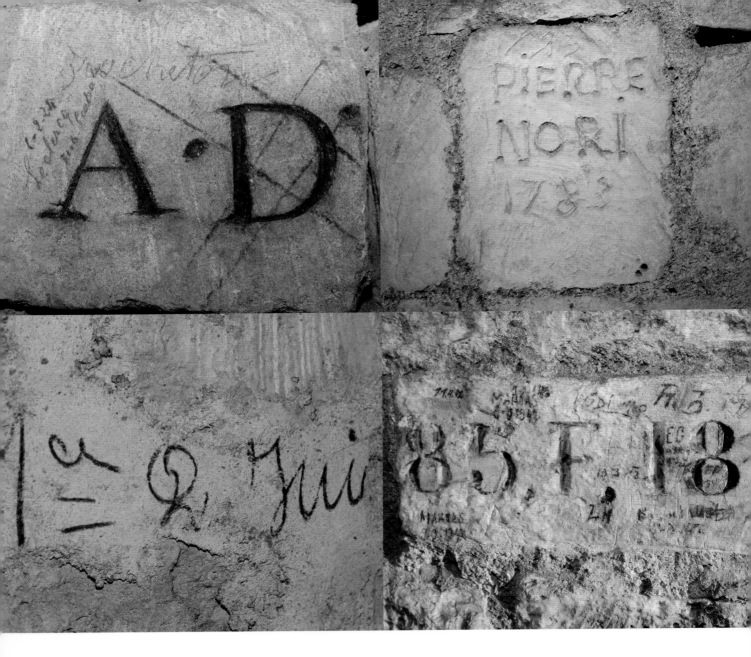

Stylistically, graffiti in the quarries may have evolved past all recognition, but its foundations remain unchanged and graffiti writers of the twenty-first century use the same text as their eighteenth-century forerunners: a name (real or assumed), sometimes a date, a place, or an evocative word in French and occasionally English.

Modern graffiti in the quarries are variable. Those who merely wish to record their presence are responsible for many of the marks; these are small, simple renderings with no artistic input. Others, with pretensions to graffiti writing, produce efforts that range in competence from mindless defacements to accomplished works of art, from the diabolical to the totally assured. Incompetence and aptitude are found in all creative fields and not all the work is done with a moral code, feeling for the environment or with purpose and many writers

 merely demonstrate their lack of talent for creative letterforms and an ineptitude with the spray can or felt-tip pen. However, a significant amount of the lettering is performed with emotion, energy and creative savvy.

Large walls, subversive attitudes, illegal situations and dangerous conditions are essential to the performance of most modern graffiti writers. The quarries admirably satisfy all criteria: they provide extensive wall space, a population of rebellious and anarchic individuals, trespassing is illegal, and danger is ever-present danger. The quarries are undoubtedly the graffiti writers' natural milieu and they find the quarry stone walls irresistible. Graffiti is a large-scale art form and the underground is accommodating with its space. Dedicated writers have the choice of prime spots that give good pay back for their risk, time and money, while small-scale graffiti tags appear in areas near the main inspection galleries in rooms where Cataphiles congregate and where marking the wall is seen as a social activity, a sign of being part of a group.

Large-scale throw-ups and small-scale tagging is a private performance in the quarries, made by anonymous individuals for the benefit of themselves and a group of initiates. The privacy of the quarries protects the writers' anonymity and emphasizes the secrecy of the act. While the individual may remain unidentified, their work and graffiti persona becomes known to the underground society.

Law-defying dangerous conditions are essential to the performance of most graffiti writers. Their work is transformed into political statements by virtue of its illegality; the danger of harassment provides sufficient excitement to engage the required adrenaline and the quarries provide the necessary physical dangers and legal prohibitions. Both the graffiti writers and the Cataphiles enjoy being a part of a movement that defies the establishment; as such they are natural compatriots.

LONGEVITY, LIFE & MOVEMENT

Wall writing is ephemeral; however, the longevity of graffiti in the quarries is greater than that at street level; it is not subject to the vagaries of the weather or to removal by zealous town councils, although some individuals and organizations have taken it upon themselves to clean up some of the name plates that have been defaced. As a consequence there is a lot of layering of one generation of graffiti on top of another and several decades of graffiti happily coexist.

Good quarry graffiti gives pleasure to the underground visitors. It also has a particular interest for typographers, lettering-artists and calligraphers. The models for many of the letters are comics, but they also share characteristics with the decorated initials of medieval manuscripts, that of refinement mixed with tastelessness. In size and vitality advertising billboards and shop fronts influence the letters. Graffiti may just be a signature or "tag" an embellished nom-de-plume with no other purpose than its own existence, but underground graffiti is about lettering as image; whatever meaning they have is in the way they are done and not what they say.

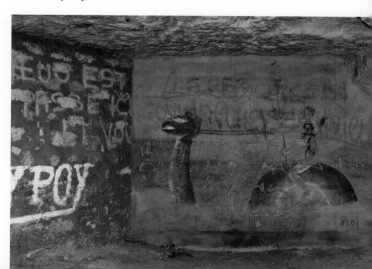

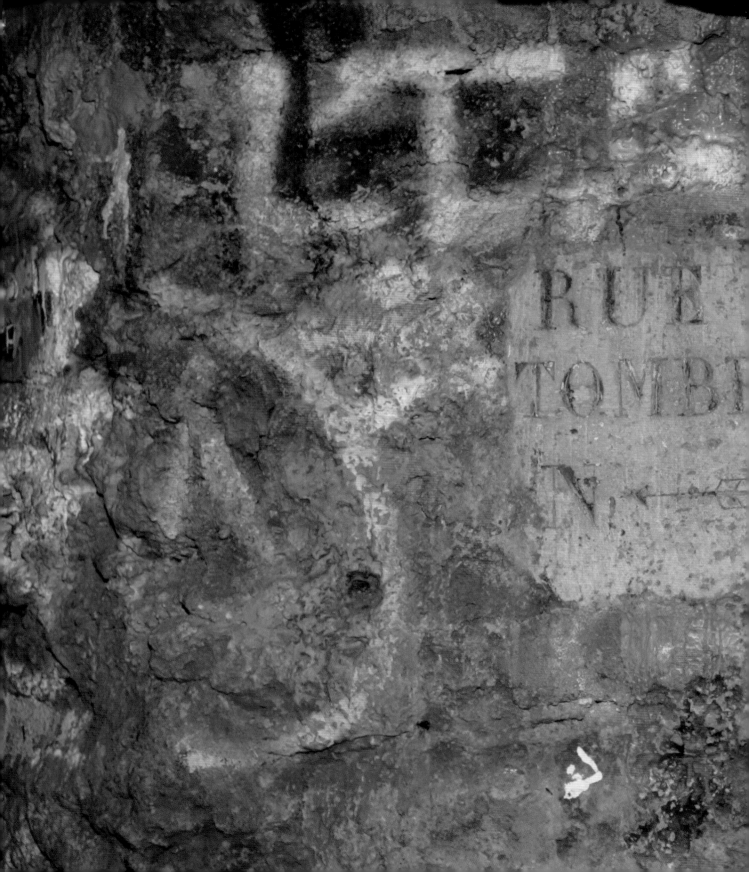

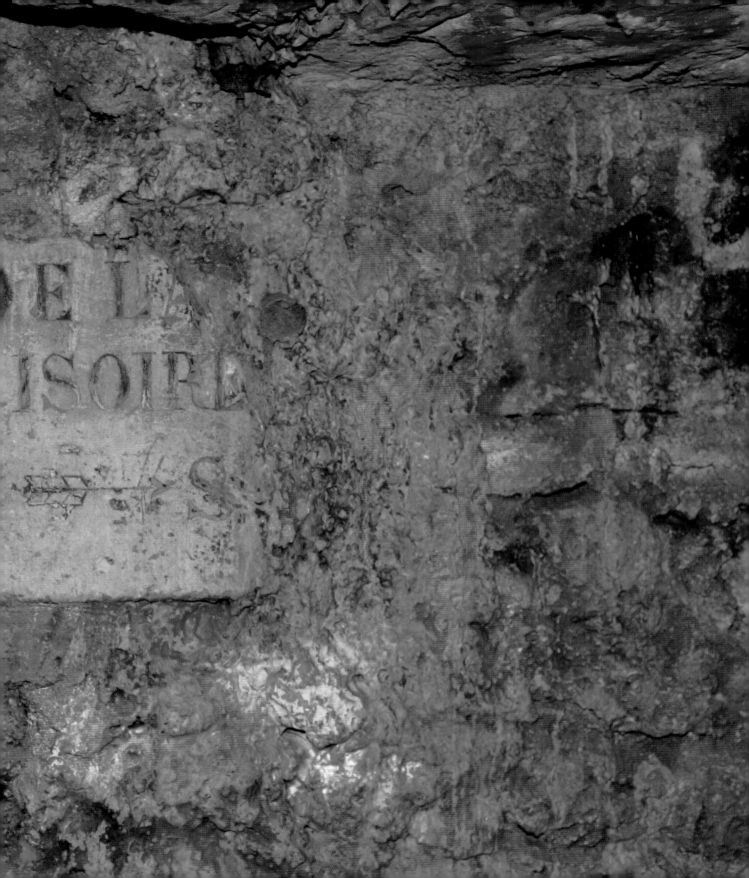

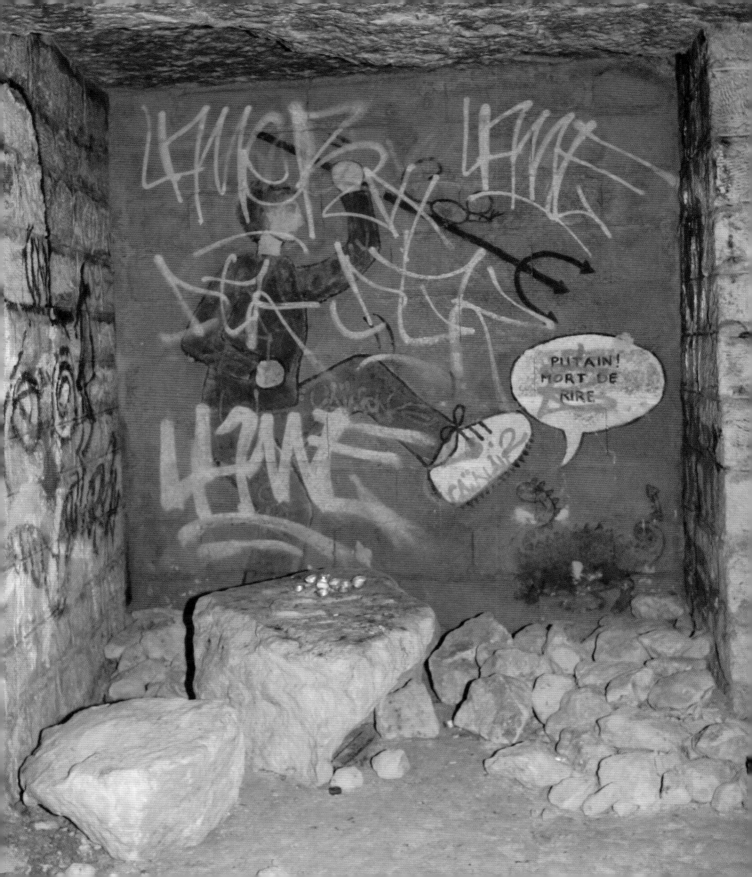

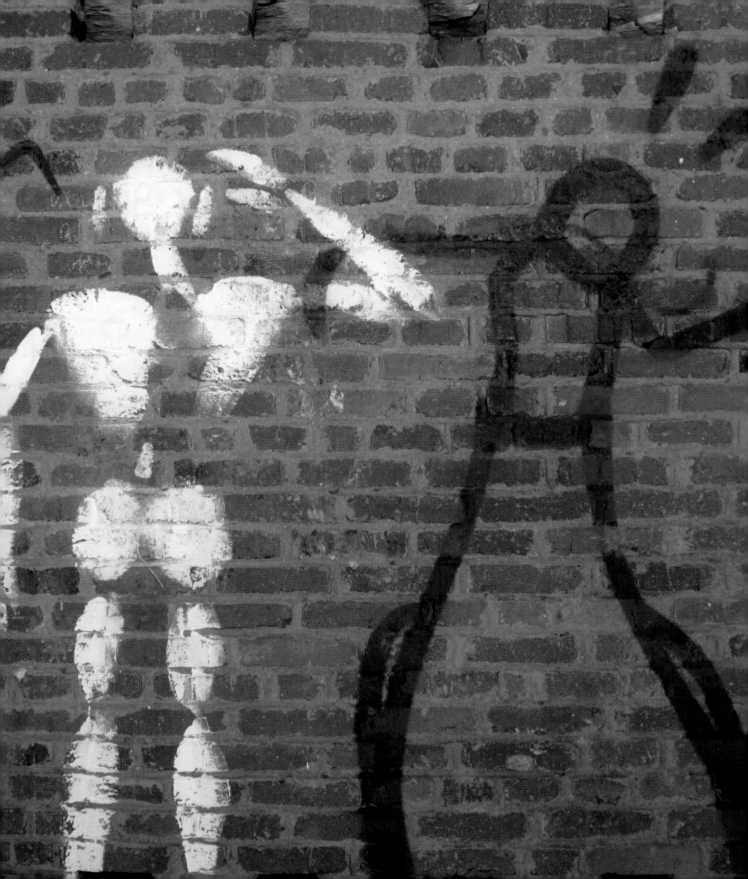

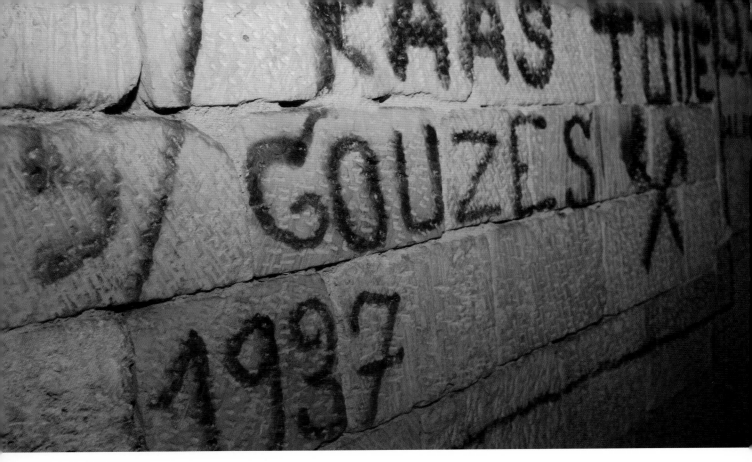

In some instances the words incorporate graphic symbols: stars of David, swastikas, yin and yang signs, peace logos, anarchy symbols, arrows and stars that transform simple tags into wild-style letters. The application of multiple spray-paint colors – white, black, pink, red, green, blue and yellow, and luminous or metallic paints – contribute to some exciting large-scale pieces in the underground that also incorporate pictorial elements. Such complex designs take a long time to produce and often need a "crew" or team to work on them. The smaller scale graffiti are done with felt-tip pen rather than spraypaint, which inevitably impacts on the formation of the letters engendering a calli-

graphic style and an evident enjoyment in the variations between thick and thin strokes can be seen.

The wild and often illegible forms are products of their time, place and circumstances. In the dark and silence of the quarries they create visual noise and chaos. In many areas expert and inexpert, large and small graffiti are mingled to form a lively, dynamic, living and evolving environment that is constantly being added to and continually changing. Often individual tags merge together on walls to form one vast piece and superposition becomes composition. In other instances the merging tags form a background canvas upon which bigger and bolder images have been drawn. Elsewhere graffiti is added on top of paintings, not to deface them but to transform them into ever-evolving entities.

Life and movement are probably the greatest attributes that the graffiti writers bring to the quarries. In the Catacombs there is a formally incised plaque that reads:

Ecoutez ossements arides
Ecoutez la voix du Seigneur
Le Dieu puissant de nos ancëtre
Qui d'un souffle créa les etres
Rejoindra vos nœuds séparés
Vous reprendrez des chairs nouvelles
La Peau se formera sur elles
Ossements secs, vous revivrez

Listen, dry bones
Listen to the voice of the Lord
The powerful God of our ancestors
Who in one breath created them
Will re-tie your undone knots
You will have new flesh
On which new skin will form
Dry bones, you will live again

The austere, rigid letters have been carved into white stone and painted a stark black: their rigidity fossilizes the information they convey. Surrounding the plaque is a black wall into which, over the years, has been carved a mass of rough graffiti letters that reveal the white stone below the black surface. The letters are disorganized, in various styles, written at a variety of angles, using many sizes and styles. In their chaos they have life and vitality and are in stark contrast to the formality of the plate they surround. They are the metaphorical skin that allows the dry bones to live again.

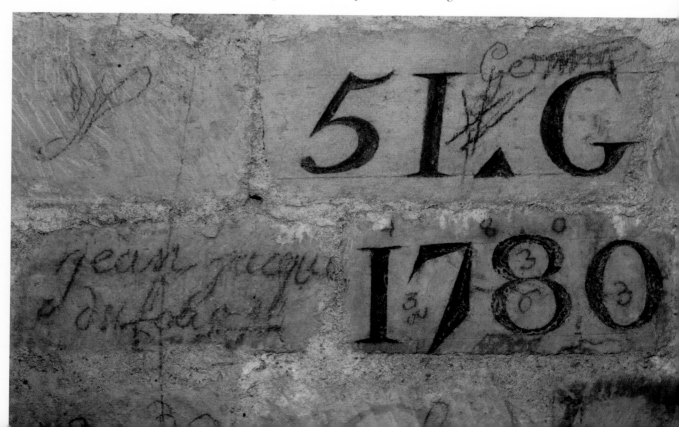

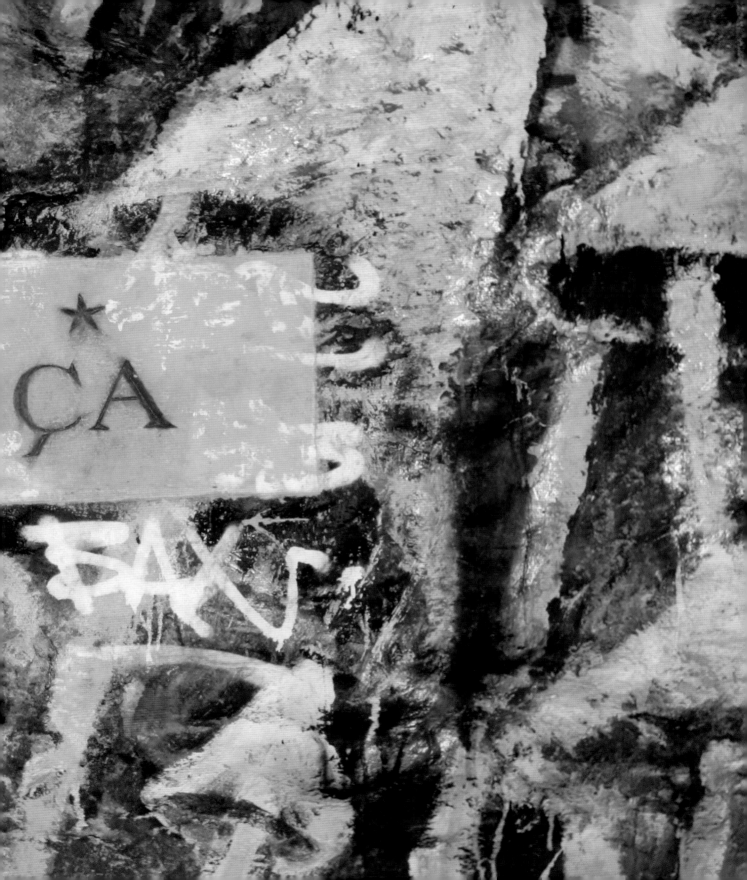

Opinion is divided over the merits of the graffiti writers' work. Some people regard it as inexcusable vandalism not to be countenanced under any circumstances, an unwelcome intrusion whose presence is destroying and defacing the city's subterranean heritage. For many others, the work is welcome and the Cataphiles are seen to have transformed the quarries into a constantly evolving and living space where graffiti represents traces of human activity amid the debris. Their work is seen to humanize an inhospitable place and to provide evidence of life in an otherwise fossilized environment. But love or hate the graffiti writers, their creations are a testimony of our time. Just as many of the quarry walls are infused with evidence of the past, so the Cataphile rooms pulsate with the vibrations of current groups and their way of life, thoughts and actions and the graffiti takes its place in the history of the quarries.

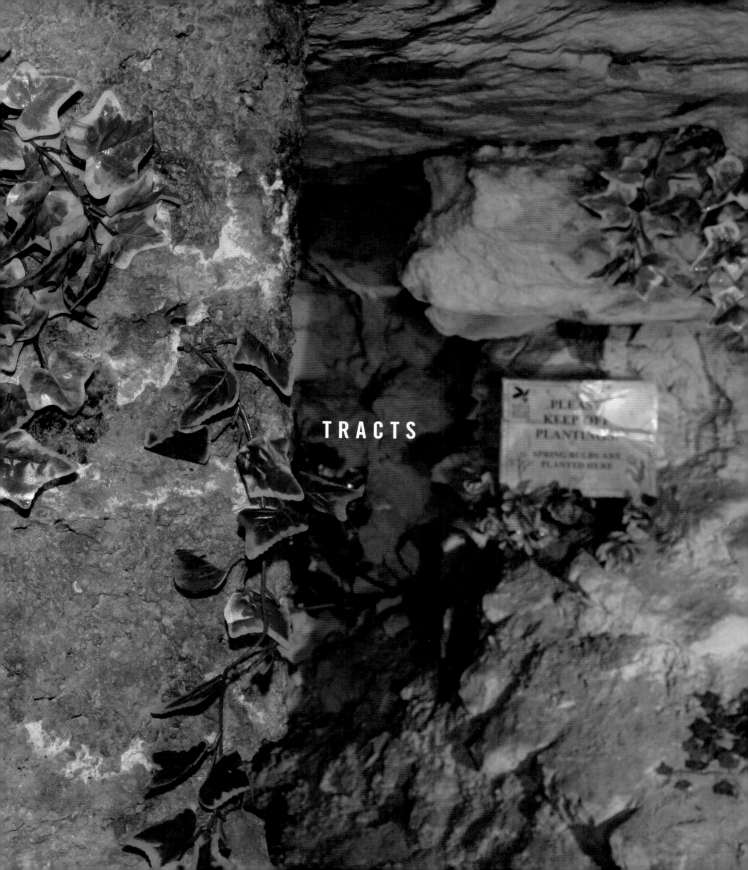

TRACTS

PLEASE
KEEP OFF
PLANTINGS

SPRING BULBS ARE
PLANTED HERE

The art in the Parisian quarries is hidden from everyone except the illicit visitors, but there is another more ephemeral form of underground art that eludes all but the sharpest-eyed Cataphile. While most of the material is highly visible on the quarry walls, there is yet more that is out of sight and buried in the fabric of the stone, and which is only seen by those that know where to look.

For the past twenty years it has been the custom of the Cataphiles to leave small leaflets or pieces of folded paper known as "tracts" in the galleries and rooms of the quarries. These tracts are hidden everywhere in the underground; some are stuck to the walls while the most beautiful, rare, or sought after are secreted in the cracks of the stone. The practice began in the early 1980s when paper notices were posted on the walls of popular quarry meeting rooms asking visitors to remove their rubbish when leaving. Today the purpose of the tracts remains primarily one of communication; however, since their first appearance the leaflets have evolved significantly both in terms of content and presentation and have developed a distinct editorial, literary and visual style.

PAPER COMMUNICATION

Every weekend Cataphiles descend into the quarries to explore the galleries, but the network is so large that many visitors never meet or get to know their fellow enthusiasts. One way in which the underground community has become acquainted with itself has been through the dissemination of paper tracts, and over the years these leaflets have grown to be the Cataphiles' principal vehicle of communication and information, and they have made it possible for either individuals, or group of Cataphiles, to make themselves known to others. Paper tracts are now a quarry institution and they are a defining and integral feature of the underground community.

The tracts are made for many reasons and are used to convey all kinds of messages, impart specific information, or announce significant events: clandestine festivals, evenings of cleaning, "kata sprints" (a race between two designated points in the quarries), weddings or birthdays. Some of the leaflets are intended to transmit a message and many promulgate a personal opinion or broadcast propaganda; they have become a pulpit from which writers can express particular opinions, defend a point of view, rant against the world or evolve a "kata philosophy." Some tracts are produced simply for entertainment and others are works of literature designed to impress and delight.

The tracts are made by individual Cataphiles and are disseminated to the like-minded. The Cataphiles are all amateur publishers, and the writing, editing and designing can be good, bad or indifferent. Some Cataphiles publish only once, others intermittently while some are issuing material almost constantly. But all the kata publishers are motivated by passion and a seemingly uncontrollable need to share their opinions with the kata world at large, and the tracts provide them with a platform for free expression that is subject to neither constraint nor judgement, and which is the occasion for some original writing and unbounded graphic expression.

Tracts are self-conscious, amateur publications that form an important part of the Cataphiles' alternative culture. Some tracts are issued at regular or irregular intervals and might even be classified as periodicals or serials, but publishing schedules are non-existent. Some of the productions are dated and numbered and some are ascribed to a particular Cataphile while others remain anonymous. While much of the art on the quarry walls is dependent upon images, the tracts are more reliant on words. Their editorial style and content is often irreverent; they can be obscene, bizarre or downright funny, and they generally display an in-your-face attitude and are written in forthright language. Not all the tracts have an idiosyncratic edge; some are sensitive with a touch of pathos while others are serious statements on meaningful subjects. But they all share the common characteristics of energy

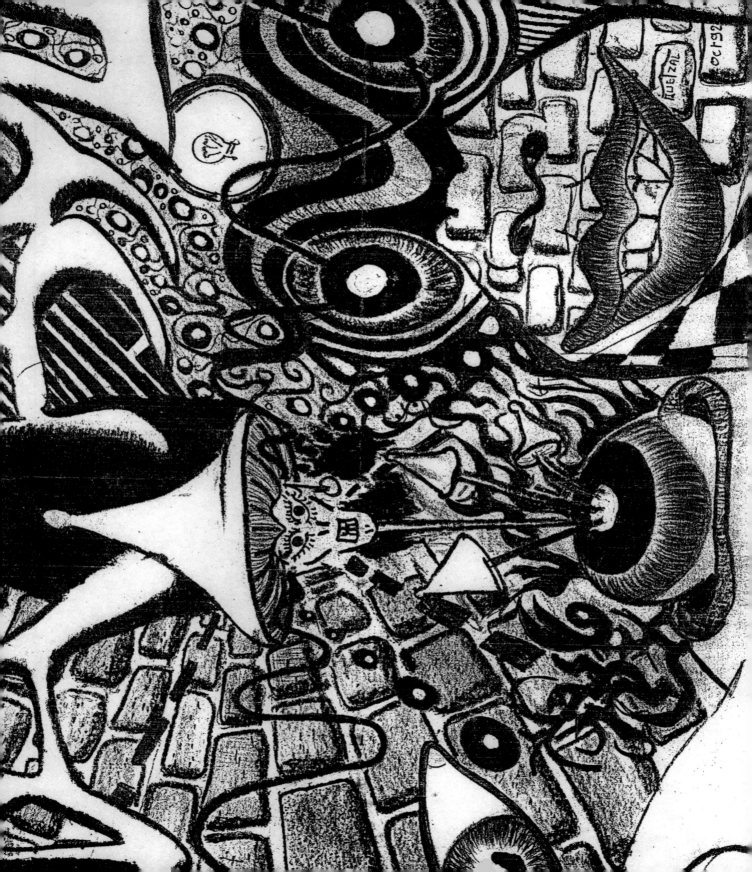

and spontaneity because their contents remain free from manipulation by owners, publishers or advertizers. Typically, a tract consists of personal observations, opinionated narratives, poems or short stories that are often accompanied by hand-drawn images or other crudely assembled illustrative matter. Because the tracts are a part of an active alternative culture their creators often exempt themselves from the traditional rules of publishing and ignore the conventions of grammar, spelling, punctuation and pagination, they pepper the text with plenty of expletives and frequently breach copyright laws. It is a form of publishing that is underground both literally and metaphorically.

FROM STENCILS TO THE DESKTOP

The early tracts were made by hand and then reproduced using stencil-duplicating machines, but with rapid developments in technology the producers quickly turned to other methods of replication, such as xerography and later desktop publishing. The increased accessibility to photocopying machines meant the tracts became progressively more egalitarian and prevalent as the new technology made it possible for everyone to publish simply, speedily and comparatively cheaply. The advent of low-cost personal computers took the production of some tracts to a whole new level, and a number of Cataphiles designed tracts using the latest desktop publishing systems and sophisticated software. But despite ready access to new technology most of the tracts remain primitive and consist of single sheets of paper printed one or both sides and folded; some are made of multiple sheets that have been stapled. Technology dictates the size of the leaflets, which are usually letter-sized and sometimes half of a letter sheet; they are folded and placed inconspicuously in the quarry walls. The tracts are customarily copied onto white paper and very occasionally onto a tinted stock, monochrome copying predominates and in recent years color leaflets have been seen in the quarries, but it is still far from the norm. The tracts are produced in relatively small numbers from a few units to several tens of specimens depending on the required impact, the individual's financial constraints, and their ability access to photocopying or laser printing facilities.

In terms of typographic and graphic presentation, the early tracts adopted a do-it-yourself look. Despite the prevalence of home computers and high street photocopiers, the majority of the current publications deliberately maintain a homespun, handmade feel. The text is usually produced by the cheapest method possible: handwriting, which ranges from the sloppy to the accomplished and which is rendered by pencil, crayon, ballpoint pen, felt-tip or fountain pen. There is also some attempt at hand drawn lettering which sometimes owes its origins to printed type, but also to the lettering styles of the graffiti writers. For those who have limited lettering skills, text cannibalized from magazines is an alternative. Words and letters are cut from pages and assembled in ransom note fashion, pasted down on the paper and photocopied the requisite number of times. Tracts with more extensive copy are produced on typewriters, word processors or, latterly, personal computers. However, little typographic computer wizardry is displayed on the tracts. While some use is made of headline types, few kata publishers succumb to the type distortions or manipulations beloved of most amateur typographers, and although modern technology is used to produce the tracts, they deliberately maintain an unsophisticated appearance that suggests an attitude that is anti-technology, non-commercial and counter to mainstream publishing.

Although the tracts are predominantly about the transmission of written messages, the text is often combined with images. Some of these contain original illustrations that have been drawn by hand and integrated with computer-generated text. Others have "borrowed" images from the mainstream press, downloaded illustrations from the Internet, or cannibalized comic strips that have been edited to serve the purpose of the kata writer. Photography

is also a popular medium, either original or "stolen" and it too is integrated with handwritten or computer generated text. Some of the tracts employ a mixture of all mediums and hand-written methods appear alongside computer-generated text, line illustrations and photographs all of which are assembled together by a process of "cut-and-paste."

Among the homespun tracts there are some that are graphically dazzling and which have been created by a designer's eye and a computer wizard's skill. They look as professional as any publication found on the surface with slick images, sharp design and color reproduction. However, these sophisticated publications appear out of place in the underground, their sophistication is at odds with the rough-and-ready environment in which they are placed and their physical appearance runs counter to the general principals behind the tracts.

FREE BUT EPHEMERAL

Tracts have a particularly short life in the quarries as the moisture and humidity quickly degrades the cheap paper on which most are produced. Discovering a tract is like finding a message in a bottle; there is excitement in coming across an old leaflet as they are like relics that reveal tracks of a forbear their discovery gives pleasure and the finder can take home a little fragment of the quarry. For some people depositing or collecting tracts is their main reason for visiting the quarries and tract collecting is a great Cataphile sport. To support this hobby, regular "tractofolie" evenings are organized in the quarries at which Cataphiles gather to exchange leaflets and meet with fellow enthusiasts. Those tracts that survive and thrive do so through mutual admiration.

Tracts have a firm standing as bonafide non-commercial vehicles of expression in the quarries and they are tributes to a belief in freedom of expression, the power of the individual, the value of diversity. Their production shows the Cataphile community to be large, vibrant, and thriving and for as long as there are passionate Cataphiles or those with agendas the tracts will continue to flourish in the quarries.

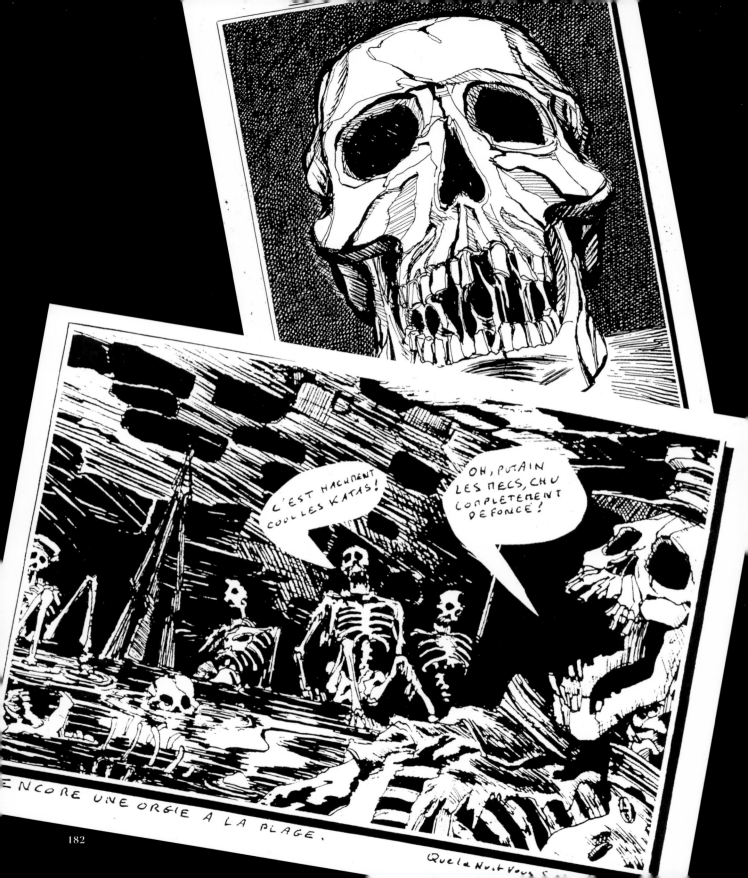

LES RÉVES INACCESSIBLES

de SARRATTE I

Mais entre le reve et la realité il y a un Monde plein
de Kta. Fils qui sont nés pour faire du rêve
un ...

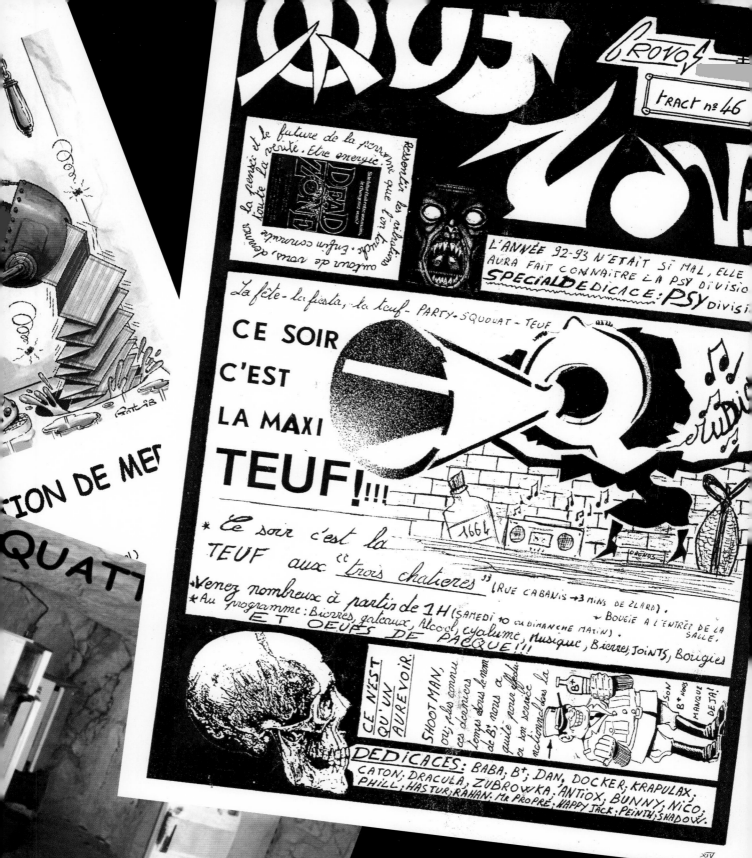

FURTHER READING

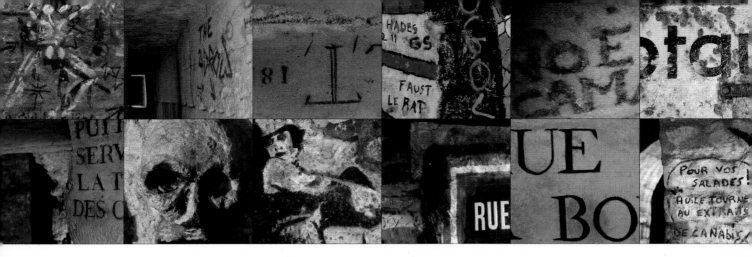

Annichini, Olivier; "Les dessous chocs du sous-sol parisien"; *Response a tout!*; Paris, November 2002.

Arnold, Marie-France; *Paris Catacombes*; Paris: Romillat, 1993.

Aubry, Anne et Frédéric; 'Le Septieme Ciel des Cataphiles'; *Jeunes à Paris*; Paris: B. P. Partners, January, 1992.

Bartram Alan; *Street name lettering*; London, Lund Humphries; New York: Watson-Guptill Publications, 1978.

Bartram Alan; *Tombstone lettering*; London: Lund Humphries; New York: Watson-Guptill Publications, 1978.

Barrios, Maurice; *Le Paris sous Paris*; Hachette, 1964.

Bremner, Charles; 'Tunnels of love spawn security scare'; *The Times*; London, September 13, 2004.

Cerf, Delphine, Babinet, David; *Les catacombs de Paris*; Moulenq, 1994.

Chardon, R.; *Inscriptions et graffiti dans les carrieres de Paris*; Paris: Editions Sehdacs, 1987.

Claustophile; *La fille des carrieres*; Paris & Montréal: L'Harmattan, 1999.

Clement, Alain, Thomas Gilles; *Atlas du Paris souterrain – la doublure sombre de la ville lumière*; Paris: Parigramme, 2001.

Cooper, Martha, Chalfant, Henry; *Subway art*; London: Thames & Hudson, 1984.

Chalfant, Henry, Pigoff, James; *Spraycan art*; London: Thames & Hudson, 1987.

Edwards, Natasha [ed]; *TimeOut Guide, Paris*; London: Penguin Books, 2002.

Fleming, Juliet; *Graffiti and the writing arts of early modern England*; London: Reakin Books, 2001.

Garland, Ken; 'Graffiti'; Redhill, England: *The Monotype Recorder – New Series*, number 7, 1988.

Gérards, Emile; *Paris Souterrain*; Paris: Garnier Freres, 1908.

Glowczewski, Barbara, Matteudi, Jean-Françoise, Carrere-Leconte, Violaine, Vire, Marc; *La cité des cataphyles – Mission anthropologique dans les souterrains de Paris*; Librairie des Méridiens, 1983.

Guerard, Lisa; 'Subterranean shudders at the new-improved catacombs'; *ViaMichelin Magazine*; Paris, October 2001.

Guini-Sklier, Ania, Vire, Marc, Lorenz, Jacqueline; Gely, Jean-Pierre; Blanc, Annie; *Les souterrains de Paris – les anciennes carrieres souterraines*; Nord Patrimoine Editions, 2000.

Henley, Jon; 'Paris's new slant on underground movies'; *The Guardian*; London, September 11, 2004.

Héricart de Thury, Louis Etienne François; *Description des Catacombes de Paris*; Paris, London: Bossanage & Masson, 1815.

Horne, Alistair; *Seven Ages of Paris – portrait of a city*; London: Macmillan, 2002.

Kunstler, Charles; *Paris souterraine*; Flammarion, 1953.

Lacordaire, Simon; *Histoire secrete du paris souterrain*; Paris: Hachette, 1982.

Suttel, René, *Catacombes et carrieres de Paris*; Paris: Editions Sehdacs, 1986.

Thomas, Gilles; '*De quelques graffiti lies au conflit de 1870/1871 relevés sous Paris*'; ASPAG-Première rencontres à Loches, 2001.

Verpraet, Georges; *Paris capitale souterraine*; Plon, 1964.

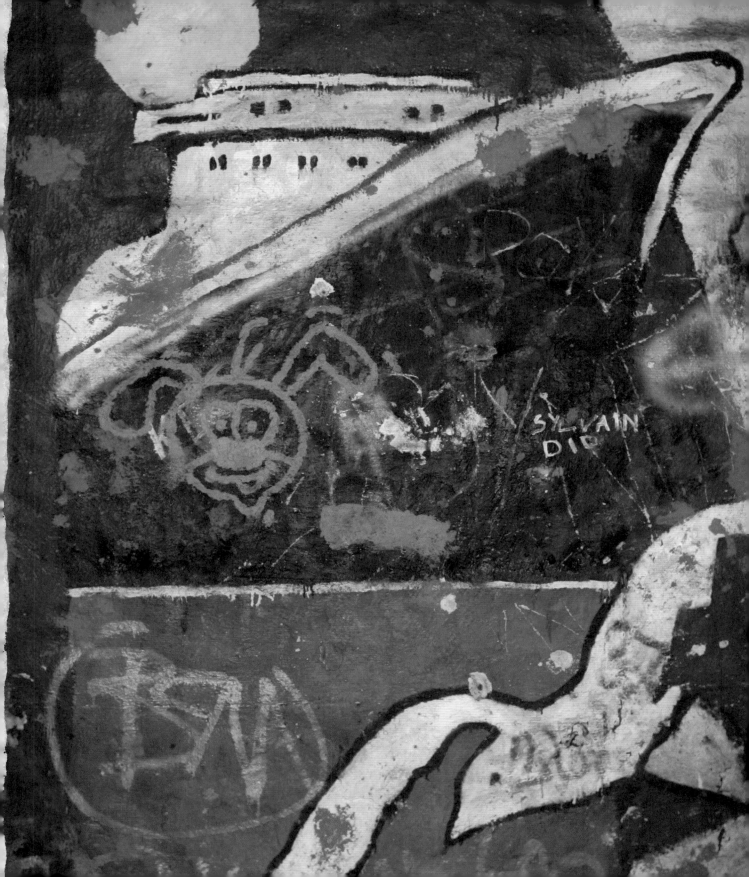